CW00546680

JOHN OSBORNE
BEFORE ANGER

John Osborne

BEFORE ANGER

THE DEVIL INSIDE HIM
by John Osborne with Stella Linden

PERSONAL ENEMY
by John Osborne and Anthony Creighton

Edited with an introduction by Jamie Andrews

Foreword by Peter Nichols

OBERON BOOKS
LONDON

First published in 2009 by Oberon Books Ltd
521 Caledonian Road, London N7 9RH
Tel: 020 7607 3637 / Fax: 020 7607 3629
e-mail: info@oberonbooks.com
www.oberonbooks.com

A catalogue record for this book is available from the British
Library.

ISBN: 978-1-84002-903-1

Printed in Great Britain by CPI Antony Rowe, Chippenham.

Contents

Foreword: Look Back at Frinton

by Peter Nichols

From the third to the eighth of August 1953, John Osborne and I played in Philip King's farce *See How They Run* at Frinton's Summer Theatre. I was the juvenile lead and he was 'The Intruder', which his future career in art and life would show to be very good casting. In fact, he was an escaped Nazi POW disguised (like several other characters in the play) as a vicar. No production photos remain among my souvenirs, nor any of the theatre itself, which memory tells me was a long temporary hut, like an army billet with a platform at one end. Frinton-on-Sea, on the Essex coast, has a nineteen-hole golf course, a grandish hotel, no pubs but many B&Bs, at one of which I must have lodged for my four weeks with the company – one to rehearse at £4.10s per week, three to play *and* rehearse at £5.00. The place was a far cry from Brighton, famously John's resort of choice. *Shell's Guide to England* calls Frinton 'select' and for many years this weekly rep company played a summer season, the sole local entertainment except for its putting links and the sandy beach for a refreshing dip in the North Sea.

Pat Sandys is listed in my surviving threepenny programme as Business Manager, though was more often director and actor in the shows. She later produced *The Bill* (through its best years). Timothy West was running the box office. Playing toffs was James Villiers (pronounced 'Villas'), of the Clarendon family, who was heard to appeal in his plummy voice to the barman of the only hotel, 'Mine host, pray favour us with another ticture of your delightful juice of the juniper berry'. The 'select' old women who came to our matinees and clinked their tea-things in the intervals were exactly the audience favoured by the Lord Chamberlain, the theatre's official censor or smut-hound. John would later suffer from this functionary's philistinism and become a prime mover in getting him abolished. In the 1990s my farce *Blue Murder* described my own meeting with his staff in St James' Palace. Though I sent up the institution, I also, for the hell of it,

found a few points in its favour. The Lord Chamberlain's motto was 'If in doubt, take it out', a Freudian slip that shows how hard it is to clean up a dirty world.

John and I had no idea we were both already writing. There were no literary exchanges, only his advice that the ingenue I fancied and pursued wasn't right for me, as though I'd told him she was my idea of a life-partner. A man who married five times must have had a romantic nature. When I arrived, he was playing a butler in *The Reluctant Debutante*, perhaps wearing the dinner-jacket we were all obliged (by Equity contract) to supply, along with 'One Lounge Suit'. Pat confided her intention of letting him go when this play's week was over. I'm happy to report that I asked her not to, saying he had an uncommonly scathing, sneering manner that made him very watchable. He stayed on for another week as one of Agatha Christie's *Ten Little Niggers*.

Our acquaintance ended there and I never thought of him again until the reviews for *Look Back* three years later when his name evoked that sneer and scowl and I kicked myself for missing the chance to know The Intruder better. When *my* second play was done by The National Theatre, he sent generous praise, though clearly didn't remember we'd trodden the boards in the sort of rubbish his own work had now replaced. I reminded him and from then on got regular firstnight greetings from 'all at Frinton'.

In his first memoir, John called Frinton the sort of place 'where the *Radio Times* was contained in an embossed leather cover'. He recalls my playing a part in a Rattigan for which I was far too young and adds 'He was definitely *not* Frinton. More of a gypsy, I thought.' What can he possibly have meant?

'That would have made quite a difference': Looking back before *Look Back...*

by Jamie Andrews

John Osborne made theatrical history when *Look Back in Anger* opened at the Royal Court theatre on 8 May 1956. Yet as much as he made history, his story has also been powerfully shaped by the perpetual critical and popular concentration on the play – riding waves of acclamation, contestation, and counter-revisionism – that has tied Osborne to the legend of '1956 and all that'. In recalling the events of 1956, it is easy to slide into the myth of the Young Turk who, overnight, heralded a new beginning at the Royal Court with his very first play. In fact, *Look Back* was the twenty-six year-old John Osborne's third play to be produced, as indeed it was the third play to open in the English Stage Company's first season at the Court.

While recent years have seen increasing critical engagement with British theatre in the years before *Look Back in Anger*, disputing the once common view of a pre-1956 theatrical wasteland, few writers have concentrated on the theatre *of Osborne* before this time. Osborne himself made fleeting and disparaging references to his early plays in his autobiography, *A Better Class of Person*, but believed the texts themselves to have vanished, a supposition reiterated in John Heilpern's 2006 biography, *A Patriot for Us.* However, in 2008, during research for the British Library's *The Golden Generation* exhibition (part of the collaborative Theatre Archive Project with the University of Sheffield), copies of the two plays included in this volume emerged from the archives of the Lord Chamberlain.

The Lord Chamberlain was the senior official of the Royal Household, whose arbitrary, unaccountable, and often antediluvian pronouncements dictated what could be seen on the English stage until the abolition of theatre censorship in 1968. Although showing some signs of age, and filed by staff at St James's Palace

in idiosyncratic fashion (Osborne is listed at one point as John Caborne), the typewritten texts are complete, and published here for the very first time.

While Osborne had written at least seven plays before 1956, the two plays that follow are noteworthy not only for their survival, but also for the fact they were actually staged. As documentation of a young writer trying to settle upon his own distinct style, and of two generic (false?) routes he could have followed, both works are intriguing. Moreover, because the sole extant texts had been submitted for licensing to the Lord Chamberlain, both retain traces of the censor's infamous blue pencil, marks of hegemonic social and cultural assumptions in early 1950s Britain.

Before Osborne began writing professionally, he was – like so many new playwrights who emerged during the 1950s – an actor. In January 1948 he was hired as Assistant Stage Manager and understudy for a regional tour of the West End hit *No Room at the Inn*, and it was during this tour, backstage at the Empire, Sunderland, that Osborne began work on his first play, *Resting Deep*. During the summer, Osborne began a relationship with Stella Linden, the new (and married) leading lady on the tour, and it was through Stella's encouragement and editing that Osborne's early draft would later be produced under the title *The Devil Inside Him*. When the tour ended in December, Osborne and Stella moved to Brighton, where Stella's accommodating husband, theatre producer Patrick Desmond, allowed them to stay in his flat on Arundel Terrace.

'Terence Rattigan was around the corner, stars were above and around us': Osborne would always recall his halcyon year in Brighton with Stella with wistful affection, and it was during this period that the two lovers collaborated on a new play, *Happy Birthday*. The text has not survived, but in unpublished drafts of his autobiography Osborne hints at the direction his writing was taking. Ironically for a writer whose uncompromising vigour is often seen to have vanquished the previous generation of post-War verse-dramatists, in 1949 Osborne recalled: 'I remember seeing *The Lady's not for Burning* [Christopher Fry's verse drama] with some excitement, thinking at least here was something

different and that perhaps this was a path I might take'. However Osborne's new-found enthusiasm found little favour with his collaborator – 'I became uneasily aware that Pat and Stella were intent upon producing plays that would out-Binkie Binkie in their Binkieness'[1] – and by summer 1949 the relationship with Stella was over, and *Happy Birthday* abandoned.

Yet the link with Patrick Desmond endured, and after finding Osborne an ASM job in Leicester, Desmond put on *The Devil Inside Him* in Huddersfield in May 1950. Following his first professional production, Osborne met an actor called Anthony Creighton, joining his shoestring Saga Repertory Company – based first in Ilfracombe and moving afterwards to Hayling Island, Hampshire – as Company Manager, before the predictable disbanding of the company in late 1950. The following year, acting in Bridgwater, he fell in love with Pamela Lane; they married in June 1951, and the bitter unravelling of their relationship over the next few years was to be acutely charted in *Look Back in Anger*.

But before their marriage was staged with such muscular realism in *Look Back*, Osborne chronicled it in an altogether more oblique way in *The Great Bear: or Minette*, written in London public libraries between engagements during 1952. Two note-books have survived, comprising the first two acts, as well as thirty-nine pages of the third act (which ends, *in medias res*, with the unfulfilled promise: 'Continued in Book III'). Osborne was clearly still under the spell of the verse-dramatists, and what Jimmy Porter described as 'a good slosh of Eliot' runs through the play. Of more interest, however, is the way in which its structure, narrative, characters and rhetorical tropes so closely mirror his famous follow-up: *Look Back* in free verse. Intriguingly, the image of bears and squirrels (the nicknames Osborne and Pamela gave each other) runs strongly through the play. *Minette* was originally titled *The Animal's Nest*, and the animal metaphors and language are both a refuge ('I played with you first as an animal, and I was happy') and at the same time a paradise constantly menaced: 'O those are traps of steel for you to blunder into…these are men to

1 Hugh 'Binkie' Beaumont was the most successful West End producer of the period.

manacle you monsters, to make you dance pathetically, fastened to a chain.' The bear and squirrel sequence that concluded *Look Back* was the one aspect of the play criticised by Kenneth Tynan in his legendary encomium in the *Observer*, and would cost it an immediate West End transfer, but the image was clearly one that Osborne had been engaging with in his writing for several years, and no whimsical, artificial graft.

For the moment, however, Pamela's verdict on his work was unequivocal – 'dull and boring' – and peripatetic years as a wandering player continued, sometimes overlapping with young writers-in-waiting such as Peter Nichols and Harold Pinter. Osborne completed a new play, *The King is Dead*, in early 1953, and when Pamela found work in Derby in the autumn, he remained in London with Anthony Creighton, researching and collaborating on a McCarthy play, *Personal Enemy*. Pamela's star was rising at the Derby Playhouse, and in early 1954 Osborne briefly joined her, an unhappy period that marked the beginning of the end of their marriage (they divorced in 1957). In between engagements at the Playhouse, Osborne furiously searched for an agent to take on *Personal Enemy*, and in letters to Creighton he tracked the changing fortunes of Senator McCarthy, speculating on the likely implications of his fall for their play. At the same time, Osborne looked for a theatre for *The King is Dead*, and sent a copy to Kenneth Rose at the Playhouse, Kidderminster (where Osborne had played the previous summer), enclosing admiring quotes from Richard Findlater and Dame Sybil Thorndike. Rose was cautiously encouraging, though felt that Osborne went 'completely off the rails' after the first Act; embarrassingly, he was unimpressed by the letters of support, and claimed to have seen at least a dozen recent plays with 'Sybil Thorndike's blessing attached to them'.

Personal Enemy was eventually staged the following year by Osborne's old mentor, Patrick Desmond, although by the time it opened in Harrogate in March 1955, Osborne claimed to have lost interest in the work. (In fact, he was still sending the script to theatres, including the Bristol Old Vic, after the Harrogate production.) An autumn tour of Wales in *Pygmalion* was followed by a cold and impecunious London winter with Creighton,

during which Osborne again collaborated on a new play with his flat-mate. Creighton had developed a dramatic situation derived from his experiences working at the telephone exchange, and onto his basic plot Osborne began to add dialogue, and a title: *Epitaph for George Dillon*. *Epitaph* is the only pre-*Look Back* play of Osborne's to have been performed and published after 1956, and a substantially revised version was first produced – to no little acclaim – by the Royal Court in a post-*Look Back* glow in 1958. In addition to the staging of *Personal Enemy*, the early months of 1955 saw Osborne begin a new work, eventually titled *Look Back in Anger*. The play was finished on 3 June, and having been turned down by Patrick Desmond, it was submitted to the usual trial by agents, before eventually ending up at the newly formed English Stage Company at the Royal Court. By now, history seeps into legend, and the events that led to George Devine rowing out towards Osborne and Creighton's barge on the Thames, which in turn led to 8 May 1956, are well known.

Ten years later, in November 1966, John Osborne gave evidence to the Joint Select Committee of the House of Lords and the House of Commons on Censorship of the Theatre, an investigation that led to the abolition of theatre censorship in 1968. As part of his testimony, he mentioned his earlier, pre-1956 work, and recalled his brush with censorship (which he mis-remembers as taking place in 1951). Evidently interested, the committee speculated that 'had it not been for the existence of the Lord Chamberlain, you might have made your appearance as a dramatist in this country in 1951 instead of 1956', concluding: 'that would have made quite a difference, would it not?' In publishing the two plays of John Osborne to be produced before 1956, we do not take aim at the radical impact or influence of *Look Back in Anger*. Rather, in bringing to light two intriguing works that are of significance to the story of Osborne – itself part of the story of post-War theatre – we hope to gently underscore the fact that a teleological view of theatre history is never the full story. A legend is an invisible melding of false starts, dead ends, and the capricious vicissitudes of chance: things might always have been different.

The Devil Inside Him

We few, we happy few…
Henry V

One afternoon she introduced me to the assistant stage
manager, a willowy good-looking young man of eighteen.
Stella had already told me about him, that he looked like
a Greek god and wrote marvelous poetry… A few weeks
later, Stella brought me a play he had written… It was
very interesting, but useless.

In his unpublished memoirs, Patrick Desmond recalls the
moment when his wife, Stella Linden, introduced him to her
fellow actor and soon-to-be lover, John Osborne. In spring 1948,
Osborne had completed the first draft of what he later described
as 'a melodrama about a poetic Welsh loon called *Resting Deep*',
and had shown it to Stella. Schooled in the demands of reper-
tory theatre, Stella immediately identified a lack of structure, and
advised a crash-course in the well-made plays of Pinero. Stella's
supercilious surprise that Osborne had not read *The Second Mrs
Tanqueray* ('that, she suggested, accounted for my blundering') has
its comic counterpoint in *Epitaph for George Dillon* when the shady
producer reacts to George's ignorance of *I Was a Drug Fiend*: 'no
wonder you write like you do. I thought everyone had seen that.'
Of equal concern to Stella was Osborne's soaring language, since
any 'intimation of poetry in the theatre was pornography to her'.
Nonetheless, Desmond was hoping to take over the Granville
theatre in Waltham Green, and Stella hinted at a production of
Resting Deep for the opening season…if changes could be made.
Accordingly, the two lovers set to work reshaping the play,
adding 'a few coarse jokes', and re-titling it *The Devil Inside Him*.
Over thirty years later, Osborne recalled one of these jokes – the
daffy daily woman singing a song called 'Oh let me play with
your snowballs' – with glee, marvelling at how they had sneaked
it past the Lord Chamberlain. He was to be less successful in
subsequent encounters with the official censor.

Waltham Green remained a pipe-dream however, and after
their tour had ended, Osborne and Stella moved together to

Brighton, where they collaborated on a new play. However, Osborne's continued attachment to poetical drama became a source of tension, and he remembered 'Stella berating me for my inexperience and disastrous tendency to poeticise rather than dramatise'. As the glorious summer of 1949 drew to a close, so did their relationship; that *The Devil Inside Him* survived the liaison was due entirely to Patrick Desmond. Producer, director, actor; Desmond was above all an impresario, with an impressive theatrical pedigree dating back to the 1930s. In the 1960s he would set up a touring company with a young Cameron Mackintosh, but he was the kind of larger-than-life figure fated to disappear from the English stage with the decline of weekly rep. Osborne admitted to partly modelling the gregarious theatre producer Barney in *Epitaph for George Dillon* on Desmond, and it may be no coincidence that an actor called George Dillon was playing in Desmond productions at this time.

In early 1950, Desmond secured the Theatre Royal, Huddersfield, for a short repertory season, to include *The Devil Inside Him.* Although Osborne had volunteered to play the leading role in his play, an 'exciting young actor' was engaged instead (cynically glossed by Osborne as 'someone inexperienced and cheap'), and 'the world premiere' of *The Devil* began to be breathlessly advertised as a 'turbulent drama with love, hate and murder'.

> On Easter Monday [in fact it opened on Whit Monday] 1950 I sat in the stalls of the Theatre Royal, Huddersfield, watching the world opening of my play, holding hands with my co-author… After less than eighteen months in the theatre, I was watching my own play – or a version of it – being performed in a professional theatre.

Takings on the opening night were good, and the *Huddersfield Daily Examiner* hailed the 'real dramatic instinct behind the play', as well as the performance of Reginald Barratt as Huw ('as brilliant a piece of acting as we have seen…for a long time'). However, audiences waned throughout the rest of the week and, in Desmond's words, 'it created no stir'. Although Osborne affectionately remembered the opening night, he found his 'remaining wastegrounds of poetry' had begun to pall, and in retrospect seems not to have dissented from the opinion of the

official censor: 'A conventionally gloomy play about the Welsh as I hope they are not?' *The Devil Inside Him* is, however, far more absorbing than the Lord Chamberlain, or perhaps its author, would give it credit for.

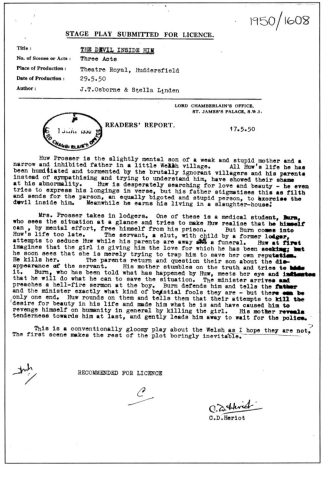

1950/1608

STAGE PLAY SUBMITTED FOR LICENCE.

Title :	THE DEVIL INSIDE HIM
No. of Scenes or Acts :	Three Acts
Place of Production :	Theatre Royal, Huddersfield
Date of Production :	29.5.50
Author :	J.T.Osborne & Stella Linden

LORD CHAMBERLAIN'S OFFICE,
ST. JAMES'S PALACE, S.W.1.

READERS' REPORT.

17.5.50

Huw Prosser is the slightly mental son of a weak and stupid mother and a narrow and inhibited father in a little Welsh village. All Huw's life he has been humiliated and tormented by the brutally ignorant villagers and his parents instead of sympathising and trying to understand him, have showed their shame at his abnormality. Huw is desperately searching for love and beauty – he even tries to express his longings in verse, but his father stigmatises this as filth and sends for the parson, an equally bigoted and stupid person, to exorcise the devil inside him. Meanwhile he earns his living in a slaughter-house!

Mrs. Prosser takes in lodgers. One of these is a medical student, Burn, who sees the situation at a glance and tries to make Huw realise that he himself can , by mental effort, free himself from his prison. But Burn comes into Huw's life too late. The servant, a slut, with child by a former lodger, attempts to seduce Huw while his parents are away at a funeral. Huw at first imagines that the girl is giving him the love for which he has been seeking; but he soon sees that she is merely trying to trap him to save her own reputation. He kills her. The parents return and question their son about the dis-appearance of the servant. His mother stumbles on the truth and tries to hide it. Burn, who has been told what has happened by Huw, meets her eye and indicates that he will do what he can to save the situation. The minister arrives and preaches a hell-fire sermon at the boy. Burn defends him and tells the father and the minister exactly what kind of bestial fools they are – but there can be only one end. Huw rounds on them and tells them that their attempts to kill the desire for beauty in his life and made him what he is and have caused him to revenge himself on humanity in general by killing the girl. His mother reveals tenderness towards him at last, and gently leads him away to wait for the police.

This is a conventionally gloomy play about the Welsh as I hope they are not. The first scene makes the rest of the plot boringly inevitable.

RECOMMENDED FOR LICENCE

C.D.Heriot

The opening scene would have been familiar to rep audiences of the time: a mysterious lodger – redolent perhaps of *The Mousetrap's* Mr Paravicini – creeps down the stairs of the boarding house, and we don't have to wait long for the introduction of a comically garrulous daily woman, and a precociously seductive servant girl. As the play advances, however, an exploration of

the cost of being true to oneself – of finding a place in an indifferent world – emerges, and Burn's comment towards the end of the play that 'those happy few don't need an interpreter' highlights the loneliness of this struggle, one bereft of any of the false comforts of conventional society or religion. These are all concerns familiar to Osborne's later heroes; and to the roll-call of Osborne's (sometimes) happy few, to the Jimmy Porters and the Colonel Redls, can be added a new member of the band of brothers: Huw Prosser.

Huw is established early in the play as an elemental, almost animalistic, foil to the hypocrisy of so-called civilised village society. Lengthy stage directions detail Huw's way of eating ('There is a strange almost primitive delicacy about the way he eats and drinks. Perhaps it can be best compared to a rabbit') in sharp contrast to the socialised routines of his parents who 'continue with their meal stolidly'. Later, in ever-increasing flights of verbal extravagances, Huw opposes the sterility of the house to the integrity of the natural world:

> I can show you the softness of the mists, wandering like strangers amongst the marshes; where the sad music of the wild birds runs like mountain water over the strings of the young reeds. I can show you the smell of dead bark freshly chipped from its tree; the urgent smell of early morning and the hushed smell of the evening.

Yet the natural world is not idealised, and Huw's job at the village butcher allows for an early intimation that the truth of the natural world barely conceals its primal violence: 'Have you ever seen a pig slaughtered? They hold its head, grip its ears and sit on it, like sitting on a bicycle. And they cut its throat just as you might cut an apple. And it screams.' While this may not seem obvious table-talk, for Huw it is the honesty of his description that counts, an honesty that his parents are unable to face ('Such a pity he couldn't have worked in the Insurance Office with his cousin David', is all his mother can muster in response). As the play progresses, it becomes clear that the village is paralysed by the prospect of such plain speaking, and numbed by fear of an ill-defined outside world. The icy minister, Mr Gruffuyd, accords himself the power to define and root out evil in the village's

midst, and in so doing employs the language of medieval witch-hunts: 'The devil is inside you, Huw. Can you feel him? Living in the filth inside you?' In Gruffuyd's determination to expel 'the voice of the devil, the tempter', the play dramatises a repressive society not dissimilar to the hysterical paranoia of McCarthyite America that Osborne would turn to in his next play to be performed, *Personal Enemy* (1955). More prosaically, the puritan Welsh minister is perhaps also a jab at a fellow actor in *No Room at the Inn* whom Osborne suspected of spreading gossip about his affair with Stella (his 'Welshness and Puritanism made him a likely double dealer').

In the confrontation at the end of Act III, the underlying structure of the Minister's cruelty is subtly dissected by Burn (a medical student and *raisonneur* of the piece), when he articulates a charge directed at crusading hypocrites throughout the ages: 'You can't stamp out what doesn't exist. You create evil. You *want* it…that's your business, isn't it? Denying life and creating your "evil" myth, making beauty into ugliness.' The play is a plea for resistance to this stultifying world-view, an appeal for a unity of mind and soul, and for 'all the good things that life has to offer'. In light of this, what then are we to make of the act that defines the play's narrative, and the character of Huw: his murder of the servant girl, Dilys, at the end of Act II? Or rather, *almost* at the end of Act II, for a crucial, single-page, wordless scene is interpolated before the Curtain, which suggests how we might read this sudden irruption of violence.

The murder scene is indicative of the way the play as a whole is positioned intriguingly between two theatrical eras. On the one hand, a good murder is a staple of the well-made rep thriller, and a common conceit to accelerate and concentrate narrative. It can set up a whodunnit in the best Christie tradition, the characters assembling in a single room for a classic unmasking scene: the daily woman in the kitchen, or the shady commercial traveller with the candlestick? However, by showing the murder on stage, and by allowing the other characters to quickly understand the identity of the killer, this approach is effectively denied. Is it then an act of isolated madness (in line with Osborne's later description of Huw as 'a Welsh loon'), an *acte gratuit*?

The detailed stage directions to the wordless scene suggest that by choosing to strike against the moralising of the village, and by assuming the consequences, the murder is in fact a truly existential – and thus transformative – act.

> This is another Huw... He seems to stand up straight mentally and physically for the first time... None of his movements are hurried, neither are they unsure.

It is an act that visibly re-defines Huw and his ethical configuration within a new freedom. We might compare this total transformation in Huw to the new-found self-awareness and decisiveness of Sartre's existential hero, Orestes, after the murder of Clytemnestra and Aegisthus in the play *Les Mouches*, Sartre's gloss on the *Oresteia* (produced in London as *The Flies* in 1947). For all Osborne's later fulminating against the pretensions of the prevailing French drama, he was reflecting deeply on the Existentialists' emphasis on the vertiginous imperative of choice and freedom. In one of his early notebooks, among notes on Sartre's classic existentialist novel *L'âge de raison* (*Age of Reason*), Osborne grudgingly admitted: 'I can't help feeling that those existentialists for all their raffishness have got something... We really do seem to be dominated by choice.'

However, there is failure at the heart of the play's narrative and extra-diegetic spaces, and it is a failure of language. Huw's action is a step towards selfhood, but (like Orestes) it is an alienating act that he is unable to share, except, briefly and tentatively, with Burn. 'Every loveliness I have known has been a secret one', Huw admits, and his early reading of Sonnet CVI – 'Have eyes to wonder but lack tongues to praise' – points at his inability to engage fully with his fellow human beings through language. Despite the clarity of the manner in which he assumes his act, communication – defined by Burn as 'the way from our loneliness' – is beyond Huw. Similarly, Osborne's dramatic language cannot quite convince in its attempts to enclose his tilt at conventional morality, and his bold appeal to the strength of the individual. The 'flashes of poetry' ultimately distract from his keenly-felt convictions, and it would take a few more years before the violence of Osborne's passion would find a more apposite

means of expression through the demotic furies of Jimmy Porter in his third play to be produced: *Look Back in Anger.*

Personal Enemy

> It was a queer, sultry summer, the summer
> they electrocuted the Rosenbergs.
>
> Sylvia Plath *The Bell Jar.*

John Osborne's second play to be produced, *Personal Enemy*, is set in small-town America in August 1953, in the middle of Plath's 'queer, sultry summer'. Amid an atmosphere as feverish as the close summer heat (referenced with conspicuous frequency by the characters), Cold War tensions within the United States were intensifying; on 19 June 1953, Julius and Ethel Rosenberg were electrocuted in Sing-Sing for conspiracy to commit espionage, while the unsatisfactory ceasefire agreed in Korea a month later did little to calm anxieties about waning American military and moral supremacy.

Personal Enemy addresses these Cold War tensions through the microcosm of the Constant family, who live unremarkable, 'apple-pie' lives in an imaginary all-American town. Even in the suburbs, the Cold War is never far away: early on, we learn that the family's elder son, Don, has been reported killed in Korea, while back home, his sister describes the all-pervasive atmosphere of fear:

> Things are brewing up all around us now. You can feel it everywhere, Mom. People are frightened.

While the Rosenbergs are never specifically mentioned, an atmosphere of domestic paranoia is thus clearly established, and references to blacklisting, testifying before Committees, or a character's dismissal from the State Department make this play a rare example in 1950s England of 'committed', social-realistic Cold War theatre.

In drafts of his autobiography, Osborne describes the genesis of *Personal Enemy*, when he was living in London with Anthony Creighton, leaving Pamela in Derby:

The McCarthy trials were at their height and I became interested in them. They seemed like the material for a play and something for me to absorb myself in until perhaps such time as Pamela came back.

Osborne spent several weeks reading transcripts of the House Un-American Activities Committee (HUAC) in the American Library in Grosvenor Square, and developed the text from his own editing of the transcripts, combined with Creighton's 'rather ludicrous melodramatic plot'.

After finishing the draft, Osborne sent a copy to Sam Wanamaker (himself a high-profile victim of McCarthyism), and was surprised when the actor replied, offering to discuss the play. If Osborne later dismissed the significance of *Personal Enemy*, claiming he only began to collaborate with Creighton 'out of laziness or want of companionship', a letter sent by Pamela from Derby suggests the prospect of the Wanamaker meeting had given him hope for the work:

> Bully for Bears [Osborne] going to see Wanamaker. I can just imagine the interview!… I shall kick myself if you come up here or go to any rep job just as things start happening to *Personal Enemy*.

In fact, little came of the meeting in January 1954. 'Knowing nothing about America', Osborne had expected Wanamaker 'to fault the technical details'. Instead, Osborne records that the older actor expressed admiration for the play, but worried that it was too critical of America for British audiences to accept. Seeing in this 'tepid endorsement' the kind of self-imposed fear that *Personal Enemy* denounces, Osborne later wrote: 'for casuistry or timidity, I thought his verdict took the Binkie Beaumont biscuit.'

With immediate hopes for a production dashed, Osborne was on more familiar ground in sending the text to producer Patrick Desmond (indeed, he originally conceived the melodrama as 'a superior kind of Patrick Desmond package'), who agreed to produce the play at the Opera House, Harrogate, in March 1955. In preparation, Desmond submitted the text to the Lord Chamberlain's office for licensing, and soon ran into difficulties caused by the censors' identification of 'dubious lines'. Not, as we might

suppose, concerning the explicit criticism of Britain's war-time ally and references to the Communist Party, but because of the equivocal sexuality of the two Constant sons, and the carefully codified suggestion of homosexuality.

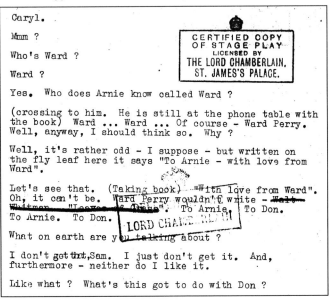

The mid 1950s saw the Lord Chamberlain embark on ever more furious attempts to uphold the ban on the representation of homosexuality in the theatre; after all, as Lord Clarendon mused in 1951, the subject was 'very distasteful and embarrassing in mixed company' and 'might start an unfortunate train of thought in the previously innocent'. Although the ban was relaxed after the *Wolfenden Report*, the censor's radar was particularly attuned in 1955, and even references codified in reaction to the existence of censorship were in their turn disallowed; in vain did Osborne and Creighton imagine the younger Constant son, Arnie, would be allowed to read Walt Whitman's *Leaves of Grass*, and a reference to the title is crossed through in blue pencil, and stamped: 'DELETED BY THE LORD CHAMBERLAIN'.

In fact, even within the narrative, the depiction of the sons' sexuality is necessarily ambiguous. The play overloads early references to Arnie's long, soft hair, his 'refined' nature, his 'long

and delicate' hands, even his gardening style ('I've never seen a man handle flowers the way he does'), while Don is not entirely 'clean and decent' and – even worse – is 'a poet'. When the FBI Investigator combines these early intimations with accusations of deviant political sympathies (a historically astute and accurate observation by the authors), it all becomes too much for the Lord Chamberlain's examiner, who strikes through the lines:

> MR CONSTANT: Just what are you implying?
> INVESTIGATOR: (*With deliberation.*) You know *just* what I mean, Mr. Constant – they go together: Communists and –

However, by the third act, a well-timed pregnancy seemingly re-establishes an acceptable heterosexual *status quo*. ('Never fails. Get someone in the family way in the Third Act – you're half way there', Barney counsels the young writer in *Epitaph for George Dillon*.) This is to the relief of the mother in the play's diegetic space, but to the consternation of the baffled censor, who by now was struggling with the complex interplay of signifiers. At one point, the assistant examiner noted in the margins that 'this could be political not sexual', the implication being that the latter represented a far graver danger to audiences than the former.

To test his suspicions, the examiner, St Vincent Troubridge, passed the play up the chain. At this point, the senior examiner intervened, concluding that 'the perverted element seems to be a gratuitous addition to an anti-Communist theme', and that 'all traces' should be removed, a suggestion endorsed by the Lord

Chamberlain, the Earl of Scarborough. So fazed by the suggestions of homosexuality was the senior examiner, that he seems to have mis-diagnosed a play that – while hardly toeing the Communist Party line – is openly critical of HUAC.

In one of the play's reviews, *The Harrogate Advertiser* predicted that 'if ever we have un-English activities inquisitors on this pattern, our sense of humour will see us through'. While the reviewer may have found the zealous Investigator to 'verge on the farcical', I want to suggest that McCarthyite inquisitions carried a contemporary English resonance for the play's authors. Post-war persecution of homosexuals was not confined to the Lord Chamberlain, and the conviction of Lord Montagu, Michael Pitt-Rivers, and Peter Wildeblood on indecency charges in March 1954 – during the composition of *Personal Enemy* – was one of a number of high-profile prosecutions in this period. The Montagu case is described in Dominic Shellard's biography of Kenneth Tynan as England's 'closest experience to McCarthyism', and Osborne was deeply affected by the police actions: 'so pointless, stupid and vindictive…how can sex between two consenting adults be <u>CRIMINAL</u>?' In letters sent to Anthony Creighton from Derby, it is evident that Osborne was following the trial attentively, and on one occasion he relates 'inside information' from a friend that 'there's no doubt the police are out for blood now…it's going to be quite a witch hunt.' Some of this concern clearly seeps into the play's depiction of the persecution of the Constant family; for all the charges of homophobia that would later be levelled against Osborne, in 1954 he was adamant that the three defendants in the Montagu trial were 'martyrs in a new battle', and it was 'up to the undoubtedly strong enlightened minority to exert pressure in high places'.

To the censors' fury, *Personal Enemy* had been sent for licensing just a few days before the intended opening, Patrick Desmond rather bizarrely claiming he had not realised it needed to be licensed as 'it is an American play'. (In fact, the canny Desmond was to play on the vogue for American theatre by promoting the work as 'the European premiere of the sensational American drama', a disingenuous line apparently swallowed by reviewers.) The late submission led to chaotic scenes in rehearsals as cast and

author attempted to incorporate the Lord Chamberlain's swinge-ing cuts, and make sense of the narrative without the disallowed vital plot device. The consequent incoherence of the censored play was remarked on by reviewers (*The Stage* noted 'some confu-sion in the story', while the *Harrogate Advertiser* wondered if the narrative obscurity was 'perhaps because of the censor's hand'), and in such unpropitious circumstances, it is hardly surprising that the play was quickly forgotten.

Yet, for all the awkwardness of the early exposition, and despite the reliance on the hoary conventions of the rep thriller (shadowy figures appear at the door, revelations fall conveniently at curtain lines), the play is an acute, and occasionally subtle, dramatisation of the dangers of betraying one's personal integrity by conforming to external pressures. For a dramatist whose early acclaim rests on his acute staging of the ennui of post-War English youth, we may find Osborne's early interest in American society surprising. Yet, beyond the socio-political actuality, what 1950s Cold War America offered the neophyte writer was a powerful dramatic situation: the characters must choose, for themselves and for others, and in taking a stand, we feel something that transcends their everyday lives is at stake. If *Look Back in Anger's* Jimmy Porter bemoaned the lack of 'good, brave causes' in post-War England, at the conclusion of *Personal Enemy*, Mr Constant comes to the realisation that 'it's time somebody made a stand against all this being kicked around', and seems to have rediscov-ered his self-respect through his resolve: 'You know – I'm quite looking forward to it.' Moreover, in contrast to the alienation felt by Huw in *The Devil Inside Him*, Mr Constant feels a communion with others through his contestation of power structures, and his final words to his wife before he goes to testify are both personally and politically affirming: 'You know another thing? We haven't been so close together in years, as we are now.'

Personal Enemy is no masterpiece, but in its interweaving of personal and national destinies, its examination of the need to confront feelings of fear and shame with an often lonely courage, even in its references to 'the devil's work' and the suggestion of 'so many witches' lurking beneath the surface of the American Dream, the play is not beyond recalling a contemporary classic

that would immediately precede *Look Back in Anger* in the Royal Court's opening season. I am talking, of course, about Arthur Miller's *The Crucible.* In presenting, for the first time, the uncensored text of *Personal Enemy*, we hope to reclaim it from the destructive intentions of the Lord Chamberlain's censors, as well as presenting a play not, perhaps, without resonance for our own times.

STAGE PLAY SUBMITTED FOR LICENCE.

Title :	"PERSONAL ENEMY"
No. of Scenes or Acts :	3 acts
Place of Production :	Opera House, Harrogate
Date of Production :	1st March
Author :	John Caborne & Anthony Creighton
Submitted by :	

Title : PERSONAL ENEMY.
No of Acts : Three.
Place of Production : Opera House, Harrogate.
Date of Production : Feb. 29, 1955.
Author : John Osborne & Anthony Creighton.

This is a play, and I have read better specimens of its class, on the increasingly frequent American theme of the indignant dramatic denunciation of that kind of modern political witch-hunting associated with the word McCartheyism.

The theme is apt, if well presented, to excite much sympathy, especially towards the Left, but why it is regrettable that this particular play has only been submitted a few days before its desired date of production (next Tuesday) is that in the first two Acts, in which the accusations are built up, there is a strong and repeated suggestion that Communism, in connection with those young male characters supposed to believe in it, is associated with sexual perversity. This is, in the final Act, more or less denied, but by that time the strands have got so twisted, and the whole thing so dubious that it needs slow and careful rather than hurried consideration.

We have the usual respectable American middle-class set-up, 'Pop' Constant in insurance, 'Mom' Constant, rather vixenish sister Caryl, and 17 year old son Arnie. There is also the elder son Don, missing and believed killed in Korea, in whose honour there is a sort of shrine corner in the living room. There is then the suggestion that both Don and Arnie were "mixed up with" a Communist librarian named Ward, who wrote them unduly affectionate inscriptions in otherwise harmless gift books, and this suggestion is eagerly taken up by sister Caryl, who should know them both. A sinister F.B.I. investigator arrives with the news that Don is not dead, but has opted to remain with the Chinese Reds - and the whole family is at once under suspicion.

In the outcome the resultant persecution grips them all. Arnie drowns himself, Pop is sacked and takes to drink, Caryl breaks up with her husband, and even the son of the woman next door loses his job in Washington. The third Act is indignant denunciation of such conditions, ending heroically with Pop's determination to fight back at the Committee investigation as he is completely innocent, and then start up in business elsewhere

Chronology of Osborne's Early Work

1929 JO born on 12 December, son of Thomas Godfrey
Osborne and Nellie Beatrice Grove.

1948 JO ASM and understudy for 'number two' tour of *No
Room at the Inn.*

JO begins writing *Resting Deep* in March in Sunderland,
completing it in Leeds the following month.

Stella Linden joins the tour in summer; helps JO re-
write *Resting Deep* (now re-titled *The Devil Inside Him*).
Stella begins affair with JO.

JO and Stella move to Brighton in December, JO acts
in *Treasure Island* pantomime over Christmas.

1949 JO and Stella begin work on *Happy Birthday.*

Short of money, Stella takes job as waitress, JO finds
work in hotel. Stella leaves JO during summer.

1950 Patrick Desmond finds JO job as ASM in Leicester.

The Devil Inside Him opens at the Theatre Royal,
Huddersfield, on 29 May; JO reunited briefly with
Stella for first night.

JO joins Anthony Creighton's Saga Repertory
Company.

1951 Acting in Bridgwater, JO meets Pamela Elizabeth
Lane, whom he marries on 23 June. JO gets job in
Camberwell, London.

1952 JO writes *The Great Bear: or Minette*; Pamela on tour.
JO begins *The King is Dead* later in the year (completed
January 1953).

1953 JO acts in *See How They Run* at Frinton-on-Sea in July and August. The programme lists Peter Nichols as Lance-Corporal Winton and John Osborne as The Intruder.

Pamela finds work at Derby Playhouse in autumn; JO and Creighton begin to collaborate on *Personal Enemy*.

Fragments of later plays including *Look Back in Anger*, *The Entertainer*, *Luther*, and *A Patriot for Me* begin to appear in JO's notebooks.

1954 JO briefly joins Pamela in Derby, before returning to London to live with Anthony Creighton. While at Derby, JO sends copies of *Personal Enemy* and *The King is Dead* to several agents and theatre owners.

1955. *Personal Enemy* opens at the Opera House, Harrogate, on 1 March.

JO and Creighton collaborate on *Epitaph for George Dillon* (opened 11 February 1958), completed by 25 March.

Look Back in Anger finished on 3 June.

JO begins *Love in a Myth* in November, finished 5 December; the play was reworked as a musical and staged as *The World of Paul Slickey* (opened on 14 April 1959).

1956 *Look Back in Anger* opens on 8 May at the Royal Court theatre, a month after the nascent English Stage Company's opening production of *The Mulberry Bush*.

Notes

The texts of the plays are taken from the Lord Chamberlain's Playscripts collection, held at the British Library Department of Manuscripts. Both texts were exhibited for the first time as part of *The Golden Generation* exhibition, British Library Folio Society Gallery, 27 August – 30 November 2008.

The Devil Inside Him. LCP 1950/1608.
Resubmitted by Patrick Desmond as *Cry for Love.* LCP 1961/65.

Personal Enemy. LCP 1955/7672.
A copy of the script was returned to Osborne and Creighton by the Lord Chamberlain's office, and is also held in the British Library's John Osborne Collection. Osborne 158.

Other background material taken from: the archive of John Osborne, and Osborne's letters to Anthony Creighton, Harry Ransom Center, University of Texas at Austin; the Lord Chamberlain's Reader Reports, British Library; Osborne's autobiography *A Better Class of Person* (1981); John Heilpern's biography *John Osborne: A Patriot for Us* (2006).

All images courtesy of the British Library and the estate of John Osborne.

Acknowledgments

I am grateful to all those whose advice and encouragement have been invaluable in this project, especially to Dr Tina Kendall, Senior Lecturer, Anglia Ruskin University; Kathryn Johnson, British Library Curator of Theatrical Manuscripts; Dr Steve Nicholson, Director of Drama, University of Sheffield; staff in the Reading Room at the Harry Ransom Center, especially Elspeth Healey. For access to his father's unpublished memoirs, and for his generosity, I acknowledge the contribution of Chris Duff, son of Patrick Desmond. I am particularly grateful to Gordon Dickerson of the Osborne Estate for his enthusiasm and good humour, and to all at Oberon.

These two plays were discovered as part of the Theatre Archive Project (www.bl.uk/theatrearchive), a collaborative project between the British Library and the University of Sheffield. I am therefore indebted to my co-curator of *The Golden Generation* exhibition, Dr Alec Patton, and to the project leader Professor Dominic Shellard, Pro-Vice-Chancellor for External Affairs at the University of Sheffield, for their support and advice.

The publication is dedicated to Ted Freeman and Monday mornings, 17 Woodland Road.

Jamie Andrews

THE DEVIL INSIDE HIM

Characters

MRS EVANS
The Prossers' daily woman

MR STEVENS
A commercial traveller

MRS PROSSER

DILYS
The Prossers' servant girl

HUW PROSSER

MR PROSSER

BURN
A medical student

MR GRUFFUYD
Minister of the village Chapel

The scene is the living room of the Prossers' cottage in a village forty miles from Swansea.

Act One	Afternoon.
Act Two Scene 1	Twenty-four hours later.
Scene 2	Three hours later.
Act Three	Early next morning.

Time: the present.

The Devil Inside Him was first performed at the Theatre Royal, Huddersfield, on 29 May 1950, with the following cast:

MRS EVANS, June Ellis

MR STEVENS, L J Meddick

MRS PROSSER, Hilda Stanley

BURN, Tim Turner

DILYS, Stella Linden

HUW, Reginald Barratt

MR PROSSER, Alan Bromly

MR GRUFFUYD, Maurice Durant

Directed by Stella Linden; scenery designed and painted by A S Saunders.

The Devil Inside Him was revived under the title *Cry for Love* (attributed to 'Robert Owen') by Patrick Desmond at the Pembroke Theatre, Croydon, on 8 January 1962.

Act One

(*As the curtain rises, MR STEVENS is seen creeping down the stairs. He is a seedy looking man of about forty, with the remains of what were once flashy good looks. He is wearing an old mac and carrying two suitcases. Keeping an anxious eye on the kitchen door he is obviously a little nervous at the prospect of being discovered. From the direction of the kitchen comes the powerful voice of MRS EVANS. She is singing a raucous little song rather ostentatiously, obviously quite proud of her singing. MR STEVENS, making as little noise as possible, puts down one of his cases and is just about to open the front door when MRS EVANS bustles in, taking off her apron. STEVENS swings round in alarm and MRS EVANS looks startled. She is a small, stoutish woman of about fifty. Her face is very earnest, with the serious concentration of a small child, and always gives the impression that she is bubbling over with grave, exciting news.*)

MRS EVANS: Oh, such a fright you gave me, Mr Stevens.

STEVENS: Sorry Mrs Evans.

MRS EVANS: To tell you the truth I thought you was Mrs Prosser and I was feeling a bit guilty on account of I was singing 'Oh let me play with your snowballs' instead of 'Lead Kindly Light'.
(*She crosses over to door recess C in front of him, to take down her shawl from a peg, thus effectively blocking his path. She prattles on, quite oblivious of his impatience.*)
Mrs Prosser doesn't like to hear anything but hymns in the house and I don't blame her, but I like an ordinary song now and then just for a change to brighten you up, don't you? (*She doesn't give him time to answer.*) There's nothing like a good song to cheer you up, I say. Hymns always make me feel, a little, well, sad somehow, you know what I mean? (*STEVENS opens his mouth.*) Even the happy ones. Always have done, ever since I was a tiny little girl. I used to cry all through the services on a Sunday. And if my father would sing a hymn while he was shavin' in the morning – and he would too for he had such a fine voice – I'd be miserable all day. And he'd say to me 'Bron, my girl,

why are you such a misery at hearing God's music? Why it should make you feel happy like a little bird.' (*She sighs reminiscently.*) I suppose it does make you feel happy, but such a lovely sad kind of being happy. Anyway you can't be religious all the time, can you?

STEVENS: I s'pose not. (*All this time he is looking anxiously over his shoulder up the stairs.*)

MRS EVANS: Well, I'd better be going before they find anything else for me to do.

(*She has put on her shawl and seems just on the point of going, when she stops, remembering something.*)

Oh, Mr Stevens, I knew there was something I wanted to see you about.

STEVENS: Oh?

MRS EVANS: Well, it's about that glass. Of course, far be it from me to mention any names or to accuse anyone, but someone broke that glass and I know it wasn't me. As I told Mrs Prosser you're the only one that goes into that room but me. Of course I'm not saying that you broke it, but who else goes into that room? I mean –

STEVENS: Oh, I didn't know I'd broken a glass. If I did I'm very sorry. I don't want to get you into trouble. You could get another glass for one and six, couldn't you? (*He fumbles in his pocket.*)

MRS EVANS: Well, I suppose I could, but that glass was very valuable. It was very old, been in Mrs Prosser's family for years, and I know she treasured it –

STEVENS: Oh, all right – five bob.

MRS EVANS: That's very kind of you, sir. (*She takes the money.*) I was only sayin' –

STEVENS: That's all right. (*He picks up his cases again.*) Now, if you'll excuse me…

MRS EVANS: Oh, are you going away?

STEVENS: Well…

MRS EVANS: If I'd known, I'd have packed your things for you. You shouldn't have brought those cases down yourself. You should have told me and I'd have done it for you.

STEVENS: That's very kind of you – but –

MRS EVANS: How long are you going to be away?

STEVENS: Well…

MRS EVANS: A few days?

STEVENS: Not exactly.

MRS EVANS: Oh, just for the weekend.

STEVENS: That's right.

MRS EVANS: Staying with friends, are you?

STEVENS: Yes.

MRS EVANS: Well now, I didn't know you had any friends in Wales.

STEVENS: Er…yes, I have. Swansea. But it's business as well.

MRS EVANS: I lived in Swansea for years before I married my husband. You see he –

STEVENS: I'm sorry Mrs Evans, but if I don't go now I shall miss the bus.

(*He gets past her and opens the door.*)

MRS EVANS: Oh. Does Mrs Prosser know you're going?

STEVENS: Yes, oh yes. Goodbye. (*Exit.*)

MRS EVANS: Goodbye (*Calling after him.*) See you Monday.

(*She waits for a reply but gets none.*)

Well, some people are in a terrible hurry.

(*She looks puzzled and stares after him again. Suddenly, with an exclamation, she rushes to the foot of the stairs and calls up.*)

Mrs Prosser! Mrs Prosser! Mrs Prosser! Come here a moment will you? Oh dear, quickly will you Mrs Prosser!

(*She rushes back to door.*

MRS PROSSER appears at the top of the stairs and hurries down. She is a tired-looking woman, also of about fifty, but she holds herself very erect like a thin, proud little guardsman, giving the impression that she is almost incapable of relaxation. Her clothes look old, but they are scrupulously kept and she wears them with a certain stiff grace.)

MRS PROSSER: Whatever's the matter, Mrs Evans?

MRS EVANS: It's that Mr Stevens. He's off down the road with both his suitcases.

MRS PROSSER: Well?

MRS EVANS: Did he tell you he was going away for the weekend?

MRS PROSSER: No, he didn't say anything about it.

MRS EVANS: Oh, dear, what have I done? Has he paid his bill?

MRS PROSSER: Yes, he paid me this morning as usual.

MRS EVANS: Oh, thank heaven.

MRS PROSSER: Well, what is it? Mrs Evans?

MRS EVANS: He seemed in such a hurry to get out. I wondered why. Then I noticed he'd got both his suitcases with him and he's only got two here. Now why do you think that is…

MRS PROSSER: (*Looks at her for a moment and then says quickly:*) Here now, get upstairs and see if his room is empty. I'll make sure my silver hasn't been touched.
(*MRS EVANS runs upstairs excitedly while MRS PROSSER makes a hurried inspection of her cupboard drawers. After a few moments MRS EVANS returns, breathless.*)

MRS EVANS: He's gone, lock, stock and barrel. (*She comes downstairs.*)

MRS PROSSER: Is there anything missing?

MRS EVANS: Nothing that I can see.

MRS PROSSER: That's most peculiar. There's nothing touched down here. Why didn't he tell me he was going? What did he say to you?

MRS EVANS: He said he was called away on business and so he was going to stay with some friends in Swansea.

MRS PROSSER: Well, I do think he might have let me know. After all it's usual to give a week's notice. I might have let the room for next week if I'd known in time. Just like an Englishman that is – rude I call it. Did he say he wasn't coming back?

MRS EVANS: No, he didn't say anything. I didn't notice at the time. It was only afterwards that I thought he looked a bit shifty.

MRS PROSSER: Oh, dear, what am I going to tell Mr Prosser? He didn't like it when there was all that scandal last month about him trying to sell that black market stuff in the village. He said to me then, 'You keep an eye on that man,

and if there's any more funny business, out he goes!' But I didn't like to spy on him. After all, he hasn't done anything wrong in our house has he?

MRS EVANS: No. But I don't suppose he was up to much good. The village is well rid of him I say.

MRS PROSSER: Yes, I dare say, but what am I going to tell Mr Prosser?

MRS EVANS: You don't have to tell him anything, do you? Say that he told you this morning he was called away suddenly on urgent business.

MRS PROSSER: Well, I can't tell him a lie but if I just tell him what you told me, it should be all right and we need say no more about it, see?

MRS EVANS: Oh, I shan't say a word. You know me Mrs Prosser, silent as the grave, I can be.

MRS PROSSER: Yes. Well, I suppose I'd better be getting the tea ready. The men'll be home soon. Oh, and the table not laid yet. Where's that girl Dilys?

MRS EVANS: I left her out in the kitchen doing the vegetables for tonight. She's that dreamy, she takes all day to do the job.

MRS PROSSER: If there wasn't someone behind her all the time she'd never get anything done at all. Go and fetch her, Mrs Evans, will you, and tell her she ought to be laying the table by now.

MRS EVANS: Oh, all right. (*Exit to kitchen.*)

(*MRS PROSSER glances at the clock on the mantelpiece and frowns. Going deliberately to the sideboard she pulls open a drawer and brings out a large white tablecloth. Crossing over to the table she unfolds the cloth and begins to spread it. MRS EVANS returns.*)

She's just finishing the potatoes, she'll be in in a minute. If there's nothing else you want, I'll be getting along home.

MRS PROSSER: Did you finish that kitchen floor, Mrs Evans?

MRS EVANS: Yes, and nearly broke my back I have, kneeling on that stone floor. It's difficult enough –

MRS PROSSER: Yes, yes, all right. Well, you can get along now then Mrs Evans, if that's all. And thank you very much.

MRS EVANS: (*Readjusting her shawl.*) I'll just go and get Mr
Evans' tea and then I'll come back and bring your washing
along, I finished ironing it this morning and it's been
airing.

MRS PROSSER: All right, Mrs Evans.

*Enter DILYS R – She hurries in and then as soon as she sees
MRS PROSSER with her back to her she stops, just inside the
doorway. She is about twenty and very sensually good-looking.
Her hair is untidy and her face is dirty. She looks troubled
and her natural self-assurance is replaced by an anxiety for
the moment. She watches MRS PROSSER's back and, for a
moment, looks insolent. Then she glances towards the front
door, ahead of MRS EVANS, and her expression changes.*)

MRS EVANS: (*Opening door.*) I shall have to hurry. It's the Choir
Festival practice this evening. There's cold again. I shan't
be long then. (*Exit C.*)

(*MRS PROSSER turns, glances at DILYS, then apparently
ignoring her, walks across to the sideboard to collect some
knives and forks.*)

MRS PROSSER: Well, don't stand there gaping, girl. What's the
matter with you? Here it is, nearly five to six and no tea on.
Mr Prosser will be home soon. And Huw. And get a tray
set for Mr Burn.

(*MRS PROSSER goes off to the kitchen. DILYS goes on laying
the table when, outside, there are shouts and jeers.
HUW comes in through the door C. He slams it quickly behind
him and stands, his back to the door, staring at DILYS's
back for a moment. It is difficult to judge his age. He might
be anywhere between sixteen and twenty and is very dark,
but he looks almost an old man, even though his face denies
it. There is an electrifying intensity about him, a tired old
look, a look that can perhaps only be described as animal. A
trapped animal, with all its qualities of simplicity, cunning,
pure instinct and emotion. DILYS, without looking at him,
continues with her work.*)

DILYS: You're late.

(*The laughing, etc, outside has now died away. HUW turns
quickly to the mantelpiece, rests against it and gazes into the*

*fire-grate. DILYS looks questioningly at him for a moment. It
is plain that she is undecided.)*
(*Arranging the cups and saucers that have already been arranged.)*
Did you see Mr Stevens at all?

HUW: When?

DILYS: (*Impatiently.*) As you were coming home.

HUW: Yes, I did.

DILYS: Where?

HUW: At the bus stop. Why are you so interested?

DILYS: I'm not.

HUW: (*Suddenly.*) Has he left?

DILYS: Yes.

HUW: Oh.

(*He goes back to gazing into the fire-grate. DILYS looks at him
perplexed, almost angry.*)

DILYS: You're glad aren't you? (*He looks up slowly.*) You didn't
like him, did you? (*A pause while she watches his face intently.*)
Not that that is anything to go by. You hate everybody
pretty well, have you ever liked anybody?
(*For a moment their eyes meet. She seems unable to meet his
earnest gaze and covers her discomfiture by crossing to the
sideboard.*)
Well, I can't stand talking here to you all day.
(*Pause.*)

HUW: You're sorry he's gone. (*He says this almost to himself, then
to her.*) Aren't you?

DILYS: (*Quickly recovering herself.*) Me? Why should I?

HUW: (*He does not meet this challenge. A new thought seems to occur
to him.*) Perhaps –

DILYS: (*Now dominant.*) Well?

HUW: Perhaps you loved him.

DILYS: There's soft you are, Huw Prosser. Like a slobbery
old sheepdog, you are. One minute you're dribbling in
someone's hand, and in the next you've bitten it off. (*She
eyes him sideways.*) Although perhaps you're not as daft as
they make out.
(*Pause.*)

HUW: Dilys!

DILYS: Yes.

HUW: Do you think I'm daft?

DILYS: (*Half surprised.*) I don't know. (*Calmly.*) A bit queer I suppose. That's what everybody says, anyway.

HUW: Yes. That's what everybody says.

(*He seems lost for a moment and then he begins to watch DILYS as she moves indifferently over to the fireplace to fetch an iron. His eyes take in every subtle movement of her body.*) Dilys!

DILYS: What is it now?

HUW: What are you doing after tea?

DILYS: What's that got to do with you?

HUW: Nothing. But I was thinking that was all. (*Suddenly.*) Would you like to go out tonight?

DILYS: (*She stops.*) With you? (*He nods.*) What for? There's a nerve you've got. (*She laughs.*) Didn't know you had it in you. What makes you think anyone would go out with you? And why ask me?

HUW: You're the only woman I know.

DILYS: The only one that will speak to you, you mean. Soft you must think I am. (*She turns to go.*) Ashamed you should be, Huw. (*Mockingly.*) To have such wickedness in your mind.

(*He snatches hold of her waist and draws her nearer to him. She stares at him and her face hardens and is covered by a sudden repugnance and she knocks his hand away.*)
Here, who do you think you are? Tell your Pa I will. And you know what that means. You don't want the Minister to know, do you? Daftie.

(*He turns away and exits R, leaving her staring after him. MRS PROSSER enters R.*)

MRS PROSSER: Was that Huw came in?

DILYS: Yes.

MRS PROSSER: What was all that noise outside?

DILYS: A lot of young lads.

MRS PROSSER: (*Comprehending.*) Oh.

(*DILYS watches the change that comes over her face.*)

DILYS: (*Casually.*) Calling after him again, I suppose.

MRS PROSSER: (*Conscious of her sudden weakness.*) There are always people who are ready to tie tin cans to a dog's tail. Get out into the kitchen girl. The gentleman will want his tea as well.

DILYS: Mr Stevens has left has he?

MRS PROSSER: Yes. He was called away to some meeting in Swansea. Hurry on now.

(*Exit DILYS R. MRS PROSSER goes over to the window L and draws the curtains. She looks worried. As HUW enters R, however, her expression changes. He walks straight to the sideboard.*)

What are you looking for?

HUW: (*He turns to gaze round the room.*) A book. An exercise book. I left it upstairs I know I did. Where is it?

MRS PROSSER: Downstairs it is somewhere, I expect.

HUW: (*His voice is challenging almost.*) But I left it upstairs and now I have lost it.

MRS PROSSER: (*Looks at him uneasily for a moment and then reassuringly.*) Well, I expect you'll find it somewhere. (*She crosses to him.*) I'll find it for you.

HUW: (*Suddenly and fiercely.*) No.

MRS PROSSER: (*Stopping short.*) But I'd most likely know where it is now. Don't go worrying about it boy. Perhaps Dilys saw it and put it in the kitchen.

(*He stares at her. There is all the wariness of the animal about him. He turns abruptly and exits R leaving his mother to return slowly to her tea table and light the oil lamp. MR PROSSER enters through the door C. He is a smallish but well built man. His eyes are keen and his whole appearance is one of keen alertness and gives the impression that he would be a good businessman if he had the talents. Like his wife he seems incapable of humour and everything he says is uttered with a genuine gravity, amounting at times, after the fashion of the rest of the family, to quiet brooding outbursts.*)

Hello father. You're early aren't you?

MR PROSSER: It is exactly fifteen minutes past six. (*Taking off his coat.*) Is tea not ready yet?

MRS PROSSER: It won't be long now. Dilys has been so slow today. I don't know what it is with her. Had to speak sharp with her once or twice today I have.
(*Enter BURN R. He is wearing his coat and hat.*)
Going out are you Mr Burn?

BURN: Yes. I thought I'd go along to the doctor's and let him know I've been fixed up.

MRS PROSSER: Aren't you going to stay for your tea?

BURN: No thank you.

MRS PROSSER: This is Mr Burn father. He's staying here for a while until he can go and stay at Dr Hillman's house.

BURN: (*To PROSSER.*) Good evening, sir. (*PROSSER nods abruptly.*) Well, I'll be getting along. Goodnight.

MRS PROSSER: What time will you be back. Will you want something to eat? We have supper at half-past nine.

BURN: No thanks. I shall probably be in pretty late.

MR PROSSER: In this house it is our custom to retire early.

BURN: I see. Well, I'll do my best not to disturb you. I have my own key, so I can let myself in. Your wife gave it to me. Goodnight then.
(*Burn exits C. MR PROSSER frowns and sits down at the head of the table.*
DILYS enters R carrying teapot. There is a stiff and short silence.)

MRS PROSSER: (*Sits.*) Mr Stevens left this afternoon.

MR PROSSER: (*Eyeing DILYS keenly.*) Oh! Why?

MRS PROSSER: He said he had some urgent business in Swansea.

MR PROSSER: Is he coming back?

MRS PROSSER: He didn't seem certain.

MR PROSSER: Well surely he must know whether he is coming back or not. (*Pause.*) I don't remember any letters coming for him this morning. Was there any post during the day Dilys?

DILYS: I don't know, sir.

MRS PROSSER: No, there hasn't been any. I was expecting a letter from Aunt Polly today you know. I can't think what has happened. She's never been strong and she won't

look after herself properly. I keep telling her about it. She will go out in these cold winds and never wrap herself up properly.

DILYS: Isn't Mr Burn having tea in his room then?

MRS PROSSER: No. Seems a funny way to carry on to me – having no tea. Still, perhaps Dr Hillman will give him some.

DILYS: Can I go now, please?

MRS PROSSER: Is there anything else you want, father?

MR PROSSER: No.

MRS PROSSER: Alright then. You can go now Dilys.

MR PROSSER: (*Looking after DILYS.*) You shall have to watch that girl carefully.

MRS PROSSER: If I didn't watch her all the time she'd never to any work at all I can tell you that. Lazy, that's what she'd be if I gave her half the chance.

MR PROSSER: I didn't mean that. There is sin in that girl. And if you don't stamp on it and kill it, it will bite you like an angry snake. (*MRS PROSSER looks shocked.*) I am pleased that Mr Stevens has gone. I don't think he was the sort of man to have in the same house with a young girl.

MRS PROSSER: He seemed respectable. And anyway I am usually here to see.

MR PROSSER: The ways of sin have all the cunning of Mammon behind them.

MRS PROSSER: Keep an eye on her I will. But I don't really think she's a bad girl. (*Uncertain.*) Still he was good looking. Lovely eyes he had. Deep-set. I noticed them as soon as I set eyes on him.

MR PROSSER: Never mind his eyes, woman. It's his religion that matters. I never saw him in chapel all the time he was here.

MRS PROSSER: Perhaps he was Church. (*He seems unimpressed by this possibility and sips his tea daintily.*) Anyhow, Mr Burn seems all right. Quite handsome he is too. He has a nice straight nose.

MR PROSSER: What does he do?

MRS PROSSER: He's a medical student. I suppose that's why he's a friend of Dr Hillman's.

MR PROSSER: Where is Huw?

MRS PROSSER: I expect he's upstairs. I'll call him. (*She begins to move.*)

MR PROSSER: Stay where you are. If he feels the need of his tea he will come for it.

MRS PROSSER: (*Hesitates, then returns to her tea.*) I think he must be tired. He was working late again at the shop last night. (*Anxiously.*) I wonder if he's all right. He'll be hungry after working all day.

MR PROSSER: Can't you stop worrying about the boy, woman? He can look after himself like anyone else, can't he?

MRS PROSSER: He's not like – other boys.

MR PROSSER: It's no use picking the scabs of old wounds; nothing can be done about that now and the sooner you get used to it after all this time the better. Everyone else accepts it – apart from you. It's time you were content with what God has chosen to give you, such as it is and you should be humble because of it. (*Thoughtfully.*) Humble because a sick mind can bring with it only shame. The way of the flesh is the way of weakness, of pain and disease. Our Lord Jesus was a weak man.
(*Most of this is spoken quite unconsciously, much as a lay preacher would recall his sermon to his family at some informal moment.*)
The man of Cyrene had to carry his cross for him. And he cried out 'Eli. Eli.' (*Pause. He recovers himself and continues more naturally.*) A weak body may lead to goodness for that is humility itself. But the mind, no. That is different. It is through the mind that we know God. A sick mind is a sick soul.

MRS PROSSER: (*Bewildered and somewhat awed by all this*) But surely that can't be a sin?

MR PROSSER: It is sin itself. Pass the bread and butter.

MRS PROSSER: (*Does so.*) But you can't help being sick.

MR PROSSER: There are those who say you can't help
being bad. But I suppose it's not so easy for a woman to
understand these things. There is good and there is evil.
That is all.
(*He sets into his meal with an air of finality. MRS PROSSER
is about to continue the conversation but is interrupted by MRS
EVANS who enters C, wearing a shawl over her head which
she quickly lowers to her shoulders as she comes in at the door.
She is carrying a bag of washing which she puts down as she
enters the room. She bustles quickly down to the table.*)

MRS EVANS: Oh there you are Mrs Prosser. No, don't get up
please. Hello Mr Prosser. How are you? (*Without waiting for
a reply.*) You're not looking too well. A bit peaky round the
face like.
(*MR PROSSER does not seem pleased.*)
Still, it's the weather I expect. So cold it is, it's no wonder
people aren't well. Old Gwm's horse is dying so I've heard.
We've all got to go sometime haven't we? I've brought
your washing, Mrs Prosser. I'm sorry it's been such a long
time, but I've been busy as you know. The number of
clothes people seem to get dirty! Still I suppose we couldn't
do without 'em could we? Even if it were warm enough, if
you see what I mean.

MRS PROSSER: (*Quickly.*) Will you have a cup of tea Mrs
Evans? (*She begins to pour her one.*)

MRS EVANS: Well no, thank you, I'm in such a hurry. Well
I mean all these preparations for the Choir Festival you
know – two lumps please – such a time we're having
practising with our singin'. And such a fuss we had last
night in the Church Hall. In the middle of the practice,
see, young Will Jones says ''Ere we've no stage here. We
can't all of us sing on the floor to the audience. We must
be raised up like.' Well I'd not given it a thought. But we
couldn't use the Chapel very well, could we? I mean you
can't sing 'Dashing Away with the Smoothin' Iron' in a
holy place, can you? But just as we was thinking we'd
have to cancel the festival, Williams the coffin maker says
he'll make one up out of coffin lids. I said to the Minister

'Standin' on coffin lids – we'll be singin' ourselves up to heaven before we know where we are.' Though I can't say he seemed very pleased with the idea. 'There now I'm not standin' on none of your old tin handles, Dai Williams, I'm telling you,' I said. And he was quite annoyed. 'I'll ask you to have more respect for my fine brass, please, Mrs Evans,' he says, 'be glad of it one day you will.' Well, I mean, some people do take things serious like don't they?
(*All this has been said with complete seriousness. HUW enters up R. MRS EVANS looks at him with uninhibited curiosity.*) Hello, Huw, how are you? (*HUW stares at her.*) Doesn't say much does he? Still I suppose that's better than havin' him talking all the time. Once you get them talking there's no stopping them. Now my cousin Maggie in the Mental Home…

MRS PROSSER: (*Exchanging a look with PROSSER.*) Drink your tea, Mrs Evans, it's getting cold.
(*MRS EVANS gulps her tea quickly and is about to go on when MRS PROSSER anticipates her.*)
What time do you go to the choir practice, Mrs Evans?

MRS EVANS: Quarter to six. And sharp. The Minister won't have no one comin' in late.

MR PROSSER: It's just five minutes past six. It's ten minutes' walk to the Church Hall from here.

MRS PROSSER: (*Rising.*) Well, don't let us keep you. (*Taking MRS EVANS gently by the arm and leading her to the door.*) You can't keep Mr Gruffuyd waiting.

MRS EVANS: That's true. I'd better be going.

MRS PROSSER: Thank you for bringing the washing.

MRS EVANS: That's all right. I'd have brought it with me this morning but it wanted airin'.

MRS PROSSER: Yes, yes, of course. It's good of you to do the work when I know you're busy.

MRS EVANS: (*At the door.*) You get on with your tea, Mr Prosser. Don't take any notice of me.
(*MR PROSSER gives his wife an almost imperceptible hopeless look.*)

MRS PROSSER: Yes. Well. Goodbye Mrs. Evans. We'll see you tomorrow.

MRS EVANS: Oh yes. I'll be on. Goodbye Mr Prosser. (*PROSSER nods. She looks at HUW for a moment, still curious. Then she goes on quickly.*) And thank you for the tea. You always get a nice cup of tea here. I was saying so to my husband only the other day.

MRS PROSSER: (*Opening the front door.*) Oh yes? Mind the step as you go. It's very dark.

MRS EVANS: Yes. I don't want another accident, do I? (*Off.*) My, there's cold it is. Does you no good going out from the warm air into the cold. You've got to be so careful I always say, haven't you?

MRS PROSSER: Yes. Goodnight Mrs Evans.

MRS EVANS: Looks like being the worst winter we've had yet. I wouldn't be surprised…

MRS PROSSER: (*Closing the door.*) Goodnight. (*The sound of MRS EVANS' voice dies away outside. HUW goes to the table and quickly takes his place.*)

MR PROSSER: You are late. (*HUW looks at his father for a split second, but says nothing. MR PROSSER does not seem to expect an answer. MRS PROSSER takes her place and HUW begins to eat. There is a strange almost primitive delicacy about the way he eats and drinks. Perhaps it can best be compared to a rabbit, whose delicate yet unmannered enjoyment of his food is marred by natural uneasiness. The contrast between his manner of eating and his parents is extreme. They continue with their meal stolidly and are obviously long accustomed to this.*) You went out last night, Huw. I didn't hear you come back. What time did you come in? (*HUW seems unable to reply.*) What time did you come in?

HUW: I don't know.

MR PROSSER: You don't know! What do you mean?

HUW: I don't remember.

MR PROSSER: Didn't you see what time it was by the clock on the mantelpiece?

HUW: No.

MR PROSSER: Didn't you look to see?

HUW: No.

MR PROSSER: Why not? (*No answer.*)

MRS PROSSER: Your father means was it very late Huw.

HUW: There was a cloud over the moon.

MR PROSSER: Where were you?

HUW: On the hills. Beyond the lakes.

MRS PROSSER: But what made you go out on the hills so late? You might have caught your death.

HUW: I felt I must go. (*Simply.*) So I went.

MR PROSSER: Do you think that you can follow every damn fool impulse you have? (*No answer.*) Well, you'd better get used to the idea that you can't. We are here to resist impulses, not to indulge them. If I were to obey my impulse now I should punch your head for being stupid. (*MR and MRS PROSSER look at each other suddenly as soon as he has said this.*)

MRS PROSSER: Were you busy at the shop today, Huw?

HUW: No.

MRS PROSSER: What did Mr Davies give you to do?

HUW: (*Slowly.*) Have you ever seen a pig slaughtered? They hold its head, grip its ears and sit on it, like sitting on a bicycle. And they cut its throat just as you might cut an apple. And it screams. They crucify them. (*MR PROSSER turns away impatiently.*)

MRS PROSSER: Get on with your tea boy. (*Thoughtfully.*) Such a pity he couldn't have worked in the Insurance Office with his cousin David.

MR PROSSER: It is a pity. But it's no use wishing over what can't happen. He has to have a job and the sort of job he has now. We've gone through that so many times. At least, it has the merit of being respectable. After all, your grandfather was a butcher.

MRS PROSSER: (*Stung by this reminder.*) And a very fine man he was. As good as you will find anywhere.

MR PROSSER: (*Tapping his pockets.*) Have you seen my pipe anywhere Annie?

MRS PROSSER: No, I haven't. Don't you know where you left it?

MR PROSSER: I thought I put it in my pocket. (*Crosses to sideboard.*) It's not safe to leave anything around in this house with that girl Dilys cleaning after you like she does. I think if you left a pound note lying around she'd sweep it up and throw it away. (*He looks in and around the sideboard, then walks to the mantelpiece where he continues his search. Upending a vase he discovers the pipe, which drops into his hand.*) Ah! Here it is. That's Dilys again I expect. (*He is about to replace the vase on the mantelpiece when he brings out a cheap exercise book.*) What's this?
(*HUW turns round and seeing, gazes at him in horror as the expression on his father's face changes rapidly and terribly. He goes quickly up R to snatch the book away but he is not quick enough. There is a long silence as the two look at each other.*) Did. Did you write this – this filth? Yes, you did. I can see it. It's branded on you. Yes, you are mad. You must be mad. No sane decent man could ever write that vile filth. Vile filth, that's what it is. (*His voice getting louder.*)

HUW: It isn't.

MR PROSSER: You are unclean. Dead you should be for it. You should be struck down for such thoughts. And the woman cursed that ever gave birth to you.
(*He hurls the book into the empty fire-grate. HUW makes an instinctive move towards it. His father looks down at him in complete disgust and pushes him out of the way. HUW staggers and almost falls. MR PROSSER strides towards the tea table, playing in agitation with his pipe. HUW stares at his mother, who is gazing at him in horrified amazement, and then at his father's back, and runs to the door C drags it open and exits.*) I never thought there could be such terrible things hidden away even in the farthest corner of the mind. (*He turns to face her.*) Your son is a maniac all right. And no woman is safe in the same room with him.
(*MRS PROSSER looks slowly from him to the crumpled book on the floor and then looks away. All her suppressed weariness and despair slowly show in her face.*)

MRS PROSSER: Huw. (*Dazed.*)

MR PROSSER: Yes.

MRS PROSSER: What can we do?

MR PROSSER: I don't know. Except pray for God's help.

MRS PROSSER: The doctor.

MR PROSSER: It's his soul that is eaten up with disease, woman, not his body.

(*He goes up C to where his hat and coat are hanging. He puts them on.*)

MRS PROSSER: (*Frightened.*) Where are you going?

MR PROSSER: I'm going for the Minister.

MRS PROSSER: But…

MR PROSSER: It's his business to save souls, isn't it? Then that is where I am going.

(*He looks towards his wife for a moment then, without a word, exits C. MRS PROSSER stares after him, then she goes slowly over to the fireplace, picks up the exercise book and returns wearily to her chair. Incredulity spreads over her face and she lets the book slide gently to the floor at her feet. She gazes in front of her, unseeing. Then, after a while she seems to pull herself together and with an obvious effort picks up the book and puts it back on the mantelpiece. She begins to clear the table, setting the tea things on to a tray and taking them off R. While she is out of the room HUW returns and looks into the fireplace for his exercise book. He turns to look round the room, and sees it on the mantelpiece and snatches it up. He glances through it quickly and then stuffs it into his pocket. He stands quite still for a moment, seems to make up his mind to go out but as he is almost at the front door he looks back at the room and then goes back to the mantelpiece. As he reaches up for a book he sees his own reflection in the mirror and looks down quickly and sits on the fender box. He opens the book on his knees, placing his exercise book on it. Taking a stub of pencil from his pocket he begins to write slowly and laboriously. But he seems unable to go on and slowly he picks up the book on his knees and reads. Then he stares hard into the fire-grate. Leaning his head back against the grate his lips move and then sounds come from them.*)

HUW: 'I see their antique pen would have expressed
Even such a beauty as you master now.'
(*He repeats the last line slowly and voluptuously.*)
'Even such a beauty as you master now.
For we which now behold these present days
Have eyes to wonder but lack tongues to praise.'
(*MRS PROSSER comes back to finish clearing the table. She
sees HUW, stops, and looks at him for a moment with love and
pity, but without understanding.*
*HUW, electrified into movement, has crammed the exercise
book into his pocket. He stands up quickly. MRS PROSSER
says nothing then goes to the table, folds the tablecloth and
puts it in the sideboard drawer. HUW watches her intently, his
quiet peace shattered within him. She turns and for a moment
it looks as though she is about to say something. He waits
defensive, but she says nothing and exits R closing the door
behind her.*
*He stands undecided, in front of the mantelpiece. The front
door opens and DILYS slips in. However HUW seems to sense a
fresh intrusion and whips round. From the noise coming from
the kitchen it is evident that MRS PROSSER is washing up.*)
DILYS: (*Softly.*) Where's your mother?
(*She nods towards the kitchen in interrogation. HUW nods in
reply. She seems reassured by this and walks over to him. She
speaks softly to him and it is obvious that she does not want
MRS PROSSER to know that she is lingering in the room. As
she is talking she seems poised, ready to walk quickly to the
kitchen door in case MRS PROSSER should come in.*)
HUW: I thought you'd gone home.
DILYS: Yes I did, but I've come back for my purse. I've left
it behind.
(*He looks away from her unable to meet her frank stare.*)
I saw your father in the village. Where was he off to in
such a hurry? (*HUW says nothing.*) Perhaps he's found
something else to do besides sitting in this blooming place
all evening. (*She grins rather unpleasantly. She is obviously in a
spiteful humour.*) It's enough to drive you mad almost.

(*He glances at her and she turns away hurriedly to avoid the expression in his eyes.*)

(*She picks up the book on the mantelpiece.*) What's this you're reading? (*She glances at him but he is staring again into the fire-grate. She looks at the book once more curiously.*) Does it make sense? What does it mean? (*She looks at him again impatiently.*) Not that I suppose you would know. (*She reads it again, puzzled.*) What is it?

HUW: It is about love. And beauty. (*Staring at her with a strange fascination. Her hair is combed now and hangs attractively on the nape of her neck.*) Even such a beauty as you master now.

DILYS: What makes you interested in it? (*Casually.*)

HUW: I have eyes to wonder but lack tongues to praise.

DILYS: Seems a bit soft to me. Funny you are, reading all that. (*She looks into the large mirror over the mantelpiece and starts putting on her lipstick and powdering her face and admiring the reflection of her cheap frock. He is standing close by her and shyly, half-frightened watches every provocative movement.*

She is obviously abstracted and as she talks to HUW it is evident that she is only half listening to what he says, while her own part in the conversation is mechanical and disinterested. She is obviously nervous, worried and grumpy. Even this, however, cannot still the temptation to taunt HUW.) You were never any good at school at all. In the same class when you left as when you started, weren't you?

HUW: Yes.

DILYS: Funny.

HUW: I hated school.

DILYS: You didn't seem very popular yourself, I remember. (*Suddenly.*) Here, when do you expect your father back?

HUW: I don't know.

DILYS: Where's your father gone?

HUW: I don't know.

DILYS: (*Reassured.*) Yes. Do you remember when they threw your trousers in the canal? And you were afraid to go in and get them. I'll bet you got a hiding for that when you got home.

HUW: Yes, I remember Miss Jones too.

DILYS: You don't like her do you? (*Turns to glance at him.*)

HUW: I asked her if I could leave the room and she said 'No'. And I asked her again and again. And when I couldn't help myself she was glad.

DILYS: Oh! How do you make that out?

HUW: Because it pleased her, the bloody old maid.

DILYS: There's language. Your father should hear that. I know (*Mockingly.*) I'd better go before it gets any worse.

HUW: Are you going out?

DILYS: No.

HUW: Where are you going?

DILYS: I said I wasn't going out, didn't I?

HUW: Then what are you getting ready for?

DILYS: I can see if I look all right, can't I, without going somewhere? I'm just seeing how my new dress looks. (*She runs her hands down her dress, bringing them down to her waist and thighs. Gives her hair a final shake and looks anxiously down at her front.*) There. How do I look?

HUW: You look lovely.

DILYS: (*Amused but not unpleased.*) You're a quaint soul.

HUW: Dilys.

DILYS: Yes.

HUW: Stay here and talk to me. Will you?

DILYS: What for?

HUW: I want to talk to you.

DILYS: What about for heaven's sake? If your mother found me here now she'd have something to say.

HUW: About – about everything. (*He crosses over to the window and stands there, his back to her. He is silent, then, turning he looks at her puzzled half-amused face.*) Will you stay with me? (*She plays with the lapel of her coat. Then she moves towards the door up R.*)
(*Going over to her.*) Please. (*Touches her arm.*)

DILYS: (*Pushing him irritably.*) Oh! Leave me alone! (*She is about to go into the kitchen but she stops, undecided.*) What exactly is it that you want?

HUW: A little beauty in an ugly world.

DILYS: (*Contemptuously.*) You talk like a book, man. (*Pause. She glances over her shoulder in the direction of the kitchen, then puts her hand on the door handle, holding it fast.*) Do you mean – love?

(*He looks her full in the eyes, then seems to recoil. She brings her face closer to his.*)

You wouldn't like to kiss me, would you? (*For a brief moment it looks as though he is about to kiss her, but he hesitates.*) Well? Are you afraid?

(*Unnoticed by either of them, BURN appears at the door C. DILYS looks as though she is about to let him kiss her then draws away playfully. Humiliated, he stands quite tense for a moment and then goes quickly up the stairs.*

DILYS sees BURN for the first time. She is somewhat startled at having had an audience and calls out to MRS PROSSER in a loud and affectedly casual voice.)

Oh, Mrs Prosser, mum (*Opening kitchen door and going in.*) I left my purse behind. Did I leave it in the kitchen here?

MRS PROSSER: (*Off.*) It's on the dresser.

DILYS: (*Off.*) Oh, thank you. I thought I'd left it here. Well, goodnight, Mrs Prosser.

MRS PROSSER: (*Off.*) Goodnight.

(*DILYS re-enters and closes the door behind her. She looks quickly at BURN who smiles at her somewhat cynically. She walks over to the door C and is about to open it when BURN speaks to her. Just as when she was talking to HUW she was poised ready to go to the kitchen door, so in the following scene she is ready the whole time to appear to be leaving. BURN obviously arouses her natural curiosity, and torn between that and the fear of being discovered, she is tense and uneasy the whole time.*)

BURN: Hello!

DILYS: Hello.

(*She hesitates at the door, and giving in to her curiosity, turns to look at him. BURN runs his eyes over her undeniably attractive form, half-amused, at the same time repelled yet fascinated by her callous sensuality.*)

I thought you had gone to Dr Hillman's.

BURN: He was called out on a case, so I went for a walk. It's quite a way back from the doctor's house.

DILYS: (*Looking at him with interest.*) Yes.

BURN: I went for a short walk to the hills just beyond. (*He goes to the fireplace, leans on the mantelpiece, takes a pipe from his pocket and begins to fill it.*) Do they never have a fire here?

DILYS: (*Having regained her confidence, leans against the back of the settee.*) No. Mrs Prosser says it's unnecessary.

BURN: Oh!

DILYS: (*Suddenly.*) How long have you known Dr Hillman?

BURN: Not very long. He works in the same hospital as I work in. What is your name?

DILYS: Dilys.

BURN: Dilys. Well, tell me, Dilys, do you live here?

DILYS: No. I just work around the house for Mrs Prosser. We have lots of visitors here in the season. They come here for the mountains. Can't think why. Can you? I wouldn't come here just to walk over old mountains.

BURN: I suppose we never appreciate anything we see all the time. (*He glances at her puzzled expression and smiles.*) Well! I've got a fortnight here and that means relaxation. Lovely; what is there to do? Apart from (*Jerking a thumb towards the window.*) climbing the mountains.

DILYS: You won't find much to do here apart from walking.

BURN: There's no cinema in the village I suppose?

DILYS: No.

BURN: There's always the possibility that it may rain. Is there one in the nearest town?

DILYS: Oh yes.

BURN: And where's that?

DILYS: Eleven miles away.

BURN: Oh well, let's hope it doesn't rain.

DILYS: You can get a bus there. They run four times a day. I go myself sometimes. They change the programme in the middle of the week.

BURN: (*Looking at the overcoat she is wearing over her dress.*) Don't let me keep you talking if you're going out.

DILYS: I don't care whether I go or not. (*She stares sullenly in front of her.*)

BURN: Come now. Things can't be as bad as that.

DILYS: But they are.

BURN: (*Pause.*) Surely not?

DILYS: (*Changing subject.*) Are you interested in people?

BURN: Yes, yes I am.

DILYS: Why?

BURN: Oh, I like trying to discover what the hell goes on inside 'em, what's going on inside your head now for instance!

DILYS: What do you mean?

BURN: I mean I'm wondering why you are obviously anxious to make sure Mrs Prosser doesn't catch you talking to me.

DILYS: Oh! You men! You all talk nonsense like that Huw. Not that he ever says much.

BURN: Who's that?

DILYS: Mrs Prosser's son.

BURN: The young man who was in here just now?

DILYS: Yes.

BURN: He seemed rather upset.

DILYS: Oh, he's always like that, sullen devil. He's a bit soft you know – (*Taps her forehead significantly.*)

BURN: Is he?

DILYS: Just a bit queer in the head. But he's harmless enough. Huw couldn't hurt a fly.

(*She stares hard at BURN, whose attention is left to the re-lighting of his pipe for the moment. When he has successfully got it alight once more, he looks up to meet her hard gaze.*)

DILYS: (*Suddenly.*) Would you help me if I ask you?

BURN: You must be in very great trouble to ask a complete stranger to help you.

DILYS: (*With sudden urgency in her voice.*) I am. In terrible trouble.

BURN: What makes you think I can help you?

DILYS: Because you *are* a stranger. And because you're – well you're the only person who can help me.

BURN: Perhaps you'd better tell me what it's all about.

(*DILYS looks anxiously over to door R. Rising she goes over to it quickly, listens outside for a moment. Hearing reassuring noises coming from the kitchen, walks over to table C. BURN waits expectantly.*)

DILYS: How long have you been learning to be a doctor?

BURN: Four years.

DILYS: Four years! How much do you learn in four years?

BURN: This is my last year.

DILYS: Oh! Then by next year you'll be a real doctor?

BURN: All going well.

DILYS: (*Half defiant, half ashamed, exclaims:*) I'm going to have a baby.

BURN: (*Rather taken aback at this unexpected confession.*) Oh! So that's the trouble. (*He sits on the R end of the settee, and looks at her keenly.*) Frightened?

DILYS: Yes.

BURN: What of?

DILYS: My father.

BURN: Your father?

DILYS: He'll kill me if he finds out. I keep thinking about it. (*She runs over to the settee and seats herself next to BURN.*) But it's not only him. It's everybody. You don't know what it's like.

BURN: I think I understand.

DILYS: Do you? When I was about fourteen a girl in the village had a baby before she was married. We used to watch her wheeling her pram along the street. We whispered as she passed. And the older people used to look at her like she had some disease. No one likes her, not even now. I don't want that to happen to me. It mustn't, it won't happen to me? (*Catching hold of his arm with insinuating appeal.*) You won't let it – will you?

BURN: What do you think I can do about it?

DILYS: You're a doctor. You know about these things. You wouldn't let me be unhappy for the rest of my life would you?

BURN: (*Ignoring this.*) Who is the father?

DILYS: Mr Stevens. The last visitor.

BURN: Couldn't you marry him?

DILYS: He's gone away.

BURN: Don't you know where?

DILYS: No.

BURN: Does he know?

DILYS: Yes.

BURN: You told him?

DILYS: Yes, I was frightened.

BURN: And you didn't know what to do?

DILYS: (*With a blatant show of self-pity.*) No, I didn't.

BURN: Well, haven't you got a boyfriend in the village? Someone who wants to marry you?

DILYS: No, I haven't, they wouldn't! (*BURN turns away.*) I don't want it! (*Her voice has a determined inflection.*) You'll help me won't you? (*Clutching his arm impatiently.*) I want to get rid of it and you can help me. Can't you? (*Wildly.*) I know you can. There *are* ways of preventing it. Aren't there? If you're in time. I've heard girls talk about it. There are, aren't there?

(*BURN rises and crosses to the mantelpiece.*)

You must help me, please!

BURN: I'm sorry Dilys. But I can't.

DILYS: Just tell me what I can do. My father will kill me when he finds out.

BURN: No, he won't kill you.

DILYS: (*Angrily.*) But you've got to help me. Do you hear? You must.

BURN: My dear girl, even if I hadn't any medical scruples, I couldn't help you. I often wonder how many women really do want the children they bear. The way they deform them and wrap them up in fear, I wonder if it wouldn't be as well if they didn't eat their babies like an angry bitch eats her pups.

(*DILYS stands thwarted, angry. MR PROSSER enters C with MR GRUFFUYD the Minister. DILYS is momentarily off her guard, makes a frantic effort to recover herself.*)

MR PROSSER: (*To DILYS.*) What are you doing here?

DILYS: I – I was just going. I came back to ask Mrs Prosser if I'd left my purse behind. Well I must go. My mother's waiting for me. Good night Mr Prosser. (*To GRUFFUYD who is looking at her sternly.*) Goodnight sir.
(*DILYS exits C. MR GRUFFUYD is a little, stocky man. He is small yet overpoweringly impressive. There is a concentrated intensity about him that could only emanate from a Welsh minister and one would hesitate to contradict him lightly. There is a tense silence as the three stare at each other, MR PROSSER embarrassed, GRUFFUYD solemn, BURN interested. HUW appears at the top of the stairs. He is about to come down when he sees his father and the Minister and stops. MR PROSSER sees him just as he turns back up the stairs.*)

MR PROSSER: Huw. Come down here. Mr Gruffuyd wants to talk to you.
(*HUW comes slowly down the staircase.*)
(*To GRUFFUYD.*) This is Mr Burn. He is staying here for a while.

BURN: Good evening.

GRUFFUYD: (*Nods.*) I haven't much time, Mr Prosser.
(*MRS PROSSER enters up R. Probably GRUFFUYD's pompous boom has reached her in the kitchen.*)

MRS PROSSER: Oh! Good evening Mr Gruffuyd.

GRUFFUYD: Good evening Mrs Prosser, I was just saying to your husband that I couldn't stay very long. I have to pay a call on Mr Lewis.

MRS PROSSER: Poor Mr Lewis. Is it true that he is dying?

GRUFFUYD: Yes. I fear he has spent too much of his life drinking spirits.

BURN: Now I suppose he is trying to commune with them.

MR PROSSER: (*Shocked.*) I didn't hear you come in Mr Burn. Are you not going out?

BURN: No. (*With a quick look at them.*) Well, I think I'll go up to my room. I've got some reading to do. (*Looks quickly at HUW and goes upstairs.*)

MRS PROSSER: Can I get you anything Mr Gruffuyd? Would you like a cup of tea? It won't take a moment.

GRUFFUYD: No thank you.

(*MR PROSSER and GRUFFUYD exchange a look and as if dismissed, MR PROSSER goes to the door R, nodding to his wife to follow him. MRS PROSSER after an anxious glance at HUW, follows him.*

GRUFFUYD stands looking at HUW who avoids him. Then slowly and deliberately walks to the fireplace and stands in front of it.)

Well, I don't have to tell you why I am here. I have known you all your life Huw. I christened you when you were a tiny baby. It was I who made you a child of God. I know you as I know every other man, woman and child in the village. I have watched you carefully and this I know, a few words from me to Dr Hillman and you would be put away. Do you hear me? Put away. I don't know what wickedness is in you. Not even you may know that. But it is there. The devil is inside you, Huw. Can you feel him? Living in the filth inside you?

(*HUW turns away in fear.*)

Do you know what becomes of people like you? Do you know what is waiting for you? When you die? I know many times I have stood at the bedside of the dying. And sometimes I have offered up prayers for them, knowing that they could never be answered.

(*HUW cries out and tries to stop him but GRUFFUYD grasps hold of him by the collar and sits him down, holding him. He goes on relentlessly.*)

Do you know what happens to such people when they are dead Huw? Black, terrible nothing. Lost darkness in the well of the dead land between earth and heaven. Coffin after coffin I have seen descend into the damp clay to rot with man or woman inside it. But they are neither man nor woman in that hollow land. They are decayed fragments, chipped off from their fellow men. You are very near to that land now. Perhaps, sometimes, when you are asleep you see it, eh? Perhaps you feel yourself falling into it. Falling into the eternity of fear – do you?

(*HUW manages to break away from his firm grasp and goes to the window, his hands convulsing.*)

Oh yes, you are afraid aren't you? For you have seen it
haven't you? When others are at peace with God and
asleep, you are fighting at the crumbling edges of the
earth. You're possessed. What does it feel like? To have
it thrashing itself against the inside of you like the ugly
reptile it is? But we've got to get it out of you. It will writhe
like a dying snake as we smother him. But we must get
him out. On Sunday when you come to chapel you will
stay behind and we will go down on our knees and pray
together for your sick soul and your weak body. You will
pray until the skin on your knees hardens. You'll pray now!
On your knees boy! On your knees to your God and pray
for release from the wickedness that has invaded your soul.
On your knees. Well! Can't you hear me?

HUW: No. No. I won't. (*Rounding like a trapped animal.*)

GRUFFUYD: (*Outraged.*) What! (*Advances and grasps HUW by the
collar.*) Down! (*They struggle fiercely.*) Out, devil! Out!
(*Enter MRS PROSSER R, she gazes at them struggling in
horror. MR PROSSER enters behind her, then goes over to them
and forces his way between them. GRUFFUYD looks furious,
obviously surprised and infuriated at having his attempts at
iconoclasm interrupted in this manner. MR PROSSER seems
half surprised at his own boldness and at the same time highly
indignant. For a moment it looks as though the two will come
to blows, when BURN appears on the stairs drawn by the
noise. They both make an effort to recover their dignity. As they
are doing this, HUW, terrified and humiliated, is out of the
door before anyone can stop him.*
Curtain.
End of Act One.)

Act Two

SCENE ONE

(*The scene is the same. It is the late afternoon of the next day. A small fire burns in the fireplace. Outside it is raining. The table is half laid for tea. As the curtain rises MRS PROSSER is seen standing at the table. In front of her on the table are two large cardboard boxes. She takes the lid off one and out of a heap of neatly packed tissue paper takes a man's black suit. She inspects it thoroughly and then begins to brush it. While she is doing this the voice of MRS EVANS can be heard from the direction of the kitchen.*)

MRS EVANS: (*Off.*) No respect at all some of these people, I say. Disgraceful way to carry on. And when the Minister put his hand under the mattress he found a bottle of whisky. Almost empty. And old Lewis jumped out of bed shouting 'You give me that back or I'll –'.
(*MRS EVANS appears in doorway R, a dish mop in her hand.*)
Well, I don't know that I like to repeat it, but you know what a rough one old Lewis is – he says 'I'll kick your –'

MRS PROSSER: (*Quickly, frowning.*) Mrs Evans, Mr Lewis is a foulmouthed man, I'm surprised at you trying to repeat things about him.

MRS EVANS: (*Very righteously.*) Oh! But I'm not repeating anything. I'm just telling you what I heard this afternoon from Mrs Rhys. She was there with Mr Gruffuyd.
A disgustin' sight it was, she says. Old Lewis standin' up on his bed without a stitch on his body. An old man like him too. Not a stitch. And the things he was doin' – well, well, I wouldn't dare repeat then. Why he –

MRS PROSSER: (*Firmly.*) No, those things are better left unsaid. What happened after?

MRS EVANS: (*Reluctantly.*) Er – well using the most filthy language and, and blaspheming. (*Pause.*) 'Get up,' says Mr Gruffuyd. (*Flourishing her mop.*)

MRS PROSSER: You're spilling water all over the carpet, Mrs Evans.

MRS EVANS: Oh dear! So I am. Well, it's only the washing up water so it won't stain will it? (*Flourishing the mop unconsciously.*) 'I don't want to get up,' says old Lewis, 'and I'm not getting' up for you or no one else. I'm a dyin' man.' 'Dyin' are you!' says the Minister. 'You're drunk, that's what you are.' 'Drunk am I?' he says, 'I'll show you!' And he gets back into bed and by the time Dr Hillman came he was dead. Well, I mean, such a way to carry on. Still he'll get his reward now, I suppose. I mustn't stand here talking, must I, I've got so much to do. I'll never get finished. (*Without attempting to move.*) People dying all the tine. It's terrible. Makes it difficult to keep your sense of humour. I mean you don't know whether it's your turn next do you? What a pity Mr Gruffuyd couldn't be at your Aunt's funeral. He always speaks so nice. When he says the words over the grave so impressive it sounds always, like a man on the wireless readin' the news. I always say to Mr Evans 'He's got such a fine voice that man.'

MRS PROSSER: Yes. You'd better finish that washing up before Mr Prosser comes in. He'll be in very soon and we don't want the place in a mess for him to come back to.

MRS EVANS: Yes. I'm just goin'. You can't go on and on without havin' a little break can you? Not when you're on your feet all day. What with people dyin' around you all the time –

MRS PROSSER: Yes, yes. Hurry up. Mrs Evans, we must get some tea shortly.

MRS EVANS: (*Going off.*) Lucky these men are, if you ask me. Everything done for them that's it. (*Off.*) Comin' home with everything done for them and then goin' out talkin' in that old 'Shepherd's Arms' all evening.

(*MRS PROSSER, looking slightly relieved, puts down the coat she has been brushing and out of the other box she takes a carefully wrapped parcel that turns out to be a large black hat of the old-fashioned straw variety. She goes over to the mirror and, putting it on, stares at herself anxiously. All the time she is doing this MRS EVANS is talking to her from the kitchen.*)

(*Off.*) I remember years ago, agoin' to old Mrs Rednegan's funeral. Never seen anythin' like it before or since. Sixty, seventy mourners there were, and well, I've never seen so many lovely flowers in all my life. And four of the finest horses she had. Looked like racehorses they said. Not that she'd have liked that I'm sure. And of all things she had a purple coffin. Purple mind you. A lovely colour but Mr Evans thought it wasn't dignified enough.
(*MRS EVANS enters drying her hands on the teacloth.*)
A bit showy if you know what I mean. Oh! There's nice you look Mrs Prosser.

MRS PROSSER: (*Doubtfully.*) It's the only black one I have. But it seems a bit tight at the back here. It seemed alright the last time.

MRS EVANS: Always the same those straw hats. A bit difficult like when you try them on after a long time. Perhaps it needs loosenin' at the back a bit, see? Let me see if I can do it.
(*MRS PROSSER hands the hat to her hesitantly.*)

MRS PROSSER: Mind your hands, Mrs Evans.

MRS EVANS: (*Wipes her hands carelessly on her apron and takes hat. She tries to stretch it.*) Just loosen it inside the brim.

MRS PROSSER: (*Anxiously.*) Be careful with it now.

MRS EVANS: It's alright. It's always better to buy them on the big side, I always think. You can always stick a hat pin through them then. And somehow a straw hat seems to look better –
(*There is a slight tearing sound as MRS EVANS 'loosens' it a little too vigorously.*)
Oh dear! Now look what I've done. I'll so sorry Mrs Prosser. I was just trying to make it all right. Still if you sew it at the back here, you could perhaps wear it at the back like you see in the papers. (*Putting it on.*) Like – this, you see.
(*Enter MR PROSSER, C. He stares in mild astonishment at MRS EVANS with her hat, apron and dishcloth hanging from her shoulder. MRS EVANS hurriedly hands the hat back to MRS PROSSER.*)

I was just showing Mrs Prosser how I thought she should put it on.

MRS PROSSER: You'd better go and finish in the kitchen, Mrs Evans.

MRS EVANS: I'm just goin' now. What with workin' all day (*Eyeing PROSSER aggressively.*) and always helpin' someone to do somethin'. (*Going off.*) You don't get time even for a cup of tea. I suppose we all get our reward sometime for what we do; still I'd like a bit of mine just now. (*Exit.*)

MR PROSSER: (*Who has been taking off his coat and bowler hat with meticulous care and shaking the rain off them, looks at his wife.*) What's all this?

MRS PROSSER: I've just had a letter from Mildred. Aunt Polly is dying (*She hands the letter to him from her skirt pocket. He begins to read.*) I've been waiting for you to come in. I'm sorry the tea's not ready. I started to get it when the post came (*He hands the letter back to her.*) What are we going to do? We must go and see her. And the sooner the better. If we catch the first bus in the morning, we shan't get there until about eleven o'clock.

MR PROSSER: Um. Perhaps we could go tonight. I'll look at the timetable. (*Goes to sideboard, takes out timetable and consults it.*)

MRS PROSSER: Poor old Polly. (*Arranging tea things.*) Knew something would happen to her kidneys I did. If you don't look after that back of yours, you're going to have trouble with it, I told her over and over again. If only she'd have wrapped herself up with red flannel like I told her.

MR PROSSER: There is a bus at quarter to seven. (*Replacing timetable.*) That means we have got just half an hour to get to the bus stop. It takes half an hour at least to walk there, so we shall have to hurry.

MRS PROSSER: Come on then. There's so much to think about. (*Picking up boxes.*) I've been looking at your black suit. You'll be needing it again soon. But it's getting so shabby. I think you'll have to get a new one. And this hat of mine looks dreadful. I haven't worn it since your mother

died. (*Calls out.*) Put the kettle on for tea will you Mrs Evans?

MR PROSSER: (*Thoughtfully.*) This means we shan't be able to get back until tomorrow. Maybe longer than that if she hangs on.

MRS PROSSER: They seemed to think it would only be a matter of a day or two. And that was yesterday. She may- she may have gone on when we get there tonight.

MR PROSSER: Well, whatever happens it isn't likely we'll be back until tomorrow afternoon. I can go and see Mr Rhys on the way to the bus stop and ask him to let me stay away from the shop for the day. He'll understand of course. It's early closing tomorrow so it will only mean the morning. But what about leaving the house? There's Mr Burn to think of, remember.

MRS PROSSER: Yes. There will be his meals to get too. Dilys might get them I suppose but…
(*They exchange glances and then look away.*)

MR PROSSER: He won't be in all the time. We can't leave her alone in the house.

MRS PROSSER: (*Goes to the settee and sits. Pause.*) Huw. What are we going to do about him?

MR PROSSER: (*Thrusting his thumbs into his waistcoat pocket and looking gravely ahead of him.*) I think one of us will have to stay behind. Perhaps you'd better go.

MRS PROSSER: Oh! We can't do that. We shall both have to go.

MR PROSSER: Why?

MRS PROSSER: Well, we must be there at the last.

MR PROSSER: Yes. Yes, of course.

MRS PROSSER: Mr Burn will be in most of the time I expect, and we can ask Mrs Evans to come in and get his meals. (*MR PROSSER looks doubtful. Calling out to kitchen:*) Will you come in a minute Mrs Evans? And isn't that kettle boiling yet? (*To MR PROSSER again.*) After all, it's only for a day. And she can send round word to Dilys' mother that she needn't come in.

MR PROSSER: Yes, that's true.

(*Enter MRS EVANS carrying kettle.*)

MRS EVANS: I'm sorry Mrs Prosser, but I can't make the kettle boil can I? And how am I to get on with my work if I keep runnin' in and out of here?

MR PROSSER: Where's Huw now?

MRS EVANS: I haven't seen him since he came in. He went straight upstairs.

MR PROSSER: Call him down will you please?

MRS EVANS: Huw. (*Calling upstairs.*)

MR PROSSER: You'd better go and fetch him, Mrs Evans. (*MRS EVANS looks at him sternly, eyes the staircase wearily, and with an expression of patient martyrdom ascends and disappears.*)

MRS PROSSER: You needn't have sent her upstairs, father. We could have called him down.

MR PROSSER: You know what he's like once he's in his room.

MRS PROSSER: (*Goes to table, picks up the boxes and carries them to the stairs.*) I do hope everything will be alright. Poor old Polly. Do you think we'll catch that bus all right?

MR PROSSER: If we hurry and you don't dither about, woman.

MRS PROSSER: I'll go up now. (*Mounting the stairs.*) There isn't time to get changed into our best things, is there?

MR PROSSER: Not if we're to get to the bus stop in time.

MRS PROSSER: Well, I'll just have a quick wash and put on a clean blouse. I can't go in this. We'll have to go as we are, that's all. (*MRS EVANS appears at the top of the stairs.*) Oh! Mrs Evans, I haven't had time to do the tea things. Would you mind doing them while I get ready? Mr Prosser and I are going away tonight.

MRS EVANS: Oh!

MR PROSSER: I don't think we shall have time to go into the shop and see Mr Rhys. It's a bit out of our way. I'll ask Huw to go in on his way to work in the morning. I'd better give him a note I suppose.

MRS PROSSER: Yes. (*To MRS EVANS.*) Pour another cup of tea out for Mr Prosser, please Mrs Evans. (*Exit upstairs.*) (*MRS EVANS comes downstairs and begins to clear the table in a half-hearted fashion. She pauses to pour out a cup of tea*

for MR PROSSER. MR PROSSER frowns to himself and goes to the sideboard. Taking out a pad, pen and ink, sits down at the table and begins to write.)

MRS EVANS: (*Pushes cup towards him.*) There's your tea, Mr Prosser.

MR PROSSER: Thank you.

MRS EVANS: I shouldn't like to have to go all that way tonight. Still, when your relatives are dying I suppose you've got no real choice, but I know I shouldn't like to have to do it in this weather. What time does the bus go?

MR PROSSER: (*Writing.*) Quarter to seven.

MRS EVANS: Oh! You haven't got much time have you? I expect you'll miss it.

MR PROSSER: Not if we hurry.

MRS EVANS: It all depends on what time it comes. Sometimes it's early and sometimes it's late. If it's early you'll miss it.

MR PROSSER: (*Looking up in irritation.*) Will you go up and see Mrs Prosser? She's in a hurry and she's got some arrangements to talk to you about.

MRS EVANS: (*Incensed. Going to stairs and mounting.*) Up and down the stairs. First one thing and then another. And there's my back feeling like I've got someone's hand inside it. (*Exit upstairs.*) No thought at all some people.
(*HUW appears at the top of the stairs. He looks down at his father and descends slowly. His father does not look up but continues to write.*)

MR PROSSER: Your great-aunt Polly is dying and your mother and I are going to see her tonight. We shan't be back until tomorrow afternoon, I don't suppose. So you will take this note to Mr Rhys at the shop for me in the morning before you go to work, in case I am not able to get back to work in the morning. Do you understand?
(*MR PROSSER looks up and HUW nods, then looks away. MR PROSSER returns his attention to the note.*)
There will be no need for Dilys to come in. Mrs Evans will get Mr Burn's meals for him. (*Tonelessly.*) You had better stay in tonight. The house will be empty and we don't want anyone breaking in. You understand?

(*Their eyes meet again and from this wordless exchange it is evident that they both understand the real significance of MR PROSSER's instructions. He pushes the note into an envelope, rises, and hands it to HUW who places it in his pocket. MRS EVANS appears at the top of the stairs and descends.*)

MRS EVANS: Well, there's a fine thing now. I've done enough work for one day without having more to do. And then there's my own home to remember. What's my old man going to say? 'Gettin' people's meals now is it?' he'll say, 'Why you'll be livin' away from home altogether,' he'll say. Why Dilys can't do it I don't know. A strong healthy young girl like her and me with my back feeling like it is. (*Goes to chair and sits down wearily.*)

(*MRS PROSSER appears at the top of the stairs carrying a small parcel.*)

MRS PROSSER: (*Descending.*) I've put you a clean collar on the bed and your other shoes are in the cupboard. I've brought your nightshirt and a towel and soap.

(*MR PROSSER nods and ascends the stairs.*)

Oh and you'll find a clean handkerchief in the top drawer. (*She goes to the front door recess to bring back overcoats and hats. She puts on her own.*)

Thank you so much for looking after Mr Burn for me, Mrs Evans. I know it's a lot to ask you but –

MRS EVANS: Oh that's all right Mrs Prosser. I'm only too pleased to help you if I can. After all, you must try and help people mustn't you? And you're always being so good to me.

MRS PROSSER: Could you cut up some of that pie and the cake I made yesterday? Mr Prosser hasn't had anything to eat and he can eat something on the way. You know how he gets if there's nothing inside him.

MRS EVANS: (*Rising reluctantly and going to kitchen.*) Yes. It's as well some of us can't afford to be bad tempered. (*Exit.*)

MRS PROSSER: (*Pours herself a cup of tea and stands drinking it.*) Now Huw, you'll tell Mr Burn what's happened when he comes in, won't you? Perhaps he'll come in before we go.

I hope he won't mind. Still it can't be helped. (*This is more to herself.*)

(*HUW stands watching her, bewildered by all the sudden activity.*)

You'll have to get yourself something to eat. Mrs Evans will be too busy. We shan't be gone long. You should know where everything is. You'll find some cold mutton and potatoes in the oven and there's some pie in the cupboard. Now what else was there?

(*She stands still, trying to collect her thoughts, and looks up to find HUW looking at her. Her expression changes and she looks at him fully. She hesitates as if she is about to speak.*)

Huw…

(*MR PROSSER appears at the top of the stairs. HUW turns away to the fireplace.*)

All right father?

MR PROSSER: My shoelace has broken.

MRS PROSSER: Oh! I don't know whether we've got one.

MR PROSSER: Well, there's no time to look for one now. Are you ready?

MRS PROSSER: Yes, I think so. I asked Mrs Evans to pack you up a little something to eat. Mrs Evans!

MRS EVANS: (*Off.*) All right. All right.

(*MR PROSSER dons his overcoat. His wife helps him. Enter MRS EVANS with small basket.*)

There you are. I didn't have time to cut sandwiches.

(*MRS PROSSER takes basket.*)

MRS PROSSER: Thank you Mrs Evans. – What else was there? I think that's everything.

MR PROSSER: (*Opening front door.*) We shall be late.

MRS PROSSER: And Huw, don't forget to lock up before you go to bed. Only make sure that Mr Burn is in before you do. Don't forget now.

MR PROSSER: Are you coming?

MRS PROSSER: Yes, father, I'm coming. Oh! and put the milk jug out for the morning. The big one in the kitchen.

(*MR PROSSER is outside now.*)

Well, goodbye Mrs Evans, I'll see you tomorrow. We'll try and get back as early as we can.

MRS EVANS: Yes, all right, Mrs Prosser, don't worry now. I'll see that everything's all right. I hope you catch the bus.
(*MRS PROSSER is about to go, when she turns to look back at HUW.*)

MR PROSSER: Are you coming, or aren't we to get there today at all?

MRS PROSSER: Coming, father. If it's all over when we get there Mrs Evans, we'll try and get the first bus back. Goodbye Huw.
(*And she steps out quickly, closing the door behind her.*)

MRS EVANS: There they go, and such a cold night. Mrs Prosser looks poorly too. It wouldn't surprise me if she was ailing for something herself.
(*MRS EVANS turns round and looks at HUW. She relaxes visibly and stares at him curiously then looks at the tea table with distaste.*)
Well, if you want any tea, you'll have to get it yourself. I've done enough today without running about after you, so you needn't stand there lookin' so soft, boy. Get on and clear this table.
(*HUW stares at her and then slowly moves to obey her. MRS EVANS goes over to the door recess C and reaches for her shawl and takes off her apron.*)
I'm goin' to get Mr Evans' tea and have a cup of tea and put my feet up. I'll be back later to get Mr Burn's supper. While I'm tidyin' the kitchen you can clear that table and maybe do some washing up while I'm gone, and try and be useful for once (*Looking at his clumsy efforts to clear the table.*) Great oaf. Well, I'm goin'. (*Exit to kitchen.*)
(*HUW begins to clear up slowly and clumsily, obviously confused. He pauses, listlessly picks up a half-eaten sandwich and takes a bite from it thoughtlessly. As MRS EVANS returns he makes an attempt to look as though he is busy.*)
Well, that's that. Hurry up and make this room a bit tidy. I shan't be long. (*Exit C.*)

(*After the recent noise and bustle it is suddenly very quiet.
HUW stands quite still, relieved at the stillness, glad that they
have all gone. It is growing darker outside. He looks at the
table, then, taking a cake, sits down in front of the fire.
BURN enters C.*)

BURN: Hello. I saw your father and mother going in towards
the village. I called out to them but they seemed in a bit of
a hurry. Are you by yourself?

HUW: Yes. They've gone away. Until tomorrow.

BURN: I see.

HUW: Aunt Polly is dying.

BURN: Oh! Sorry. Do we get our own tea?

HUW: Mrs Evans is going to get your meals. We've had tea.

BURN: That's all right. I'm going to have dinner with some of
the doctor's friends so I shan't be in anyway. I came back
to have a wash. You all alone? (*BURN goes over to the table.*)
Mind if I pour myself out a cup of tea?

HUW: No. (*He turns away and looks into the fire.*)
(*BURN pours out tea for himself, staring curiously at HUW.
Then goes over to the window and draws the curtains.*)

BURN: Shut it out shall we? (*He goes over to the oil lamp and
strikes a match to light it.*)

HUW: No. Don't light it please.
(*BURN smiles, blows out the match and sits at the table. The
two can scarcely see each other. They are little more than two
voices from out of the firelight.*)

BURN: Strange how much interest people take in the dying
when they can't really help them. Always the hopeless
things. They could help the living but they never bother.
Until it's too late. (*HUW is silent.*) Do you mind if I sit here
for a little while? Or would you rather be alone?

HUW: I am always alone.

BURN: I'll go if you like.

HUW: No, don't go. I want you to stay. I want to hear you talk.
Your voice is soft, soft like music.

BURN: Don't you want to say anything? (*No answer.*) We all feel
like you do sometimes, afraid. You know, I am studying to
be a doctor, but I have learnt far more about the insides

of men by watching them and trying to understand them than by reading my medical books. I have learnt more about how to make them well that way. There are strange, secret things inside a man, Huw. Mysterious depths of undiscovered beauty. They are always striving for fulfilment, peace. But that peace never comes. Until they find what they are looking for. Communication. That's what they are looking for, Huw. That is the greatest and most beautiful thing in the world. It is the way from our loneliness.

HUW: (*Slowly.*) I hate people. I hate them all. I hate them in this village. They think I am mad and unclean. But I'm not mad. I'm not unclean. Do you think I am – daft?

BURN: No. I don't think so, Huw. And Dr Hillman doesn't think so either. He would like to help you if he could, but as it is, he can do nothing for you. You must help yourself. You could be your own doctor.

HUW: They have always called me daft. They have called out after me ever since I was a little boy. They called out after me because I had a head too large for me, and legs too short to run like the other boys. But that didn't make me mad. That doesn't mean I'm daft does it?

BURN: No.

HUW: Ashamed of myself I have been. Ashamed of my awful body. Looked at myself in the mirror I have with nothing on. And I have been afraid. But why are we ashamed of our nakedness? It's God's isn't it?

BURN: Yes, Huw, I suppose it is.
(*HUW stops and seems unable to go on.*)
Go on.
(*Pause.*)

HUW: Every loveliness I have known has been a secret one. With a fearfulness about it. It is always there, cold, hard around you, nailing into you. I feel like – like a sly hog amongst sheep. It must be wonderful to feel fresh and clean in a mucky world, but it's horrible to be dirty amongst the clean things.

(*He pauses for a moment. Again he seems to be struggling for expression.*)
Sometimes, when I am alone, I sit where the fire should be and write down the things that come into my mind. Just as they feel and happen. I don't write well. I can't spell. But I learned a little by reading. They are beautiful these things, to me, beautiful. But yesterday…

BURN: Yes. What happened yesterday?

HUW: Yesterday my father found them. He found my book. It was awful. I wanted to die. I was ashamed in front of my mother.

BURN: You don't get on with your father, do you?

HUW: He hates me. I thought my mother was pure. I thought she might try to understand. But she is the same as them all.

BURN: But…

HUW: It's the truth. She is ugly. They are all ugly. I haven't talked to anyone like this before.

BURN: Haven't you? If you tried to understand more you wouldn't hate them so. I have been talking to Dr Hillman about you and he thinks you need helping. But you must help yourself more than anyone. Or you might destroy yourself.

HUW: I – I suppose that is what they mean when they say my book is ugly. I don't think it's ugly. Would – would you like to see my book?

BURN: If you feel that you want to show it to me.
(*HUW stares at him for a moment and then feels in the corner of the settee, puts his hand down and brings out his exercise book.*)

HUW: I hide it in here. It's not safe to hide it in my room.
(*He gives it to BURN who comes over in to the fireplace so that he can see to read. As he reads HUW watches his face in the firelight intently. BURN reads carefully, and slowly his expression becomes intent, surprised. He looks up slowly.*)

BURN: Did – did you write these?

HUW: Yes. (*He holds out his hand for the book, sorry now that he has shown his treasure.*)

BURN: (*Keeping the book.*) Oh! No, you've no reason to be ashamed of this, Huw. Oh I can understand the family uproar about this. It's crude, primitive. (*He looks at the book again.*) Some of it has great beauty. (*Slowly.*) Yes. Great beauty. Tell me about it Huw. How long have you been writing?

HUW: Ever since I could write. And before that I just used to think the words and remember them inside me. Words are wonderful, lovely things. They come on me like dew falling from poppies on to the earth.

BURN: Real poetry is even more rare than that. Poetry is like a delicate flower trying to force itself past the diseased things, the false things. Trying to throw up little seeds of beauty into our meaningless lives. And pretty rocky ground that is for most of us. You have a vary rare and precious gift, Huw. Do you know that?

HUW: You – you're making fun of me.

BURN: No, I'm not, Huw. I've never been more serious in my life. You have a great gift. You mustn't waste it. To waste it would be the most wicked thing you could ever do.

HUW: How can it be rare or precious? They all make fun of my words. Sometimes they even hate me for them.

BURN: Of course they make fun – because they don't understand. People always hate what they can't understand. Oh! How can I explain to you? You, who have never been outside your little Welsh village. We all have the seeds of poetry in us but very few ever burst into flower. Only a few in a hundred years. But yours has blossomed and is blossoming now.

HUW: I don't understand. You – you're making fun. I wish I'd never shown it to you. You're laughing at me, you're laughing at me, just like everyone else.

BURN: No, I'm laughing at myself, Huw, I'm laughing at myself because I see in you what I have always wanted in myself. I am the fool, the village idiot, the failure. You think you're the failure and I'm the success. But you're wrong. It's the other way round. My family have always wanted me to become a doctor. My father's a specialist

and my grandfather was a doctor. I grew up taking it for granted that one day I too should be a doctor. In a few months' time I shall take my final examinations. I know I shall fail. Maybe I haven't studied hard enough. Perhaps I've been too busy looking through people's bodies into their souls. And a good doctor is concerned with bodies – not souls.

HUW: Can – can you separate them – souls and bodies?

BURN: I'm sure you can't.

(*There is a sound at the door C. It is DILYS but in the dim light she is not clearly visible.*)

HUW: Who is that?

DILYS: It's me.

(*There is a short silence and a sound of feet crossing the floor. They are thrown into relief as a match is struck by DILYS who is standing at the table. She lights the oil lamp. Her back is towards BURN so she cannot see him. She stares at HUW and grins.*)

DILYS: Sitting in the dark is it?

BURN: We've been having a little talk.

DILYS: (*Turning, startled.*) Oh! I didn't see you there. I came to see about your supper.

BURN: You're a bit early aren't you? I thought Mrs Evans was to get the meals.

DILYS: She was, but I told her not to bother. I met her going home. I said I'd do it and I will. Can't think why they asked Mrs Evans at all. They know she's busy. Seems daft doesn't it?

BURN: (*Nods.*) Well, I'd better go and get washed if you'll excuse me. I'm going out to dinner this evening Dilys, so I shan't need anything anyway. I expect Huw here can get himself something.

(*With a quick glance at DILYS, who looks at him with a faintly grinning assurance, BURN exits R.*)

DILYS: What's wrong with him? (*HUW says nothing, but rises slowly and goes clumsily over to the fireplace. She seats herself nonchalantly on the edge of the table.*) Hello! A fire in the hearth. I'll bet that's Burn's doing.

(*Pause. HUW fingers the mantelpiece awkwardly.*)
When are they coming back?

HUW: Tomorrow.

DILYS: Of course it might be longer if the old girl hangs on.

HUW: The minister shall stand over the open grave and repeat these words. Man that is born of woman hath but a short time to live. He cometh up as a flower and is struck down. One flower is gone but a hundred are coming up. They are always coming up. It is strange why people take such an interest in the dying. Yes, it is strange.

DILYS: In one of our talkative moods are we? Well, you've been sulky enough lately.
(*Re-enter BURN.*)

BURN: Perhaps I shouldn't have stayed so long talking. (*Eyes DILYS.*) Or perhaps I should have stayed longer. (*Glancing at watch.*) I shall be late. (*Opens the front door a little and looks out.*) Why don't you go out, Huw? It's stopped raining. It's cold but it's a lovely night. The wind is singing madly in the hills! And in the quiet places where the darkness is like a soft hand over your ears the clouds rush over your head like wild, frightened things. There's a whole world out there for you tonight, Huw. You'd be safe there for a few hours.
(*As the two look at each other there is an instant understanding between them.*)
Think it over.
(*With an anxious glance at DILYS, who is staring at them in astonishment, BURN exits. There is silence for a moment while DILYS gazes at HUW.*)

DILYS: Well, what's the matter with him? Who wants to go out on a night like this? (*HUW is staring after BURN.*) I don't. Not when it's nice and warm and cosy inside, eh? (*She takes off her coat and crosses to HUW, who avoids her and walks downstage.*) You don't want to go out. Do you?

HUW: (*Uneasy.*) I'd better go.
(*He makes a movement towards the door, but she anticipates him and stands leaning with her back against it. HUW goes to the fireplace, looking at her, fascinated. She locks the door*)

behind her and keeps the key. Then she turns out the lamp on the table.)

DILYS: You want to be with me, don't you?

(*She goes over to him and faces him. For a moment they look at each other in the dim light. The fire casts a dull glow over the settee and soft shadows waver over the walls.*)

What's the matter? Are you frightened of me?

(*He clutches her wildly and their lips weld together. Almost as suddenly he breaks away. Holding her by the shoulders at arm's length he looks at her. After a few seconds, still holding her with one hand, he takes a grubby handkerchief and goes to wipe her mouth. She tries to pull away, protesting.*)

Here, what do you think you're doing?

HUW: I want to see your face. I've never seen it. Only the shape. I want to see it real, underneath. Not painted.

DILYS: Go on, old fashioned. A girl looks better for a bit of colour.

(*HUW, still holding her by the shoulders, tenderly pulls her a little closer.*)

HUW: Listen, little Dilys girl; you know that white church near the big village over the hill?

DILYS: You don't mean the Roman Catholic church?

HUW: (*Nods.*) Have you ever been inside?

DILYS: What do you think I am? Wicked that place is.

HUW: I've been inside.

DILYS: Huw!

HUW: I wanted to see what was this Catholic. Why it was different. So I went inside. Like magic it was. A holy place. And they have women's figures – little. And they was painted lovely colours. I felt them to see why. And they was only wood. That's why they had to paint them, girl. Because they wasn't life.

(*He wipes the powder and lipstick from her face. She submits without protest and watches him, almost stunned by his tenderness. He puts his handkerchief back in his pocket and touches her cheek for the first time, gently, as if he were afraid of bruising it. With wonder and delight he traces the shape of*

*her lips and, in a half dream, kisses her again. The firelight
plays on their swaying bodies. As they embrace she slips the
key in his pocket in view of the audience. After a while he tries
to break away from her, but she holds on to him. He struggles
fiercely and in doing so accidentally tears her dress. He gazes
at her in horror, and goes to the window to throw back the
curtains and let a broad white stream of moonlight flood into
the room. He stands erect, staring out into the dark. DILYS
watches him.*)

DILYS: What's the matter? Like a wild animal you are. You're
 afraid. What of? Me?

HUW: I don't know.

DILYS: Women frighten you, don't they?

HUW: Yes.

DILYS: Why?

HUW: They're cruel.

DILYS: So are men.

HUW: No. Men are just blind. You can be thirsty and, drinking
 clear, spring water, find it bitter.
 (*She rises and crosses to him.*)

DILYS: Why don't you come away from that window?

HUW: The hills are out there. A wild, sharp wind comes down
 from beyond them and she comes with it. She is part of it
 and it sparkles through her hair.

DILYS: Who?

HUW: She is a dream.

DILYS: What dream?

HUW: One I dreamt when I was a little boy.

DILYS: (*Puzzled.*) What does she look like?

HUW: I don't know. I've never seen her face.
 (*He draws the curtains quickly and as he does so he leans over
 her clumsily. She looks up at him. Slowly, he draws his hand
 away from them.*)
 Dilys.

DILYS: Well. (*He hesitates.*) What do you want?

HUW: Say that you love me.

DILYS: What for?

HUW: Go on.

DILYS: Go on with you (*She laughs uncontrollably.*) Want everything, don't you? (*They embrace and kiss savagely.*)

HUW: Do you love me?

(*There is an urgent inflexion in his voice that makes her look up at him startled. His grip on her tightens visibly, but soon she recovers her old superiority and breaks away firmly.*)

DILYS: Yes. (*Calmly.*) I love you.

(*She crosses above the settee and sits down. By accident she puts her hand on his exercise book. She draws it out, glances at it and then begins to read. Immediately HUW runs to the back of the settee and tries to snatch the book, but she hides it behind her back.*)

What is it? I want to read it.

HUW: You can't.

DILYS: Why not?

(*He comes around the settee and tries to take it from her, holding her arms as he tries to get it from behind her back. She is too quick for him and breaks away but as she does so he makes a grab at her and tears her dress again. They both stop still and stare at it.*)

Now you shan't have it.

HUW: Give it to me.

DILYS: If you want it you can come and get it. (*Backs downstage. He advances towards her.*) Well, see if you can.

(*He catches hold of her wrist, swings her towards him and tries to kiss her but she turns her head away.*)

You leave me alone Huw Prosser.

(*She struggles violently, dropping the book as she does so.*)

Leave me alone. (*In a husky wail.*)

(*In short waves her voice breaks into a scream. He stands amazed at this surprising outburst. She slaps his face savagely and runs screaming to the door to drag it open, tearing her dress with her hand as she does so. She pulls at it, then frantically hammers on it. She waits. There is no reply. She screams again.*)

Help! Give me the key.

HUW: The key? (*Dazed.*)

DILYS: Yes. (*Calmly.*) You locked the door, don't you
remember?
(*HUW is too astounded to answer.*)
You put it in your pocket.
(*He feels slowly in his pocket and draws out the key. His eyes
look up to meet hers. He looks almost triumphant.*)

HUW: What were you screaming for Dilys? Why did you run
to the door? You know you locked it.

DILYS: No. I don't.

HUW: Why did you lock the door? Because you didn't want
anyone else to come in was it?
(*He takes her in his arms, but she breaks away, screaming,
and bangs on the door.*)

DILYS: Help!
(*She continues to bang and scream, waiting for short intervals
for a reply from outside. There is a long silence and the two
watch each other. DILYS suddenly realises that there is no one
outside to hear her. Silence.*)

HUW: They have all gone. To the Choir Festival. Had you
forgotten that too?

DILYS: They can't be. Not all of them.

HUW: Mrs Jenkins is in next door.
(*Genuinely frightened now, she cries out hysterically for help.*)
She is stone deaf. (*Pause.*) Why did you stay here tonight?
Why?
(*She retreats above the settee down to the fireplace.*)

DILYS: I came to get Mr Burn's supper.

HUW: He went out to dinner. Why didn't you go then? Why
did you stay?

DILYS: I thought I'd keep you company.

HUW: (*Realisation coming gradually upon him.*) Why did you
scream? Why did you tear your dress?

DILYS: I didn't. You're daft. You're imagining it.

HUW: Why did you scream? Why did you scream as if…
(*Shouting.*) Why? (*He goes to her and touches her. She stiffens
defensively.*) Why did you put your arms round me?

DILYS: You wanted to do it, didn't you?

HUW: You didn't. You wanted something. You wanted your dress torn. Yes. You wanted that. And to scream. Why? (*He grabs hold of her impulsively.*)

DILYS: Leave me alone.

HUW: Why have you changed, Dilys? What's the matter? You're afraid. Afraid I may understand you. Aren't you?

DILYS: Me? Afraid of you?

HUW: What were you afraid of when you screamed? You didn't scream before. You wanted to bring then in, didn't you?

DILYS: No, I didn't know what I was doing.

HUW: But there was no one there. You'd forgotten that. You'd forgotten the Festival. You've a bad memory. But I haven't. (*He tries to kiss her, but she struggles.*) Why did you let me kiss you? All the time pulling at me. Was it because you loved me? Was it? (*He brings his face closer to hers.*)

DILYS: (*For the moment her fear is replaced by a savage, half tearful defiance.*) No! You fool! Stupid, ugly fool. I hate you! Do you hear me? I hate you.
(*He looks as though he is about to move, but the words freeze him.*)
(*Gathering confidence.*) There's something inside me. Something that can make me miserable for the rest of my life; something you see in people's faces and never forget. You wouldn't understand. But that's not happening to me. I won't let it. Why should I? But if I were attacked – by someone a bit queer in the head – it would be different. It wouldn't matter. Does that shock you? Well, there's nothing you can do about it. Someone will be back soon.

HUW: They won't believe you.

DILYS: Oh! Won't they? Do you think they'll believe you? Anyway, I shall be able to prove it to them soon, shan't I? (*She points to the exercise book on the floor.*) That should open their eyes about you. You and your talk of beautiful words. Daft, that's what you are. Daft. Why you're a – sex maniac.

HUW: You did read it!

DILYS: Yes. I read it. (*Laughing hysterically.*) See yourself.

(*He stares at his reflection in the mirror over the mantelpiece.
She looks anxiously at HUW who watches her in the mirror.
He turns slowly. The key is in his hand. He taps it slowly
against his palm. Uncertain, she runs to the door up R, but
he is there before her, blocking the way. His back to the door,
he makes certain it is locked. He walks clumsily up R to the
sideboard and opens a drawer. Taking advantage of this,
she runs to the window and is about to throw it up when he
reaches her and drags her back to the settee. In his hand now
is a long carving knife. They struggle slowly and his strength
tells and he forces her back over the settee and kneels over her.
The firelight plays on her face as he forces her head back until
it almost touches the ground. For a moment there is a glimpse
of a slender white throat arched under pressure with the skin
drawn taut: then it is hidden by HUW's arm. There is one
short, terrible scream and he draws back the knife. He is quite
still.
The firelight flickers on them and then, once more, there is only
a red glow in the fireplace.
Curtain.*)

SCENE TWO

(*It is three hours later. The room has been tidied up slightly; the end of
the settee has been moved to cover the place where DILYS would have
been lying. HUW enters from the kitchen carrying the oil lamp, which
he places on the table. This is another HUW. The sullen, frightened,
hiding creature is gone. He seems to stand up straight mentally and
physically for the first time. There is a sense of wild pride about him.
Yet it is a soft luxurious, dreamy pride. None of his movements are
hurried, neither are they unsure. He walks over to the fireplace, taking
his exercise book out of his pocket as he does so. He looks at it with
affection, smiles, but this new HUW no longer needs it, and he burns
it, marking the close of a phase of his life. He kneels at the fire, lights
the corner of the book and holds it in his hand while it is burning.
Then he throws it into the fire and watches the last shreds of paper
curl into ashes and disappear. He takes out his handkerchief to wipe
his hands. It arrests his attention as he remembers wiping DILYS's
face with it. Smiling to himself, with great tenderness, he wraps the*

handkerchief round his hand and holds it against his cheek for a moment.

His reverie is interrupted by a fumbling at the latch of the front door. Quickly, but without fluster, he goes back into the kitchen, not wishing his calm to be destroyed. He leaves the door partly open.

Enter BURN *at the front door. He looks around the room, surprised to find no one there when the lamp is still burning. He shrugs his shoulders and goes over to the sideboard and lights a candle. He starts to go upstairs but changes his mind, wondering whether to lock the front door or not. Decides against it, turns out the lamp and goes up to bed. As soon as the light of his candle has faded,* HUW *comes back into the room. He crosses straight over to the front door and opens it. He stands for a moment, smelling the sharp night air. On a sudden impulse he goes to the window and flings it open. Still holding the handkerchief to him he sits against the window, staring out into the night.*

Very slow curtain.)

Act Three

(*Curtain rises slowly to find HUW in the same position as he was when we left him. Nothing in the room is altered. The first light of early dawn is coming through the window.*

Upstairs there is a sudden noise as a door is slammed. HUW does not move. BURN appears at the top of the stairs, clad in a dressing gown, trousers and pyjamas. He looks cold and dishevelled. He sees HUW sitting by the open window.)

BURN: Wake up boy. What on earth are you doing? It's freezing in here. (*BURN rushes over to the front door and closes it. Then closes the window.*) Well, I should think you need a cup of tea. I know I do. (*Exit into kitchen R. There is the sound of water being poured into a kettle. Shortly BURN reappears and goes over to the sideboard to get cups.*) What do you think you're doing anyway?

HUW: I was wondering whether to go out.

BURN: Bit early for a walk isn't it? Why don't you go back to bed? You look as though you could do with some sleep. (*Peering at him carefully.*)

HUW: I haven't been to bed.
(*BURN looks enquiringly then goes to the sideboard and, taking two cups and saucers out, puts them on the table.*)
I have been watching out of my window. The day is festering like pain on the mountains and spitting blood into the valleys. Chasing dreams like a mad dog chasing wild sheep.
(*BURN looks startled. This new, peaceful, ecstatic boy is new to him.*)

BURN: Huw – has anything happened?

HUW: (*Crossing over to the window and drawing the curtains further apart.*) Have you ever walked in the blueness of the morning? When the sun is in a thick weal in the mist? I have gone out and no one known it. (*Pause.*) It's like – like going out to face God. The animals hurry back to the earth. Like sad ghosts clutching leaves in the wind. And I have

come back afraid. I came down to go out again because I
wanted to know it for the first time. (*Slight pause.*) You told
me to go out last night. Didn't you? You told me to go out.
(*Staring out of the window.*) I killed her. (*BURN gazes at his
back in amazement.*) Her body was soft, soft like a bed of
bracken.

BURN: (*Recovering himself.*) Huw – you – you're dreaming.
You're tired. It'll be daylight soon. This is reality, Huw.
This is another day. Dreams are over for the night.

HUW: Oh! But this is in no dream. (*Turning surprised.*) Don't
you believe me? (*He looks at BURN, hurt that his one friend
should fail to understand him. He goes quickly over to the settee,
and pulls it back and points to the floor. BURN gazes at it in
horror.*) She lay, her head on the floor. And I kissed away
the blood from her lips. (*Simply.*) They had never been so
red.

BURN: Dilys?
(*BURN, recovering from his initial horror, replaces the settee.
He stares at HUW, who seems to be in a trance.*)
Oh, my God! Of course I shouldn't have gone out. I might
have known.
(*HUW moves up towards the door.*)
(*Sharply.*) Where are you going?

HUW: I'm going out. Out to feel the wet furrows of the
morning in my hair and stand up from the earth and face
the wind, while the wild things are returning. Ride on the
crest of it over the hills and beyond to the quiet, sweet
places. Do you know what peace is? Peace is a softness
with arms that hold tender fruit like a woman's womb.

BURN: (*Strides over to him angrily.*) Come back and sit down.
You've got to talk to me. Don't you understand? Don't you
realise what you have done?
(*HUW looks puzzled and for the first time uneasy and agitated,
fear eating away at the edges of his calm.*)
Listen to me Huw. We've got to try and help you.

HUW: (*Dazed.*) Help me? I don't need your help now! I can
help you. I can show you all you ever wanted to know.
All you ever wanted to feel. I can show you the softness of

the mists, wandering like strangers amongst the marshes; where the sad music of the wild birds runs like mountain water over the strings of the young reeds. I can show you the smell of dead bark freshly chipped from its tree; the urgent smell of early morning and the hushed smell of the evening. I can show you the feel of a hundred things, of the soft cheeks of flowers hiding on the hillside, of the grass like a whispered blanket as you lay your head on the earth. Yes, I can show you all these things and others I have never discovered.

BURN: But this is different, Huw. Dilys is flesh and blood. And you've killed her.

HUW: They've been killing the inside of me ever since I can remember.

BURN: But all that's idea. You can't kill flesh and blood.

HUW: Is it worse to murder a body or a soul? You said yourself there was no difference.

BURN: You've murdered a woman. Don't you see what that means? She'll be missed. It means that in a few hours the whole village will know and turn out to find her. When she isn't found there'll be investigations – the police. Gruffuyd will be like a hound after you. Now, what are we going to do? Begin by telling me what happened last night.

HUW: The police? The village? (*Runs his fingers through his hair.*)

BURN: Tell me what happened last night.

HUW: She ran her long fingers over my body like fire. I wanted to run away. Run away and hide my face deep in the earth. I thought she wanted me. But she didn't. She was going to have a child. She wanted to use me.

BURN: (*Starting.*) Oh! What a fool!

HUW: I was never very good with a knife. My fingers are clumsy. Mr Davies used to swear at me because of it.

BURN: Where – where is it?

HUW: In the loft – mostly. What shall I do? What shall I do when they come?

BURN: I don't know yet. I – I must have time to think.

HUW: Perhaps I can run away.

BURN: Your only chance of running away is by staying here. I'll do what I can. If we can stave off their suspicions for a while – perhaps – well, perhaps we can try and do something. Now look, if you have ever needed strength, you need it now. As soon as they think you are the last person to see Dilys alive, they'll hammer at you relentlessly. You must have strength Huw. You've got to face them – face them as you would have faced the morning. You must.

(*Enter MRS EVANS C. She hangs up her shawl and looks at BURN and HUW in surprise. BURN looks quickly and anxiously at HUW, seeing the fear manifest that he himself has created*.)

MRS EVANS: Oh! You're both up, are you? Good morning Mr Burn. I've come to get your breakfast. There (*To HUW.*) you left the front door unlocked all night. I walked straight in. Anyone might have come in during the night. I suppose neither of you have seen Dilys have you?

BURN: No.

MRS EVANS: Oh, such a fuss goin' on. She's not been home at all since yesterday evening. Not all night. Her mother's frantic. Doesn't know where she is. Came round to our house this morning weeping almost. Worried out of life she is. Can't think what can have happened to her can you? (*Without waiting for a reply.*) Well, I can't stay here talking all the morning can I? I'll put the tea on. (*Moves up R.*) Still, it's worrying when somethin' like that happens. It's always better to know somethin' than nothin' at all, I always say. (*Exit MRS EVANS.*)

BURN: Don't worry Huw, she doesn't really suspect anything. But the tongues haven't started their work yet, and it won't take them long. You must say nothing. Don't answer anything. Close up. You've done it often before and they're used –

(*Enter MRS EVANS.*)

MRS EVANS: Someone had left the kettle on. Boilin' like mad it was. I had to open the windows to let the steam out. That's Huw again I suppose.

BURN: I put the kettle on Mrs Evans. I'm sorry I forgot it.

MRS EVANS: Oh! (*She starts crossing from the sideboard to the table, laying the breakfast.*) Well, if you ask me I shouldn't be surprised if she's gone off with some man or other. She'll come to no good that girl, I've said so many a time to Mrs Prosser. Thinks too much of herself. Always foolin' about with the boys. Still, I wonder where she is. I mean people don't just stay out all night for no reason do they? Such a shame about Mrs Prosser's aunt isn't it? Still, as I always say, we I've all got to go sometime, the high and the low. She did ask me to come along last night and get the supper and tell Dilys she needn't come in. But I felt that ill last night and when I saw Dilys in the street she offered so nice to come and do it for me, I didn't think it would matter. (*Looking at HUW blankly.*) Still, perhaps I shouldn't have. Oh! dear, I hope Mrs Prosser won't be cross now. I felt as bad as I could last night. (*Putting her hand to her back.*) I've got that arthritis in my back you know and they can't do nothing for it, the doctor says. Terrible thing it is when no one can do anything for you isn't it?

BURN: Yes.

(*MRS EVANS glances at the clock.*)

MRS EVANS: Um. Half past eight. Mrs Prosser said if the old lady had passed on they could come back early and catch the first bus so that Mr Prosser could still get to the shop. I don't think he wants to stay away unless he has to. He hasn't been away once for twenty-three years. It's a long time. So they may be in soon. I'd better lay for them just in case. Will you have breakfast now, Mr Burn?

BURN: I only want a cup of tea, thank you, Mrs Evans.

MRS EVANS: Oh! Is that all you're going to have? Well, I know some people don't eat much first thing. I always think myself you should have something warm inside you to start off the day. What about you, Huw? It's about time you were getting ready for work, isn't it? I'll get you something quickly. We can't have you bein' late.

(*MRS EVANS exits R.*)

BURN: Now Huw, we've got to think quickly. Have you any blood on your clothes? Let me look at you. (*Examines him.*) Have you got another suit you can change into?

HUW: Only my best suit.

BURN: Um. You can't change into that. Don't lift that arm higher than you can help. Are there any stains in the kitchen?

HUW: No – no – I don't think so.

BURN: And on the stairs?

HUW: I – I'm not sure.

BURN: I didn't notice any – still. What have you done with the knife?

HUW: I – I don't know. I can't remember.

BURN: You must remember. What did you do with it?

HUW: I – I –

BURN: Think. Can't you remember?

(*BURN breaks off as MR PROSSER strides in at the door C. He ignores BURN and looks straight at HUW, who flinches visibly.*)

MR PROSSER: What's been going on while I've been away? (*No answer.*)

What's been going on?

(*MRS PROSSER comes in; she is breathing a little heavily and has obviously been hurrying behind MR PROSSER. She looks tired and anxious.*)

MRS PROSSER: Now, don't get cross, father. Good morning Mr Burn. Have you had your breakfast?

(*Before BURN has time to answer MRS EVANS comes bustling through the door up R.*)

MRS EVANS: Oh, there you are. You've come early after all. It's alright, your breakfast won't be long. I'll have you a nice cup of tea in a minute. There's tired you look, Mrs Prosser. Bad news I suppose? Still, I always say…

MR PROSSER: Why did Dilys come in here last night?

MRS EVANS: Oh dear, Mr Prosser, I hope you're not cross, but I felt that bad and when Dilys offered –

MR PROSSER: I thought Mrs Prosser made it clear that Dilys wasn't to come in?

MRS EVANS: I'm so sorry, but you see I thought…

MR PROSSER: You thought! You'd no right to think, woman!
(*MRS EVANS looks indignant.*)
(*To MRS PROSSER.*) Didn't you tell her what to do?

MRS PROSSER: Yes. Yes, I told her.

MRS EVANS: Well, I didn't think – I – well, you can't help
feeling ill, I mean – well, can you?

MR PROSSER: Well, why couldn't you…

MRS PROSSER: Father, please. Mrs Evans didn't mean to.

MR PROSSER: (*Turns away impatiently.*) Did you see Dilys last
night Huw?

BURN: She left just before I did.
(*MR PROSSER stares coldly at BURN.*)

MRS EVANS: Oh. So you've heard about Dilys?

MRS PROSSER: Mrs Rhys stopped us on the way from the
station.

MR PROSSER: She said the last time her mother saw her she
was on her way here to get Mr Burn's supper ready for
him.

MRS EVANS: Yes, I know. It's dreadful isn't it? By the way, how
about your aunt, Mrs Prosser?

MRS PROSSER: She'd passed away two hours before we got
there. Still we went and looked at her and she looked so
peaceful and nice. She had a goitre you know, but it was
hardly noticeable.

MRS EVANS: Oh, yes. Dear, dear. Well we all have our time to
come and some sooner than others. (*Quick look at PROSSER.*)
As I was saying to Mrs Rhys only this morning…

MRS PROSSER: I think I'll have a cup of tea.

MRS EVANS: Oh, I'm sorry. Standin' here talkin' while you
want a cup of tea. The water's boiling and it won't be a
minute.
(*Exit MRS EVANS. MRS PROSSER moves towards the kitchen
door somewhat wearily, then stops.*)

MRS PROSSER: I'll go and see about your breakfasts. Who's
been moving my settee? That's Dilys again I expect. She
knows I don't like it there.

(*She moves it and her attention is suddenly fixed on the floor. For just a moment she is horrified. Then perfectly calm and collected she replaces it. She glances round quickly but only BURN and HUW have noticed her change of expression. Looking quickly from HUW she notices BURN and for a few seconds their eyes meet.*)

MR PROSSER: What's the matter with you woman? Get and see about some breakfast if you're going to. I shall have to be going soon or I shall be late.

(*MR PROSSER is about to sit at the table when there is a sharp officious knock at the front door. They all look towards it. MR PROSSER stands up slowly, goes to the door and opens it while MRS PROSSER sits down carefully on the settee. The open door reveals GRUFFUYD.*)

Oh! Come in Mr Gruffuyd. Come in. (*Calling out.*) Another cup for the Minister, Mrs Evans.

(*GRUFFUYD enters and looks around him carefully. Finally his attention fixes itself on HUW, from whom it is never quite removed.*)

GRUFFUYD: Good morning Mrs Prosser, I'm sorry to hear of your sad news. Mrs Evans told me about it last night. How is the old lady? Has she –

MRS PROSSER: Yes. She – she passed away yesterday evening. (*Enter MRS EVANS carrying tray with tea.*)

GRUFFUYD: Jesus said 'He who cometh to me I shall in no wise cast out'.

MRS EVANS: Amen. (*She pours out the tea.*)

GRUFFUYD: I've come along early before you all go to your appointed tasks for the day so that I might find out a little about Dilys. I suppose you've heard about it. She hasn't been home all night.

MR PROSSER: Mrs Rhys told us about it on the way home from the station.

GRUFFUYD: It's a distressing business when a young girl disappears from her home all night. It's difficult to think what might have happened to her. I am thinking of getting a search party to go out on the hills if she's not to be found in the village. It's unlikely, but she may have got lost. But if

we don't find her soon – I think we shall have to call in the police.

MRS PROSSER: The police!

GRUFFUYD: Yes. I think it looks as serious as that. In the meantime, however, I think we could get a party of those who are able to, to go out this morning. Mr Prosser will have to go to the shop, I expect, but perhaps if Mr Burn has nothing else to do he might help.

BURN: Certainly. Thank you Mrs Evans. (*As he is handed a cup of tea.*)

GRUFFUYD: And I don't suppose Mr Davies would miss you for a few hours, Huw, would he?
(*No answer. GRUFFUYD looks at MR PROSSER and jerks his head meaningly at MRS PROSSER and MRS EVANS. MR PROSSER looks puzzled for a moment.*)

MR PROSSER: Well, Mrs Evans, have you no work to do?

MRS EVANS: Well, yes, I suppose I have.

MR PROSSER: Go and see to it in the kitchen then. (*To MRS PROSSER.*) You can go with her, mother.

MRS PROSSER: I'll just finish my tea first.

MR PROSSER: (*Exasperated.*) Go into the kitchen, woman!
(*MRS PROSSER, tense and quite still, makes no move.*)
Do you hear me? Go into the kitchen!

MRS PROSSER: No, father. I'm going to stay here.

MR PROSSER: The minister has something to say to us, Annie, and it may be no thing for a woman to hear.

MRS PROSSER: If Mr Gruffuyd has anything to say, he can say it in front of me. Too often a woman has to bear what she may not hear.

MR PROSSER: I asked you to leave the room, and, as my wife, I expect you to obey.

MRS PROSSER: (*Not moving.*) Yes, father.

MR PROSSER: Well?

MRS PROSSER: I'm sorry, father, but I'm staying.

MR PROSSER: You disobey me?

MRS PROSSER: Always I have obeyed you before, because you are head of the house.

MR PROSSER: Then do as I say.

MRS PROSSER: Never, since we were married have I
 questioned anything you have said. Always I have done
 exactly as you wished. Not once have I contradicted you. If
 what Mr Gruffuyd has to say affects my family then I have
 a right to hear it. If it doesn't, then it can't hurt me.

MR PROSSER: Am I to be plagued by a disobedient woman,
 now of all times! With Mr Gruffuyd here and a serious
 matter to be discussed. Heaven knows what may have
 happened to this girl, and you expect me to stand here
 arguing. Are you my wife or not?

MRS PROSSER: Have you ever thought of the meaning of
 'wife'? Not just your shadow or drudge or housekeeper.
 Yes, I am your wife, but I am still myself. And I am a
 mother. If what the Minister has to say concerns Huw, if he
 is in any trouble…

GRUFFUYD: Who said anything about Huw being in trouble?
 Why should what I have to say concern Huw? Why are
 you frightened, Mrs Prosser? Do you know anything?
 (*No answer. MRS PROSSER realises her mistake.*)
 If you do it is your duty to speak whether it concerns your
 family or not.

MR PROSSER: How could she know any more than I do? You
 know we have been away all night and she hasn't left my
 side since we got off the bus. Don't mind a woman's silly
 chatter, Mr Gruffuyd.

GRUFFUYD: Women are deep creatures, Mr Prosser. Never
 disregard a mother.

BURN: You must be tired Mrs Prosser. (*To the men.*) She's had
 a trying time. Another cup of tea and a little rest would do
 you good. Don't worry. I shall be here. Go into the warm
 kitchen. And don't worry.

MRS PROSSER: (*Pauses for a moment, trying to read BURN's face.*)
 Perhaps you're right. Perhaps you're right.

BURN: Come along then. (*Gently he leads her to the door.*)
 (*Exit MRS PROSSER. MR PROSSER and GRUFFUYD look
 meaningly at BURN, but he ignores them and goes over to the
 fireplace and lights a cigarette.*)

GRUFFUYD: (*To HUW.*) What time did Dilys come here last night? (*No answer.*) What time did Dilys come here last night?

HUW: I don't know.

GRUFFUYD: Of course you know, boy. (*To PROSSER.*) He can tell the time, can't he?
(*MR PROSSER nods.*)

BURN: It was about seven. I told her I didn't want any supper and she left soon afterwards.

MR PROSSER: My son can speak for himself, Mr Burn.

GRUFFUYD: (*To BURN.*) She went out with you then?

BURN: Yes.

GRUFFUYD: Are you sure?

BURN: Quite. She seemed in a bit of a hurry.

GRUFFUYD: Then she must have come back.

BURN: Why must she have come back? (*GRUFFUYD looks quickly at HUW.*) Don't you think you're giving all this undue importance? After all, people are human even in a Welsh village. She's probably run off with a lover or something. She is an attractive enough girl.

GRUFFUYD: There are no young men missing from the village.

BURN: She might have gone to join someone outside the village. There is a world outside, you know.

GRUFFUYD: And where would she go?

BURN: Well, to one of the lodgers who have stayed here at some time for instance. People do have urges of the flesh, Mr Gruffuyd, even if you do like to pretend that they don't.

GRUFFUYD: I pretend nothing of the sort. I know only too well of the sickness of the flesh. But I don't think it's likely she would leave her own village to go and have some evil association with a stranger, particularly when she's taken nothing with her except the clothes she stands up in.

BURN: You said yourself she might have got lost on the hills.

GRUFFUYD: I think it's a possibility, but it's unlikely that a local girl would get herself lost. (*To HUW.*) What were you doing last night when Mr Burn went out?

MR PROSSER: Well, Huw?

BURN: Can't you leave the boy alone? He's not well.

GRUFFUYD: What do you mean? Is he ill?

BURN: He's suffering from a certain nervous strain and…

GRUFFUYD: And what?

BURN: And a few other things he's been suffering from for years.

GRUFFUYD: Why doesn't he answer me, tell me that?

BURN: Does he usually answer you? Can two men speaking different languages answer each other? You can only beat a dog so long, you know.

MR PROSSER: I think I can look after my son, Mr Burn.

BURN: Look after him! You've never looked after him in your life. Oh, you've fed and given him a bed and clothed him, but even cattle may expect that.

GRUFFUYD: Remember yourself Mr Burn. Mr Prosser is a respectable man and he has brought up his son like any God-fearing man…

BURN: Like any life-fearing man. Fearing living. Fearing being…

GRUFFUYD: Fearing God. And fighting evil.

BURN: Evil! What do you mean by evil? Doing what your being tells you to do?

GRUFFUYD: There is evil in this room and I intend to find it out.

BURN: You mean that you smell something unpleasant and you want to scrape it out and enjoy the stench.

GRUFFUYD: (*Furious.*) What do you mean?

BURN: You are one of those whose life knows so little truth or beauty that the only way to justify it is to create evil. The desire for evil is stronger than anything else –

GRUFFUYD: The desire to stamp out evil is the strongest.

BURN: You can't stamp out what doesn't exist. You create evil. You *want* it. Oh, the world is full of you – you secretly want wars, you *want* disease, you *want* poverty and human misery. Joy through discomfort, happiness through misery, salvation through discomfort. Life is meaningless and death means everything. All you have to offer at the end of it is

a dull stupid and unlikely heaven that nobody but a fool would want to exist in and only

GRUFFUYD: (*Outraged.*) Mr Burn. I…

BURN: Oh no! You can't interrupt me. You've been interrupting people all their lives but you don't frighten me. I was going to say – and only created by someone who had denied life. And that's your business, isn't it? Denying life and creating your 'evil' myth, making beauty into ugliness, turning…

GRUFFUYD: Turning the minds of the wicked to goodness and casting out wrong thinking and self-adulation. I do my best. And God is my judge.

BURN: And the excuse for all your obscenity.

(*GRUFFUYD advances upon BURN and seems about to strike him when MR PROSSER intervenes.*)

MR PROSSER: (*To BURN.*) That is no way to talk in my house.

BURN: Your house! What sort of house is this to bring up anything fine or free or noble? Why don't you let some clean air into the place? You can smell the fear, the petty indulgences, the backache, the near-pornography, the abstention from all the good things that life has to offer – the running away from the senses, running away to a vicious, sterile spirituality.

(*There is a short shocked silence.*)

MRS EVANS: (*Off.*) Mr Prosser! Mr Prosser!

MR PROSSER: Not now, woman. Not now.

MRS EVANS: (*Off.*) Can you come in here a moment, Mr Prosser?

MR PROSSER: What is it?

MRS EVANS: (*Entering.*) Well, the sink's blocked up and I can't get the water to run away.

(*BURN and HUW exchange quick glances.*)

MR PROSSER: Well, can't you use the plunger?

MRS EVANS: No, I can't. Not since I broke my wrist last year. And Mrs Prosser can't do it.

MR PROSSER: Well, can't it wait?

MRS EVANS: The sink's full of water and it'll overflow almost any minute.

MR PROSSER: Oh, well. (*Moves towards door.*) Why you have to fill it up I don't know. Surely you don't have to swamp the kitchen to fill a kettle.
(*Exit R, followed by MRS EVANS.*)
MRS EVANS: Well, I was only trying to run the water away.
GRUFFUYD: (*Returns to HUW.*) Well, boy. What have you got to say? Dilys was here alone with you last night, wasn't she? She did come back, didn't she?
(*HUW looks wildly at BURN.*)
Answer me!
HUW: No.
GRUFFUYD: She did.
HUW: No.
(*BURN crosses over to where HUW is standing.*)
GRUFFUYD: But I know she did.
BURN: No. No. No. No!
GRUFFUYD: But Mrs Jenkins next door heard. She told me so this morning. She heard her screaming.
(*Both BURN and HUW seem taken aback. BURN soon recovers himself.*)
BURN: How do you know it was Dilys?
GRUFFUYD: Who else could it be?
BURN: But I heard Mrs Prosser say that the woman next door was stone deaf.
GRUFFUYD: She can hear when she wants to.
BURN: You *have* been busy haven't you?
GRUFFUYD: Why did she scream Huw? Why did she scream? What did you do to her? What did you do to make her scream?
BURN: (*Turning to HUW to give him strength.*) You don't have to answer him, Huw. He's not a police inspector. Nobody's going to rely on the evidence of a deaf old woman.
GRUFFUYD: It's not the police inspector that matters, Huw. It's not that that matters. It's your God you'll have to answer to, boy. Remember. Remember the devil inside of you. Can you feel him now? Twisting like a trampled thing. Can you feel him?

BURN: There's no devil inside you Huw. Only the fear that other people have put there. Listen to the other things inside you, the lovely things for the sad wind and the quiet places in the hills. You said that yourself. Life. There's that inside you. That's your right.

GRUFFUYD: Heathen nonsense, Huw. The voice of the devil, the tempter. You know the devil when you feel him, don't you? You can feel him and now you can hear him, can't you?

BURN: It was never there Huw. It never has been.

GRUFFUYD: What does this man know about you? He's a stranger to you. He's from the outside. He has nothing to do with you. He knows nothing about your life.

BURN: I know you as you are, not as other people want you. I know you as you should be.

GRUFFUYD: I have known you ever since you were born, just as your father and mother have. Don't you think we don't know that you can't lead a life of lust? Of filth? Do you think you can hide yourself away from God? Aren't you afraid of Him? You believe in God, don't you? (*No answer.*) Don't you?

HUW: (*By this time incapable of collecting himself.*) No. Yes. No – I – I don't know – I –

GRUFFUYD: Do you think we've all been wrong all these years? Do you think we can all be wrong? What are you? An ignorant half-wit? Do you hear me?

BURN: Don't listen to him Huw. It's not true. None of the things he says are true.

GRUFFUYD: How can you say it isn't true? What do you know about God?

BURN: Not as much as you I suppose. I don't have a private chat with Him before breakfast every morning.

GRUFFUYD: Mr Burn!

BURN: Hang it man, what *can* we know about God? You like to give the impression that people can only reach God after a personal introduction from you. But it isn't so. Each person has to find God in his own way. To meet his own particular need. You can't just shout at them and make them accept

your God because of a few man-made laws that you believe in.

GRUFFUYD: I don't thank you, Mr Burn, for making mock of my calling. I am not here to account for what I believe in, but to do my duty as minister in this village. And I intend to do it without being turned aside by the secular yammerings of an outsider.

BURN: Outsider! That's the name you give to anyone who challenges your hold over the people.

GRUFFUYD: You challenge me!

BURN: Yes. I challenge you. You're a fraud, Mr Gruffuyd. A fraud.

GRUFFUYD: Remember yourself, sir!

BURN: By what right do you set yourself up as God's own ambassador? Who *gives* you the right?

GRUFFUYD: (*Quietly triumphant.*) The people. They give me the right. By their consent I am their Minister.

BURN: This time the voice of the majority cannot hold for the individual. There are those who prefer to find God on the hillside. Not in your cold little chapel. Those happy few don't need an interpreter.

GRUFFUYD: You can't break the tradition of centuries. A thousand years ago from this very village the word was sent to Cornwall and Brittany. The word is written in the heart of the people from their birth and neither you nor anyone else can change it.

(*Taking no further notice of BURN he swings on HUW.*)

And now, tell me what happened? What did you do last night? What happened?

(*HUW looks at BURN hopelessly. He looks as though GRUFFUYD has broken his resistance completely. GRUFFUYD looks triumphant.*)

HUW: I...all right. – I –

BURN: Huw!

GRUFFUYD: Go on.

HUW: Dilys, she –

(*There is a sudden clatter from the kitchen as a bucket is dropped on the stone floor. A slight pause. Then MRS EVANS*

Comes on R looking terrified. She stops in the middle of the room, unable to speak and looking away hurriedly from HUW gazes in terror at GRUFFUYD. MR PROSSER enters. He is no longer the proud assured, respectable man of the village. He looks suddenly old and tired. Broken. MRS EVANS turns round, sees MR PROSSER and makes for the front door.)

GRUFFUYD: What's wrong with the woman?
(MR PROSSER strides after her and catches hold of her arm as she reaches for her shawl.)

MR PROSSER: You – you're to say nothing of this in the village, woman. Do you understand? Nothing.
(She stares stupidly at him, briefly pulls her shawl from the peg, disengages herself and goes out, leaving the door open. MR PROSSER looks after her undecided. MRS PROSSER appears R. Seeing MR PROSSER standing at the front door, lost, his strength gone from him, she crosses to him, closes the door and puts her arm gently round him.)

MRS PROSSER: (*Softly.*) Come and sit down, father.

MR PROSSER: Did – did you see?

MRS PROSSER: Yes. You see I – I knew – I knew.

MR PROSSER: How? (*MRS PROSSER does not answer.*) Why? Why did he do it? So – so horribly? (*He sits down by the stairs.*)
(HUW, unable to stand the strain any longer, makes a dash for the door, but GRUFFUYD intercepts him, grasping him roughly. He manages to break away and turns to face them.)

HUW: Alright, alright. I'll tell you. You made me. And I'll tell you.

GRUFFUYD: Well?

HUW: Yes, I did it. I did it! (*In GRUFFUYD's face.*) I killed her. Do you hear me? I killed her.

GRUFFUYD: So. You murdered her. I knew it – knew what had been going on. You were alone with her last night and you…

HUW: She played with me. Tearing at me. Destroying me. I had wanted for so long for someone's soft hand to touch me like love. To love my poor body. I had to kill her. I had to.

GRUFFUYD: He's mad. Have you no shame? No fear?

MRS PROSSER: Leave my boy alone.

GRUFFUYD: This is no boy. This is the –

MRS PROSSER: Can't you see he's tired and ill?

HUW: Stop it! No, I'm not afraid! Not now. I've been afraid all my life, but not now. Because I understand now. Yes, there has been a devil inside me.

GRUFFUYD: Oh, so you know that now?

HUW: Yes, I know it. You have all been the devil inside me. Ever since I was a little boy. Always at me. Never with me. All of you. I wanted the life in me. You made me kill her. You make all the dirtiness and the meanness, you made ugliness out of the lovely things. You told me that the things I knew were inside me were wrong. That I wanted to feel and feel and feel, touching at the edge of the world and feeling it all slip through me. I knew I was right. I knew I was right. And now I've proved it to myself. (*To GRUFFUYD.*) You want the devil. The bad things.

GRUFFUYD: I'm not going to stand –

HUW: No, you can't interrupt me either now. You've been interrupting my whole life. Stifling me, making them laugh at me, ashamed of me. (*He sits down.*) When I was young, they threw my clothes away and I ran to my mother. I wanted to tell her of the things – the things like blisters in me. I wanted to cry my tears into her. Weep love and hate into her.

MRS PROSSER: (*Softly.*) Huw.

HUW: But I suppose she was too busy. Perhaps she was more ashamed of me than anyone. Ashamed that I should want to be loved. She said, 'Go away and don't bother me. I've got other things to do.' I never went to her again.

MRS PROSSER: I didn't know I – I –

HUW: I cried out 'love' and you made me hate. (*To GRUFFUYD.*) God is love, God is love, God is love – I hate God. I've never seen him. All I've seen are men and women like black stones choking the earth. (*He stops and looks at his father.*)

You gave more of yourself to Mr Rhys than you ever gave to me. I wonder what he will give you. (*Turning to them all.*) But there are places where your evil can never get to. Half way beyond the world in a thousand places of soft, sad music, whispered words like tenderness, being like love, free like the wind, and there are no cries of the lost things to be carried back on the air and buried in loneliness. (*Pause.*) Before, I could live but I didn't understand. I understand now, but I can't live. Still, most people live all their years and never understand. Perhaps I'm lucky. Perhaps I'm lucky.

(*He breaks down into a tired whimper and buries his face into MRS PROSSER. She soothes him gently. After a while he becomes quiet and relaxed. Then she leads him, childlike, to the stairs. With love and without any shame she helps him to clumsily ascend the stairs. MR PROSSER turns away and buries his face in his hand. BURNS and GRUFFUYD stare after them. MRS PROSSER pauses at the top of the stairs and looks down at GRUFFUYD for a moment; he averts his gaze. He looks troubled, deflated, his assurance and pomp gone from him. He looks, troubled, at BURN, who has no eyes for him either.*)

GRUFFUYD: I – I suppose I'd better go for – for the police.
(*BURN doesn't even look at him. MR PROSSER remains head in hand. MRS PROSSER goes on up the stairs with HUW. Slowly GRUFFUYD reaches for his hat and crosses over to the door and opens it.*
Curtain.
The End.)

PERSONAL ENEMY

Characters

CARYL KESSLER

SAM KESSLER

MRS CONSTANT

MR CONSTANT

'ARNIE' CONSTANT

MRS SLIFER

THE REV MERRICK

AN INVESTIGATOR

WARD PERRY

The action throughout takes place in the home of the Constant family in Langley Springs, USA.

The Time	August 1953.
Act One	Early morning.
Act Two Scene 1	Midday, two days later.
Scene 2	The same evening.
Act Three	Late afternoon, a few weeks later.

Personal Enemy was first performed at the Opera House, Harrogate, on 1 March 1955, with the following cast:

CARYL KESSLER, Mary Kean

SAM KESSLER, David Lawton

MRS CONSTANT, Ursula Granville

MR CONSTANT, Douglas Malcolm

ARNIE CONSTANT, Barry England

MRS SLIFER, Maud Long

THE REV MERRICK, C Lethbridge Baker

AN INVESTIGATOR, Alan Foss

WARD PERRY, Tom Conway

Directed by Patrick Desmond; settings by Oliver Richardson

Act One

(*The home of the Constant family, Langley Springs, USA. Early morning, August 1953.*

The stage is divided into two areas, the biggest of which is the sitting room. The other, smaller area is the hall R, which is elevated two feet above the ground level of the sitting room.

Centre back of the hallway is the front door of the house, which is of fine wire mesh.

The door has no catch. On either side of the door are small shrubs in tubs. Going off R is the staircase, a small telephone table below it. A door Centre R leads to Mr Constant's study known as 'the foxhole'.

A heavy velvet curtain hangs from ceiling to floor at the back where the hall rostrum divides the sitting room. This is drawn back into a drape now, suggesting that in winter it would be drawn along, shutting off the hall.

Two steps lead down from the hall to the sitting room. Back C of the sitting room is a long window through which can be seen the porch, which runs the whole length of the house. Up L is a door leading to the kitchen. Up C below the window is a dining table with three chairs.

Below the steps R is a long, low table. On stage, above table, is an armchair. There is a long, comfortable settee LC facing DR.

Most of the wall L is taken up by a long, low series of bookcases, below which is a Console Television set facing in-stage at an angle so that the screen is not visible. Above the bookcase is a standard lamp, and a small lamp on the table DR. Overhead (lantern effect) light in the hall.

In the jog of the set, between the kitchen door and the bookcase is 'Don's Corner', consisting of several shelves, containing his photographs, a large one of him, vase of flowers, Medal of Honour in a case, silver cups, diplomas, prizes, etc.

The room is well furnished, but the overall effect should be well lived in, clean but untidy.

At rise of curtain the stage is empty.

From the kitchen L comes the shrill, rising scream of a boiling whistling kettle. From upstairs comes MRS CONSTANT's voice, calling:)

MRS CONSTANT: (*Off.*) Arnie! Arnie!
 (*Simultaneously, there is the sound of a car drawing up and door slam, followed by the sound of hurrying steps approaching the porch.*
 A shadow falls across the mesh-door and –
 CARYL KESSLER enters. She is about 25, efficiently good-looking, the well-polished American average. She is carrying a large bouquet of roses.
 MRS CONSTANT calls from upstairs again –)
 (*Off.*) That you, Caryl?
CARYL: It's me, Mom. (*At stairs.*)
MRS CONSTANT: (*Off.*) For heaven's sake, be a dear and turn that kettle off, will you?
 (*CARYL starts to cross hall and down into the living room to the kitchen.*)
CARYL: OK.
MRS CONSTANT: (*Off.*) Isn't Arnie there?
CARYL: Haven't seen him.
MRS CONSTANT: (*Off.*) Are you early, or am I late?
CARYL: What's that?
 (*CARYL exits into kitchen.*)
MRS CONSTANT: (*Off.*) Are you early or am I late?
 (*SAM KESSLER appears at the front door. He is about 30, wide-shouldered, tall, good-humoured and easy-going. He is carrying three large parcels.*
 The kettle whistle has stopped.)
SAM: Come down here, Mom. I ain't coming up the chimney.
MRS CONSTANT: (*Off.*) That you, Sam?
SAM: Me or Santa Claus.
MRS CONSTANT: (*Off.*) Just coming. Can't seem to get my hair fixed.

SAM: Hurry on down. I got news for you.

CARYL: (*From kitchen.*) I've got news for you, Mr Kessler. Nothing's been done and if you don't come and give me a hand, there'll be no picnic.

SAM: (*Crossing to living room.*) OK, Honey. What do I do with these?

CARYL: (*In from kitchen.*) Well, look at you, Rudolph! Here give them to me. (*She crosses to table DR.*) Can't think what's happened. Nothing's prepared. Where is everybody? (*She places parcels on table.*) Where's Sarah? (*Crosses to stairs.*) What's happened to Sarah, Mother? Is she sick or something?

MRS CONSTANT: (*Off.*) No, dear, she's not sick. It's her sister.

CARYL: Well, shall I get on with things?

MRS CONSTANT: (*Off.*) Would you mind, dear? Oh, and would you fix your father's breakfast? He's got a conference at 9.30 so hurry it up, would you, dear?

CARYL: Sure, Mom.

SAM: (*To CARYL.*) Pop not coming with us?

CARYL: I don't know. Isn't that like Sarah? To go off today – Mother's birthday! Of all days!

SAM: OK, OK. Let's get on with it. What'll I do?

CARYL: (*Crossing.*) You'd better fix the table. Pop'll have to make do with flakes and orange juice.
(*Exit CARYL into kitchen.*)

SAM: He'll have to wait till Father's Day comes round!
(*SAM clears baseball mitts and magazines off the table in a leisurely way, goes to the television set. He swings out chair to sit in front of the set, and is about to switch on when – CARYL re-enters from kitchen. She carries a tray with an earthenware jug of coffee, package of cereal, jug of hot milk, three bowls and spoons, cream jug, glass jug containing juice and glasses, which she begins to lay in their places on the table.*)

CARYL: Stop messing around with that thing. We haven't time.

SAM: What the heck! How can we eat breakfast without Fred Muggs!

CARYL: I don't need any Fred Muggs with you around. Put that chair back, and come over here.

SAM: Right, Sergeant. (*He does so, taking off his jacket, laying it on the back of the chair.*) Gee, it's hot as hell already. I'm sweating!

CARYL: Not from overwork, you big ape. Fetch those presents over here and set them down by Mom's place. This old coffee jug doesn't even pour straight any longer.

SAM: Hope she likes my silver pot all right.

CARYL: That *I* bought.

SAM: Out of *my* pay!

CARYL: You should worry. You got a raise, didn't you? (*She surveys the table.*) What next? Picnic hamper, I guess. (*CARYL returns to the kitchen.*)

SAM: Are we going to the same place as last year? (*He takes out his cigarette case from his hip pocket.*)

CARYL: Why not? You know Mom likes doing the same things year after year.
(*SAM's cigarette case is empty and he goes to the upstage end of the bookcase L, where he takes one from a box and lights it. He stands, facing US, looking at 'Don's Corner'.*)

SAM: Maybe I'm wrong.

CARYL: (*From kitchen.*) What's that?

SAM: Maybe it *isn't* right having a picnic today.

CARYL: It's Mother's birthday, isn't it?

SAM: And the second anniversary of Don's death tomorrow.
(*A pause.*
CARYL appears at the kitchen door, wearing an apron.)
Some present.

CARYL: We did it last year, didn't we?

SAM: Seems it was your idea, I remember.
(*CARYL comes down to SAM.*)

CARYL: Well, why not? We've got to face up to it, Sam. There are thousands of American mothers with sons killed in Korea. Even in a town this size there are half a dozen others. Mrs Myers, Mrs Struble, she's a widow, poor dear –

SAM: I know. It's her birthday just the same. Still –

CARYL: (*Quickly.*) You know how Mom is about Don. He was more than anything or anyone to her. When we were kids, Don was the one who brought home all the prizes and cups. He was the great light of the family, and the shining star of the town. He may still mean more to her than any of the rest of us. But now he's dead, and he mustn't be more important than the other things in her life. Not any longer.

SAM: He was a good guy. So he gets killed in Korea. Well, thank God it's all over now, and all those other boys are on their way back.

CARYL: But it isn't all over, Sam. You read it in the newspapers, the war's over, hear it on the radio, see it on television. Bands playing, crowds cheering, flags flying. But it isn't over, Sam. Not for you, me, or the rest of us Americans.

SAM: Uh huh. I know what you mean, Caryl. Seems crazy a kid like Don. All that promise. And a big ape like me just sitting around. Sometimes, I've wished I was back with the old mob, like in the last war, giving those kids a hand. (*CARYL goes to him and links her hands behind his neck.*)

CARYL: Oh, Sam. Don't you see? Everyone can't get into uniform, and shoot it out. It isn't just a Shooting war. It's a war for you and me, and Junior, and Mom, the Reverend Merrick.

SAM: Yes; but Honey –

CARYL: It just gets me scared sometimes, Sam, when I think of the future.

SAM: You've been seeing too much television. What's all this politics in the early morning? (*He laughs.*) I buy defence bonds, don't I? I don't see any Commies cracking *us* up.

CARYL: Not even from within?

SAM: I guess not. Not while there are kids like Don. (*CARYL looks at him for a moment without answering. She breaks away from him.*)

CARYL: What on earth's happened to the family! (*She crosses to the hall and calls up the stairs on her way to the front door.*) Hey, family! (*She opens the front door and bends down to pick*

up a crate, containing four pint bottles of milk and a bundle of newspapers.)

SAM: Your kid brother's up. He must have slept out all night. His blankets were on the porch when I came in.

(*CARYL comes back into the sitting room, to the window.*)

CARYL: Yes. Arnie's a glutton for early morning swimming this weather. Maybe he's down at the river. (*She tosses the papers to SAM.*)

(*SAM catches them and goes to the settee L centre and sits. CARYL stops by the window C.*)

Will you look at that! There he is – picking flowers.

SAM: Why not? (*Reading papers.*)

CARYL: Oh, nothing. Everyone's just wasting time today. That boy needs a haircut.

SAM: Maybe he likes long hair.

CARYL: I don't like boys with long hair; Mom must tell him about it.

SAM: Says here 120 more GIs were handed back by the Reds yesterday. Won't be long now before they're all back. Mrs Collyer's boy – isn't he one of them?

(*CARYL is staring out of the window.*)

CARYL: He's too delicate. I've never seen a man handle flowers the way he does.

SAM: Uh?

CARYL: Arnie.

SAM: Arnie's a delicate sort of kid. Bit refined, I guess.

CARYL: Wonder how he'll make out in the Army.

SAM: Just like the rest, I guess. Say, do you know some of these GI prisoners have refused to be repatriated? Can you understand that? Wanting to stay with the Reds? Chinese Reds.

CARYL: (*As if to herself.*) Seems crazy.

(*MR CONSTANT appears at the stairs. He is carefully dressed and wears rimless spectacles. His manner is quiet and methodical. He is about fifty. Crossing the hall, he comes down into the sitting room, goes to the table, after carefully removing SAM's jacket to the upstage chair.*)

Why, Pop! Good *morning*!

MR CONSTANT: Good morning, Caryl. Hullo, Sam.
(*CARYL kisses him, putting down milk crate and pouring coffee for him.*)

SAM: (*Rising.*) Good morning, sir.

MR CONSTANT: Sit down, son.

CARYL: (*Handing him coffee cup.*) I'm sure it's stone cold by now.

SAM: (*Giving him papers, having tried to re-fold them.*) Got your papers here. I'm sorry you're not coming with us.

MR CONSTANT: Yes.

SAM: Business?

MR CONSTANT: That's it. (*He takes the papers from SAM and helps himself to orange juice and cereal.*)

CARYL: Shall I rustle up some cookies? (*She takes the crate of milk bottles into the kitchen.*)
(*Exit CARYL.*)

MR CONSTANT: (*As she goes.*) No, thank you, my dear. This'll do fine for me. How's the automobile business, Sam?

SAM: (*Sits settee.*) Pretty good. Just had a raise.

MR CONSTANT: That's good, Sam. Have the dollars rolling in, and you'll keep the womenfolk contented. I should know. It's my job to make 'em discontented.

SAM: How *is* the advertising racket?

MR CONSTANT: Still insidious.
(*ARNIE enters through the front door. He is about 17, tall and wiry. His hands are long and delicate. There are tight lines around his eyes already, and you notice how old his eyes look for so young a face. He wears jeans, is stripped to the waist, and a towel hangs round his shoulders. He is carrying the flowers he has picked from the garden. He crosses into the sitting room.*)

SAM: Hi, Arnie! Did you swim the channel?

ARNIE: There and back.
(*He goes over to 'Don's Corner' with the flowers, which he starts to arrange in the vase by Don's photograph. Suddenly, and instinctively, he becomes aware of SAM's eyes on him and, in his confusion, knocks over the vase, which smashed on the floor.*)
Oh heck!

MR CONSTANT: OK son.

ARNIE: Sorry, Pop. (*He kneels down to pick up the pieces.*) Mom'll be mad.

MR CONSTANT: Can't be helped, son.

(*CARYL enters with a dustpan and brush.*)

CARYL: Here – bull dozer!

(*SAM takes it from her without a word.*)

ARNIE: Guess I don't know how to handle flowers.

CARYL: Oh?

MR CONSTANT: How did you sleep out there, son?

ARNIE: Fine.

MR CONSTANT: Get bitten?

ARNIE: No. Had a net.

CARYL: A *hair*-net? (*Exit CARYL to kitchen.*)

MR CONSTANT: Got your Mom's present?

ARNIE: Heck! I haven't packed it yet!

(*ARNIE leaps up, leaving the dustpan etc. on the floor, dashes to the hallway, pausing to turn on the steps.*)

Can I use your fishing tackle today, Pop?

MR CONSTANT: Sure, Son. You know where it is – in the 'foxhole'.

ARNIE: Thanks a lot.

(*ARNIE dashes off up the stairs.*)

(*Off.*) Hi, Mom! Happy birthday!

(*MR CONSTANT rises, taking out his pocket watch.*

MRS CONSTANT enters from the head of the stairs.

Though middle-aged, she is trim and scrupulously turned out.

Her zest for work and play – the same to her – her insatiable

curiosity in all things, is tremendous, and is the dynamo from

which the entire family, and even the town, draws its powers.

She looks back over her shoulder…)

MRS CONSTANT: Well! (*Coming down the stairs.*) I know everybody's cross with me because I'm late, but I don't care because it's my day today. And I can do just as I like, can't I, Sam?

(*As she crosses the hall to the sitting room steps, –*

SAM goes to meet her.)

SAM: Sure you can, Mom!

(*CARYL marches in from the kitchen bearing bouquet, singing:*)

CARYL: (*Singing.*) 'Happy Birthday to You…'

(*SAM swings MRS CONSTANT down into the room.*)

SAM: Happy birthday, Mom!

MRS CONSTANT: Oh, you darling family!

(*CARYL hands her the bouquet. MRS CONSTANT kisses them both.*)

Oh, where did you get these? Not from Leon's! But he's so expensive! You should have – but never mind… They really are lovely! (*She buries her face in them.*)

(*ARNIE leaps down the stairs.*)

ARNIE: I'm not too late, am I? You haven't opened the presents yet, have you, Mom?

MRS CONSTANT: You didn't kiss me good morning. You just went flying past like the house was on fire or something.

ARNIE: (*Offering her a small package.*) Here you are, Mom. Happy birthday!

(*She takes it and he embraces her.*)

MRS CONSTANT: Watch out for my flowers, Arnie! Thank you, dear. (*She kisses him on the forehead.*) And now I must see what you dear people have brought for me. I suppose I should pretend to be surprised, but that's silly. (*To MR CONSTANT.*) Oh, darling, I haven't said good morning to you yet.

MR CONSTANT: Hullo, dear. Happy birthday.

MRS CONSTANT: Bless you, dear. (*She kisses him.*) Now! (*She moves around to the US end of the table.*)

(*SAM pulls out the chair for her and she sits.*)

Thank you, Sam.

CARYL: Aren't you going to have some breakfast first?

MRS CONSTANT: No, I'm too excited to eat. (*She starts to examine each of the four parcels in turn.*)

MR CONSTANT: What time do you think you'll be back, dear?

MRS CONSTANT: I don't know. What time will we be back, Caryl?

CARYL: About seven-thirty, eh, Sam?

SAM: Just as you like.

(*MR CONSTANT disappears into his study in the hall R.*)

MRS CONSTANT: (*Putting her ear to a parcel.*) Now, what's this? Ohhhhh! (*As she reads the label.*) How sweet! Arnie, be a dear, and put my flowers in water, will you? My wonderful flowers.

ARNIE: OK Mom. (*He crosses and takes them from the table into the kitchen.*)
(*Exit ARNIE.*
SAM stands behind MRS CONSTANT's chair.
CARYL is in the chair R of table.)

MRS CONSTANT: I don't care what happens or what we do. This is going to be just one wonderful day.

SAM: You bet.

CARYL: Mom. Isn't Pop going to give you anything?

MRS CONSTANT: Oh, silly, of course! You know your father. He likes to time his little moments. You watch and see if I'm not right. (*She picks up a third parcel.*) Now, let's see who this is from? Ummm. Why, it weighs a ton!

SAM: One of Caryl's cakes, maybe.

CARYL: No, dear. One of your socks.

MRS CONSTANT: Caryl! Don't be disgusting. Shhh! (*She holds up her hand.*) Isn't, isn't this sweet? (*Reading aloud.*) 'To Mom – Don't bury this 'cos it's not a bone. With woofs and wags and lots of love from – Bumper!' Oh, where is he? Let me thank him. (*Calling.*) Bumper! Bumper, Bumper!

CARYL: Don't be silly, dear. You know you don't like dogs about the place. We left him at home today.

MRS CONSTANT: Now. What is this? (*She begins untying it.*)
(*MR CONSTANT comes out of his study with his hat and briefcase and goes to the front door and opens it.*)

MR CONSTANT: Have a good day!

CARYL: (*Half rising.*) Pop!

MRS CONSTANT: Shhhh!
(*Slight pause as they all watch him.*)

MR CONSTANT: Going to be a mighty hot day. (*Turns to go and stops.*) Oh, I clean forgot!
(*General laughter.*
MR CONSTANT comes back to the steps and –
MRS CONSTANT comes to meet him.)

MRS CONSTANT: As you've forgotten every year for the last thirty years. Darling, thank you.
(*MR CONSTANT hands her a small, oblong, scarlet jewel case and –*
MRS CONSTANT kisses him.)

MR CONSTANT: Well, I must be going. (*At the front door.*) 'Bye, all.
(*MR CONSTANT goes out as –*
They call their goodbyes.)

MRS CONSTANT: This is something special, I know. I'll leave this till later. (*She places it on the low table DR.*) Now, where was I? (*Crossing back to US table.*)

CARYL: (*Looking at SAM.*) Come on, Mom. I can't wait to see what Bumper's got you this year.
(*MRS CONSTANT sits and goes, on with unwrapping Bumper's present.*)

MRS CONSTANT: Dear Bumper! Oh. Caryl, dear! Do remind me to call the Reverend Merrick before we go out, and ask him to pop over and see Sarah's sister. She's sick, poor thing.

CARYL: Let's hope Sarah tells her she is before he gets there.

MRS CONSTANT: Caryl, you mustn't – (*Opening the parcel to reveal a large, heavy book.*) Why, it's a book.

CARYL: A book?

MRS CONSTANT: (*Reading.*) 'The Od –'

SAM: Odyssey.

MRS CONSTANT: 'Odyssey of Homer, Rewritten in Modern, Everyday English for Ordinary Man and Woman'.

CARYL: Well! Bumper's a bigger egghead than I thought.

SAM: (*Taking the book from MRS CONSTANT.*) How about this! (*Declaiming.*) 'Here, in this book is the magic of the Glory That Was Greece. The Greatest story of all time, pulsing with unforgettable action and lusty adventure, and the names of the warrior heroes and their alluring women that are ingrained in our culture today. No wonder that the gorgeous panorama of this book has thundered down thirty centuries, to be told at last in simple language for all to understand!'

CARYL: What does Bumper think Mom is!

SAM: Maybe she could read it as a weekly serial to the Guild. Mom'd kill 'em reading that. You know, I always think, with that voice of hers, she should have gone on the movies. *And* that figure! (*Giving her a squeeze.*)

MRS CONSTANT: (*Laughing.*) Sam! Well, I don't know. It doesn't sound a very decent book.

CARYL: Seems a funny kind of present to me. Last year it was 'Gems of Shakespeare'.

MRS CONSTANT: Bumper knows how I love literature.

CARYL: Well, aren't you going to look at mine?

MRS CONSTANT: But of course, dear. (*Opening it.*)

SAM: Maybe it's Uncle Remus.

CARYL: That's kid's stuff.

MRS CONSTANT: (*Revealing present.*) An Electric Mixer! How like Caryl! So practical. Thank you, dear. (*Laughing.*) Oh, Caryl, do you remember that time you and Don were playing with my electric mixer – the first one your father gave me? Why, you couldn't have been more than – what? (*Undoing SAM's present.*) Don would have been seven… Yes, and I remember coming back from taking the girls to a regional Baptist meeting in the station wagon, and there you were, Caryl, sitting at the kitchen table in tears because Don was forcing you to eat scrunched-up snails on toast! Remember, Caryl?

CARYL: (*With genuine distaste.*) Yes, mother. I've never looked a snail in the face since.

MRS CONSTANT: We laughed so much, your father and I. We just couldn't do a thing about it because Don quite seriously thought that he was on to something good in the food line!

SAM: Yes. Don always seemed to take food very seriously – for an intelligent man, I mean. Funny thing.

CARYL: Logically speaking that makes your IQ around zero. Whenever I get Sam a meal, I have the same old line – whether it's a thanksgiving spread or a boiled egg. 'Darling, you're the most super dooper little cook – and that was a super dooper meal!'

MRS CONSTANT: (*Holding up SAM's coffee pot.*) Oh, Sam! How wonderful! Really, you shouldn't have! (*Kissing him.*) Now isn't that elegant. I want to use it right away!

CARYL: Mom, darling – I love you, and all that, but are we ever going to get out today?

MRS CONSTANT: Of course, dear. But I can't just get over these lovely things. You really are two very dear children, and I know you can't afford it.

SAM: But we can, Mom. I've just got a pretty good raise. That's what I wanted to tell you. And Caryl and I were thinking that maybe now we could get ourselves a bigger place. Maybe a junior or two – you know?

MRS CONSTANT: But that's marvellous, Sam. I *am* glad, and I think it's about time you two had children. My own children have brought nothing but joy to me; watching them grow up – their funny little ways. Their dreams and ambitions are yours, and then there's the joy of sailing along together on their ideals. Arnie is like that. Oh, he has great things locked up inside of him – I'm sure of it. Don had, of course. And you know – it's funny: when Don was killed, and people said to me, 'I'm so sorry, Mrs Constant', I said to them – I'm not sorry, not in a sad sort of a way, not really sorry. I believe that when people die, we should be sorry that they have to wait until we can join them. It seems your Father never will understand that, Caryl. He just seemed to close right up when Don went. And that's wrong. God just meant him to be taken from us all. But Donald's flame still burns. I know. His light still shines right here through Arnie, and I think: there's my boy, my boy who is going to do great things. Oh, we really are very lucky people: Caryl's got you, Sam, and I have such a lovely, lovely family. (*To the window.*) And it's such a lovely, lovely day. (*She is crying just a little.*)

(*CARYL goes to her.*)

CARYL: Of course, dear.

SAM: Now, what about the last present – Arnie's. Looks a cute package.

MRS CONSTANT: Oh yes, of course. I'm sorry. Silly of me. It's just that I'm very happy, and I'm sure I don't deserve it. (*Returning to open package.*)
(*ARNIE enters from L carrying his mother's flowers tastefully arranged in a vase.*)

ARNIE: Pop's letting me use his fishing tackle today. (*Placing vase in 'Don's Corner'.*)

MRS CONSTANT: That's nice, dear. (*Opening box containing earrings.*) Oh, Arnie! They're beautiful! See how they sparkle. Such sparkle! Look, Caryl! See the sparkle in them! (*Going to ARNIE and embracing him.*) Bless you, my dear! I'm so pleased with them. (*Seeing dust-pan, pieces and flowers.*) What's happened here? (*Picking up piece of vase.*) Why, who broke this vase? Who broke Don's vase?

ARNIE: I did, Mom. I'm sorry.

MRS CONSTANT: But why didn't you tell me? Do you mean to say it's been lying there broken, and no one said a word? How could you be so unkind? How could you! You know so well how I treasured that vase. It was the very first thing that Don ever gave me. The very first thing.

CARYL: It was cracked at the base, anyway.

MRS CONSTANT: That's not the point, Caryl. That is not the point. He came right though that door – I remember so well. – 'Mom', he said, 'I've got a surprise for you.' He was that proud. Your father had given him a dollar for raking some leaves. And out he went – straight away – and spent the money on me. There must have been a hundred things that boy might have gone and bought himself, but he bought that vase for me – and now it's broken.
(*Telephone rings.*)

ARNIE: (*Going to phone.*) I'll get it.

SAM: Well, shouldn't we make a start? Isn't the food to be fixed yet?

CARYL: Well, I did start on sandwiches, but I don't seem to have got very far.

ARNIE: (*At phone.*) Yep… Yes, it is…

MRS CONSTANT: I'll get on with the food, Caryl – if you two don't mind clearing up a bit.

(*Exit MRS CONSTANT to kitchen.*
CARYL starts stacking breakfast things.)

ARNIE: (*Phone.*) I can't… I just can't, that's all…

SAM: (*To MRS CONSTANT – in kitchen.*) What about your sparklers, Mom? (*Picking up ear-rings.*) Don't you think you ought to wear them on a day like this?

MRS CONSTANT: (*In kitchen doorway.*) Of course, Sam. Of course. (*Puts them on.*)

SAM: (*With a hug.*) There's my girl!
(*MRS CONSTANT laughs and exits to kitchen.*)
Now, what can I do?

ARNIE: … In a couple of days, maybe… I guess I'll have to think about it…

CARYL: (*Glancing out of window on way to kitchen.*) You might bring in Arnie's blankets and things from the porch. Heaven knows how long he's going to be on the 'phone. (*ARNIE glances across at her.*)

SAM: Yes, ma'am. Where'll I put them?

CARYL: Put them up in the Rumpus Room, at the top of the stairs.

SAM: Sure. (*Goes through front door to porch.*)

ARNIE: Yes, yes… Of course I will. 'Bye. (*He puts the receiver down and goes upstairs quickly.*)
(*CARYL takes things into kitchen as SAM puts his head in through the window.*)

SAM: I feel I ought to tell you, Mesdames, but here comes more hindrance.

CARYL: (*In to window.*) Who, who is it? Oh, no!

MRS CONSTANT: (*Calling.*) Who is it, dear?

CARYL: It's Mrs Slifer.

MRS CONSTANT: Oh, dear.

CARYL: More like oh damn, mother darling.

MRS CONSTANT: Oh, Caryl!
(*SAM comes in from the front door with an armful of blankets and cushions. As he mounts the stairs a thick book with a distinctive yellow cover slips from one of the blankets, unnoticed, and falls to the floor.*)

SAM: She looks mighty red in the face. (*Exit SAM upstairs.*)

MRS CONSTANT: (*From kitchen.*) I suppose I'd better put some coffee on – be a little sociable.

CARYL: (*Table now clear.*) Oh, mother, no! We'll just have to tell her we're going out.

A shadow on the mesh door and the doorbell rings.

MRS CONSTANT: You mustn't be unkind, Caryl. (*Appearing at the kitchen door.*) Live and let live. (*Crossing to the front door.*) We all and each one of us have our place in this world. Don't forget that, Caryl. And Mrs Slifer has hers, just as well as you. You young people are so intolerant nowadays; yes, intolerant – even about things you know nothing about. I notice these things. Live and let live, dear.
(*As the doorbell rings again, and SAM reappears, coming down the stairs, she opens the front door.*)
Why, Mrs Slifer! How nice!
(*MRS SLIFER enters. She is about 50, plump, likeable and voluble. She speaks with a marked Polish accent.*)

MRS SLIFER: I have to come at once!

MRS CONSTANT: Of course. (*She picks up the book from the floor and hands it to SAM, who is now at the foot of the stairs.*) Put this away, dear.
(*SAM places it on the telephone table and lights a cigarette. Then picks up the book idly and begins reading it. The two women cross the hall into the sitting room.*)

MRS SLIFER: Why, hullo, Caryl! Ain't it hot! And you know me – this heat it gets me. I must tell you, Mrs Constant: by the second post comes this letter. Yes, you're right – it's from Paul again. Which I don't understand, properly. You know me: talk I understand all right, but words – when Paul writes me them long words, me – with no high school education – it ain't easy. Many times I say to Paul, I bet if you was writing to some girl, you wouldn't go using all them fancy words! (*She roars with laughter.*) Did he laugh at that! But he ain't really interested in girls. With Paul, it's work, work, all the time. But why I come to you, Mrs Constant, is to ask you about this. (*Holding up letter.*) You see, it's this way, Caryl! Every time I see that postmark – Washington, I'm so excited, I don't even

read properly, even if I could. Once a week, regular, he writes to me. People say to me, 'Ah, Mrs Slifer, you must be proud of that boy of yours, working like he does, in the State Department in Washington.' You say it to me, Mrs Constant. Everybody says it – and I'm proud. Sure, I am proud. But why I am proud, I don't know. I don't even know what is the State Department!

(*CARYL and MRS CONSTANT laugh with her.*)

And look at Sam there!

(*SAM is reading and does not look up.*)

All the people I know are so clever. Wish I was like that.

CARYL: Don't you think –

MRS SLIFER: Like you, Caryl. You're clever. All your family is clever, Mrs Constant. There's so much education these days. It's all education – reading, writing, always reading, writing. Like it says on the radio the other day – if all them words spoken in the last six months, or was it six years… Anyway, if all them words spoken by them politicians, where my Paul is, were written in them Government books and was stacked right up – they'd be higher than the Empire State Building! And I can't even work out this letter for myself! Paul is wonderful with letters, Caryl. Makes you feel real good. He used to write to your Don regular as clockwork before he was killed. They were good friends, such good friends. Weren't they, Mrs Constant? Good boys. And Don used to write back – about what he was going to do when he got back from the war. What they was both going to do. But you know, it seems to me Paul ain't the same in his letters now. I don't feel he's so happy somehow. These last two letters –

MRS CONSTANT: Why is that?

MRS SLIFER: I don't know. Somehow I just feel it. What you call it? Intuition. Yes, intuition. That's a good word, eh? It's right there in the letter. Look, Mrs Constant – that's intuition, ain't it? INTU – (*Pointing to letter.*)

MRS CONSTANT: (*Reading.*) 'I have a strange intuition, Momma, that I may be leaving Washington soon –'

MRS SLIFER: Leaving? Leaving Washington? Whatever for? Why should he leave Washington?

MRS CONSTANT: I don't know. (*To her.*) Why don't you come and talk to me in the kitchen? (*Crossing R with her.*) You know I'm supposed to be going out on a picnic today, and we haven't a thing packed yet!

MRS SLIFER: A picnic! All them parcels! Why, it's your birthday. Here am I talking on, and it's your birthday! Oh, I am sorry, Mrs Constant. I had no idea – just talking on. You know me –

(*Exeunt MRS CONSTANT and MRS SLIFER to kitchen.*)

CARYL: Time lag – one hour!

(*Pause.*)

Phew! It's so hot already. I don't know whether it's better to have the windows open or shut.

SAM: Caryl.

CARYL: Mmm?

SAM: Who's Ward?

CARYL: Ward?

SAM: Yes. Who does Arnie know called Ward?

CARYL: (*Crossing to him. He is still at the phone table with the book.*) Ward… Ward… Of course – Ward Perry. Well, anyway, I should think so. Why?

SAM: Well, it's rather odd – I suppose – but written on the fly-leaf here it says 'To Arnie – with love from Ward'.

CARYL: Let's see that. (*Taking book.*) 'With love from Ward'. Oh, it can't be. Ward Perry wouldn't write – Walt Whitman. 'Leaves of Grass'. To Arnie. To Don. To Arnie. To Don.

SAM: What on earth are you talking about?

CARYL: I don't get that, Sam. I just don't get it. And, furthermore – neither do I like it.

SAM: Like what? What's this got to do with Don?

CARYL: Listen, Sam: upstairs, packed away in one of Don's trunks is a book. A book exactly like this one. Exactly. Same cover, same title, same inscription – except for one thing. It's signed 'To Don – with love from Ward'. Don't you see? To Don!

(*A shadow of a man falls across the mesh door which is pushed open wide, and in walks the REV MERRICK. He is tall and thin, with a voice to match. His manner is insinuating, and slightly impudent. A vigorous sixty. He has a nervous habit of tapping and rubbing the bridge of his nose – his sinus.*)

(*Still to SAM.*) Now do you understand why I don't like it?

MERRICK: What's this now? What's this, eh? On such a day as this there shouldn't be a thing for you to dislike. Come now, should there, Mrs Kessler?

CARYL: (*Turning without pause.*) Why no, Mr Merrick, no of course not. I'll tell Mother you're here.

(*Crossing to kitchen – Exit CARYL.*)

MERRICK: Well now, young man – how's the world treating you?

SAM: Fine, just fine, sir. Thank you. (*Holding book behind him.*)

MERRICK: Your wife gets prettier every day. (*Eyeing CARYL up and down as she exits to the kitchen.*) Yes – prettier every day.

MRS CONSTANT: (*In from the kitchen.*) Why, Mr Merrick. How kind of you to call. I told Caryl only this morning – do remind me, Caryl, I said, to give the Reverend Merrick a call – and here you are.

(*CARYL in from kitchen.*)

MERRICK: I called primarily to let you know that I thought of dropping over to see Sarah's sister. Old Jessup at the drugstore tells me she's in a bad way. She's got some kind of fever, and the doctor don't know what it is.

MRS CONSTANT: Oh, I *am* sorry! I had no idea it was as bad as that – really. Oh, Caryl – do you think we could drop off there for a minute on the way to Silver Lee? I could take her some preserves or something.

CARYL: Of course, Mother. Just as you wish.

MERRICK: Going to Silver Lee, eh? Get some good fishing there, I believe. 'Course, don't know what it's like now but remember when I was a boy used to ride over on a horse. Now it's machines, machines. No longer God's animals, God's country – or, even in some places, God's people, eh, Mrs Constant? God's people.

MRS SLIFER: (*From kitchen door.*) Psst!

MRS CONSTANT: Oh, come in, Mrs Slifer. I'm so sorry.
(*She comes in and curtsies shyly to MERRICK.*)

MRS SLIFER: Good morning, sir.

MERRICK: 'Morning. Ain't seen you at the meetings lately. How's that?

MRS SLIFER: Well – well, it isn't that I don't want to come, but, well, I guess you know how it is when you got to keep house, and look after kids.

MERRICK: Do indeed, my good woman. Do indeed. See you Sunday, I hope. Got a special meeting – something the whole town, should hear about. I know *you'll* be there, Mrs C. Yes, I know you'll be there.

MRS CONSTANT: Of course.

MRS SLIFER: I've got to go now. If you'll excuse me. I just came in, you see, sir, because I have this letter from Paul. Mrs Constant is so good and kind to me, and she reads it for me.

MERRICK: How's that boy doing, Mrs Slifer? Quite intelligent, far as I can recall.

MRS SLIFER: Oh, he is, sir. He is. Big man in Washington. I should like to go to Washington some day. They say that's a marvellous place. Do you know Washington, sir?

MERRICK: Can't say as I do. Can't say as I want to. Langley Springs occupies half my mind. God occupies the other half.

MRS SLIFER: Yes; yes. I expect so. Thank you, Mrs Constant. You are so kind, very kind. I'll tell Paul when I see him. Goodbye, Caryl. I won't forget. I'll tell Paul, see if I don't. (*Crossing to front door.*) You give her a good day today, eh? You know what we all do when my Paul come home? You know what we do? We all go out and get blind drunk, eh? (*Exit MRS SLIFER.*)

MRS CONSTANT: Oh, Mr Merrick, you must be quite hot – can I offer you a glass of lemon or orange?

MERRICK: That would be nice. Yes, indeed. That would be nice.

MRS CONSTANT: (*To kitchen.*) Good. (*Exit to kitchen.*)

MERRICK: You know, Mrs Kessler, didn't like to say it in front of your mother, but I feel I ought to tell you what the meeting's about tomorrow. Now we all know – the whole town knows – with sorrow– that tomorrow is the anniversary of your brother's death. God rest his soul. But I won't deny that it was not without a little coincidence that I decided to talk about those boys out there in Korea – in view of that which I read in the morning newspaper. And I shall say – without any hesitation – that some of these men that are returning are an insult to your brother, and those who died with him.

SAM: I don't think I understand.

MERRICK: Reds, son. Reds. Now do you understand?

SAM: Yes, I guessed that was what you meant, but –

MERRICK: Be there tomorrow, son. You won't need to guess. This ain't no parlour game. It's fact. That's what it is – fact!

MRS CONSTANT: (*In from kitchen.*) Here you are, Mr Merrick. I hope you'll find it refreshing. (*Handing him glass.*)

MERRICK: Thank you, Mrs C. Thank you. (*He quaffs it in one swallow and hands back the glass immediately.*) Guess I'll be on my way. Got other things to do before I get to Sarah's sister. Don't forget what I said, Mrs Kessler. And you, son. (*Crossing to front door.*) Have a good trip, Mrs Constant. Silver Lee's the place to be this weather. Yes, sir, that's the place to be. (*Exits.*)

MRS CONSTANT: What wasn't a parlour game, Caryl? What did he mean when he said it wasn't a parlour game?

CARYL: Well – as you know, Mom, tomorrow's the anniversary of Don's death, and Mr Merrick thought it might be a good idea to mention it at the meeting.

MRS CONSTANT: Isn't that thoughtful? That's really nice. Oh! The eggs! You know I put the eggs on to hard boil ages ago! Heaven knows what they'll be like! (*Exit to kitchen.*)

SAM: Look Caryl – I'm all mixed up about all this business about Don and this book.

CARYL: Yes – that book. Where is it?

SAM: I don't know. I guess I left it over there somewhere. (*Pointing to telephone table.*)

CARYL: (*Crossing to it.*) There's more in this than meets the eye, Sam, and we've got to do something about it – and quick.

SAM: Who is this Ward Perry? (*Following her.*)

CARYL: (*Finding book on chair by phone table.*) Ah, here it is. Ward Perry is now chief Librarian of the Town Library – was High School Librarian when Don was there, and since then I don't know what happened to him, until he came back to the town library, when it opened last year – remember?

SAM: Yes, I remember.

CARYL: Can't you see, Sam? What sort of a person Ward Perry is? Can't you see why he was mixed up with Don in High School days? And now why he's getting mixed up with Arnie?

SAM: Don? You mean Don was mixed up – that's nonsense Caryl, you're out of your mind to say such a thing!

CARYL: It's no good, Sam, I've got to say this, and you've got to believe me –
(*ARNIE comes down the stairs.*
CARYL stops him and shows him the book.)
Is this yours?

ARNIE: Why yes – it is. Thanks. (*He puts out his hand to take it but –*)
(*CARYL opens the book to fly-leaf and shows it to him.*)

CARYL: Signed and sealed!

ARNIE: I don't know what you're talking about. Let's have the book, Sis.

SAM: Aw, come on, Caryl! Let him have it.

CARYL: I'll let him have it all right. How long have you known this Mr Perry?

ARNIE: Known him? A long time – why?

CARYL: And how well do you know him? Pretty well, I guess – from this. (*Indicating inscription.*)

ARNIE: Let me pass, Caryl. I've got to get the fishing tackle out.

CARYL: You know what I'm getting at – first Don, now you.

SAM: Caryl!

CARYL: It's true. I've know for years what Don was, and all the other nice things that little boys are made of.
(*ARNIE sits on the stairs, head in hands.*)
For two years now, every time I've come here I've seen that – that – shrine (*Pointing to the corner.*) and known what a sham it all was. An utter, utter sham.

SAM: Caryl, listen! Keep your voice down.

CARYL: Keep it down! Keep it down like I've kept everything else down all this time. The time has come when I can't keep it down any longer. When I feel I just can't get to the washroom in time – when someone else has got to clean up the mess that Don made.
(*MRS CONSTANT enters from the kitchen and stands looking across at them.*)

SAM: Caryl, control yourself!

MRS CONSTANT: (*Very quietly.*) The eggs were burned; the shells were burned black. Caryl, what was that you were saying about Don?
(*ARNIE rises and – goes upstairs.*)

CARYL: Never mind.

MRS CONSTANT: (*Moving in.*) I want to know, Caryl. I want to know what was the mess Don made.

CARYL: All right. You heard me talk about Don, and the mess he always left behind him. And wherever he went, there it was. Something that was always inside of Don, just waiting for him to tickle his throat in that clever talk way of his, and spew up his rotten, putrefying attitudes!

SAM: For God's sake, will you shut up!

CARYL: Whatever was clean and decent and innocent was just waiting to be messed up for good by Don. Whatever was sacred and good, he was against it. Don, with his smart-alec ideas… Why the hell he ever went to Korea, I shall never know. That boy was fighting on the wrong side, you bet. It was American boys he should have been killing – not his precious Red pals!

SAM: So he was a windbag! Will you shut up!

CARYL: No, Sam, I will not! Why should Mom or anyone else be allowed to go around with their eyes shut to every

rotten, dirty thing that's going on in this world we've found ourselves in. In this mess, that people like Don have got us into!… Like I said to you, this war is still on all right. And it isn't just a shooting war! How Don would have laughed at me now! How he'd have made everyone laugh! What a fool he'd have made me look! He could do that. You were so right about him being clever, Mom. He was clever – and some more! Poor Mom, you don't understand, do you? You really don't. But didn't it ever strike you that the really respectable people in town weren't too crazy to take Don to their hearts? Blonde, beautiful Don, Don the reformer, Don, the Laughing Cavalier of Free-thinking and Atheism; Don the smarty talk, the poet. The *poet*! (*Her voice rises shrilly.*) Don the Big Mouth. That's what they called him in High School. Did you know that, Mom, did you know that? Don, the Big Mouth!

(*SAM grabs her roughly.*)

SAM: If you don't shut your mouth, by God, I will!
Pause.

MRS CONSTANT: Leave her alone, Sam. Don never hurt anyone. No one. (*Quietly.*) He never hurt me. Only in one thing. That was religion. He turned his back on it, I know. There was nothing I could do about it. When he was young, I begged him to be confirmed, but – no – he wouldn't. I cried all one night over it. About all those other things, I don't know. I don't think I understand what you mean, Caryl. Politics aren't important. Not like that. He was young, and he wanted to do things for people. He was a good boy. There was great love in his heart. Everyone loved him for it. I know that. I just don't understand.

(*A shadow appears on the mesh door. The doorbell rings. Nobody moves.*
It rings again.
SAM goes, takes a telegram from messenger boy. He gives the boy a coin, and closes the door. He looks at the envelope.)

SAM: It just says – Constant.

CARYL: Open it, Sam.

(*SAM does so.*
Pause.)

SAM: Don is alive.

(*MRS CONSTANT gives a sharp sob and remains still.*)

It says – that they are pleased to inform you that Don was a prisoner of war and will be returning to the USA shortly, await further confirmation.

(*Quick Curtain.*
End of Act One.)

Act Two

SCENE 1

(*A few days later. Midday.*

A mop is leaning against the banister of the stairs.

At rise of curtain MRS CONSTANT, wearing overall, is speaking on the telephone. A duster is in her hand.)

MRS CONSTANT: (*On phone.*) No, I don't know yet. They said they'd let me know when… You're very kind… Oh, yes. Yes. Very thrilled. You can imagine… I really haven't had much time to think about it, you know. My routine is completely shattered… What's that?… We'd love to very much. Yes… On the same plane? Yes, that would be a coincidence – I suppose…
(*MRS SLIFER comes in from the kitchen L bearing a small tray on which is a cup of coffee and a sandwich, which she places on the phone table for MRS CONSTANT and MRS SLIFER goes back to the kitchen.*)
No, I'm afraid I didn't – I heard all about it though… Yes, do please, any time. Thanks for calling me… Yes. Goodbye. (*She replaces the receiver very slowly and starts sipping her coffee.*)

MRS SLIFER: (*Entering with cup of coffee.*) Goodness! How that woman can talk. (*Crossing to MRS CONSTANT.*) When she was on the Inter-Faith Council she never stops. Always how good her garden was, how grand her house was, how she buys new carpet for the floor which match the furniture and drapes. Why, Mrs Constant, you not eating? Come on, now. You got to keep yourself looking good for Don. He won't want –

MRS CONSTANT: Not just now, Mrs Slifer – not just now. We really ought to get that room finished. It's taken such a time to get all his books out and set them back on the shelves.

MRS SLIFER: I never seen so many books. I thought my Paul had books – but your Don! And how Paul love his books.

Last time he comes home, he puts his hands over them so gentle. 'They're like old friends, Momma,' he says. 'Like old friends.'

(*MRS CONSTANT picks up the tray from the table and crosses to the kitchen as the phone rings.*)

I'll take it.

MRS CONSTANT: Please.

(*MRS CONSTANT exits kitchen.*)

MRS SLIFER: (*Answering phone.*) Constant's residence…what?… I don't understand… Hullo… (*Replacing receiver as –*)

(*MRS CONSTANT re-enters.*)

They hung up.

MRS CONSTANT: Who was it, Mrs Slifer?

MRS SLIFER: I don't know – it's very funny, Mrs Constant. Maybe I am not very bright, or I don't hear good. But it's very funny. All they say is 'Why don't you paint your front door a dirty red?' What's that they mean, Mrs Constant?

MRS CONSTANT: I don't know, Mrs Slifer. (*To settee.*) I don't know. (*Sits and cries very quietly.*)

MRS SLIFER: (*To her.*) Now, you mustn't cry, honey. You've to brighten up now that your Don is alive and coming home right here, to you. Like my Paul. He says on the telephone to me only yesterday, very serious – just like my Paul – 'I may be home soon, Momma'. And I cry, I am so happy too – like you must be!

MRS CONSTANT: (*Recovering.*) Of course, yes, of course. It's been a great shock to me. Just when I was used to the idea that my son was dead. I loved him very much.

MRS SLIFER: Sure you love him. And now – everything's the same. Just like it was. There – you feel better now?

(*MRS CONSTANT nods.*)

Sure. When I feel nervy like that, I just take a good, deep breath, and say: Anna, you keep calm – real calm – and not take your strength away with silly nerves, eh?

MRS CONSTANT: Yes, calm. That's it. Quite, quite calm. Decide what has to be done. What is for the best. Just strong and calm.

MRS SLIFER: That's right, Mrs Constant. Now I'll go finish Don's room, while you get things fixed like you want. (*To stairs as –*)
(*Car sounds outside.*)
Sound like Mr Constant's back already.
(*Exit MRS SLIFER stairs.*
MRS CONSTANT remains on the settee. A shadow appears on the mesh door which opens slowly.
CARYL enters.)

CARYL: Hullo, Mom.

MRS CONSTANT: (*Going to her.*) Caryl! My dear.
(*They embrace.*)
I did wonder when you were coming over. When you left on Saturday –

CARYL: Look, Mom –

MRS CONSTANT: I know, dear. And please believe me, there's nothing more to say. I've done a good deal of thinking, Caryl, since then. We have always been such good friends, and we must always be friends. Nothing need ever come between us – least of all Don. He's coming back, Caryl. He's alive, and he's coming home. He's coming back to his family. Think what that boy has been through, what he has endured. (*Crossing to 'Don's Corner'.*) He fought with courage, Caryl. Whatever you may say about him – (*Their eyes meet. Then, pointing to the medal in its case.*) Do you think he won the Medal of Honour for nothing? Only a real man could win such an honour for his country. Why, his citation's right here – I've read it a hundred times. I know it by heart. I know that one August day, near Yeongdeungpo, Korea, Lieutenant Constant's platoon was assaulting a vital position called Hill Eighty Four. Suddenly, it hit a field of fire from a Red Machine gun. The important attack stopped cold. And I know that, alone, and armed only with a .45 calibre pistol, Lieutenant Constant jumped to his feet and rushed the gun. He despatched its five men crew, then re-loaded, and cleaned out another foxhole. Inspired by his daring, the platoon cleared and captured the hill.

(*Pause.*)

So you see, Caryl, whatever you may say – and I don't even pretend to understand all that you have said – we must, above all, live and let live.

CARYL: It's not what I say, Mom! It's what those people out there are going to say, and are saying already. At that meeting on Sunday –

MRS CONSTANT: I don't want to hear about it, Caryl – thank you –

CARYL: Sure, Don is just another man coming back from a prison camp. He's suffered and he's got a splendid record. If things were normal, everyone would feel very different about a captured soldier coming home. But things are brewing up all around us now. You can feel it everywhere, Mom. People are frightened. Oh, maybe there's no logical reason why anyone should pick on Don. People are nice in this town all right, but no one could accuse them of being capable of logic. If the security they have looks like being threatened, they'll act first and, if they think at all, they'll think way afterwards. Believe me, Mom, you couldn't bury your head in the sand at a worse time. For heaven's sake, don't let's play the ostrich now!

MRS CONSTANT: Please, Caryl, don't be rude. Don has come back to me. I have both my boys now, and I have you – at least, I hope I have.

CARYL: Both your boys?

(*Sound of car drawing up.*)

MRS CONSTANT: There's your father – Caryl, we're friends again, aren't we? We must be friends.

CARYL: Sure. Yes, of course we are, Mom.

(*MR CONSTANT enters at the front door.*)

MR CONSTANT: Hullo, dear. Why, hullo, Caryl. (*Takes off his hat.*) How are you?

CARYL: Just fine, Pop. You?

MR CONSTANT: Oh fine. Any news yet, Mom?

MRS CONSTANT: No, nothing yet, dear.

MR CONSTANT: Just heard they say the Allen boy's being flown back to the States on Thursday.

MRS CONSTANT: Why, Ted Allen! Oh, I'm so glad. His mother will be just wild. I must call her up. Remind me, will you dear?

MR CONSTANT: Maybe we'll hear soon.

CARYL: Red tape, I guess, Pop.

MR CONSTANT: Do they still have that kind?

MRS CONSTANT: I've been working on his room and it's almost ready. It wouldn't matter if he was to walk in right now. Scratch meal in the kitchen today, dear, if you don't mind.

MR CONSTANT: (*Going upstairs.*) Good. Just going up for a wash. Shan't be long.
(*Exit MR CONSTANT.*)

MRS CONSTANT: (*Calling.*) Was Arnie with you?
(*ARNIE enters through front door.*)

ARNIE: Calling for me, Mom?

MRS CONSTANT: Oh, hullo, dear. I just wondered if you came back with your father.

ARNIE: Sure. I've just been putting the car away. Hullo, Caryl.

CARYL: Hullo. Well, I'll have to go. Sam's coming home early today. He's taking me to the movies. He says people don't drop in the middle of it, and expect to be entertained, like they do with television. So much for my social life. (*Kisses MRS CONSTANT.*) 'Bye, Mom.

MRS CONSTANT: Goodbye, Caryl. Call me if the movie's good. I haven't been in ages. I might find time to go myself in the week.

CARYL: Can't see that.

MRS CONSTANT: Well, maybe not. Guess I'm too excited for the movies.

MR CONSTANT: (*Off.*) You going? Goodbye, my dear.
(*Exit CARYL through front door.*)

MRS CONSTANT: (*Going to ARNIE.*) Had a nice time, dear. (*Smoothing back his hair.*) My! But your hair is so soft. Like a girl's.

ARNIE: Shucks, Mom! Don't do that, please!

MRS CONSTANT: Well – there's no need to be temperamental about it.

ARNIE: Well, a feller doesn't like women mussing around with his hair.

MRS CONSTANT: No, dear – just as you say. Though I do remember when your father was young, and he and I – (*A shadow falls across the mesh door. It is the large outline of a man wearing a wide-brimmed hat.*

MRS CONSTANT sees it and her voice stops. A slight pause and the doorbell rings.)

See who that is, will you, dear?

(*ARNIE crosses to the front door and goes out on to the porch. A man's deep voice can be heard.*)

ARNIE: (*Calling back.*) It's for Pop!

MRS CONSTANT: (*Crossing to door.*) Well, who is it, dear? Your father's washing at the moment. Go up and tell him there's a gentleman to see him, will you?

(*ARNIE goes upstairs leaving the front door open and revealing a tall, bulky man. He is the INVESTIGATOR. About 45; he wears a light linen suit with a light grey, wide-brimmed hat and carries a brief case. His manner is shrewdly pleasant, hearty, and a good after-dinner speaker, one would imagine, although a tendency to laugh at the end of almost every other line tends to become overbearing.*)

Do come in, please. I'm afraid we're in rather a muddle.

(*The INVESTIGATOR follows MRS CONSTANT into the sitting room.*)

We're so busy these days, preparing for my son's arrival from Korea. Prisoner of War, you know. Do make yourself comfortable. Would you care for a cup of coffee while you're waiting? I'm sure my husband won't be very long. Excuse me, won't you?

(*Exit MRS CONSTANT to kitchen.*

The INVESTIGATOR sits in the settee for a moment, then he rises and he goes to 'Don's Corner' and picks up the photograph, looks at the cups, medal etc. He moves down to the bookcase and selects one or two with an apparently casual air. He flips through more books and his interest grows more intent. He nods his head as if he were making mental notes. He replaces books and walks up to the window C as –

*MRS CONSTANT comes in with coffee in the silver coffee pot
and cup and saucer on tray. She places them on the table
behind the settee and pours coffee. She has removed her
overall.)*

MRS CONSTANT: Oh, I'm afraid the garden is just burnt to
a cinder with this heat. And none of the family have a
great deal of time to attend to it. It's a shame, really. My
husband usually looks after it but business seems to have
taken up more and more of his time this year. And I have
my committees and a hundred other things to see to. Of
course things were very different when my daughter was
at home – that really was a great help. She's married now
to Sam Kessler. Oh – (*She laughs.*) I expect you know all
that – in this town I guess everyone knows everything
about everyone.

INVESTIGATOR: No, as a matter of fact, I'm a stranger here.

MRS CONSTANT: Really? Oh, is that so? Have you come far,
Mr – er –?

INVESTIGATOR: Washington, as a matter of fact.

MRS CONSTANT: Washington? Well now, isn't that nice? The
journey must have been terribly hot for you – oh! (*She
stops short.*) You mean to say you've come all the way from
Washington just to see my husband?

INVESTIGATOR: Could be, ma'am. Could be.

MRS CONSTANT: Oh – you're a friend of my husband's?

INVESTIGATOR: No – not really.

MRS CONSTANT: I see. Well, I think I'll see where he's got to.
(*Cross to staircase.*) Do help yourself to coffee, won't you?
(*Exit MRS CONSTANT.*

*The INVESTIGATOR goes to the bookcase again, takes out a
notebook and makes notes. Pensively he licks his pencil and sits
on the settee.*

*ARNIE enters from the stairs and goes out of the front door.
The INVESTIGATOR watches him as MRS CONSTANT comes
down.)*

My husband will be right down, Mr – Well, do you know, I
don't even know what your name is!

INVESTIGATOR: I take it that was your son who went out?

MRS CONSTANT: Oh, yes. My youngest – Arnie. Goes into the Army pretty soon. To tell you the truth, I don't think he's really looking forward to it.

INVESTIGATOR: He isn't. Not so bad, you know, once you're in. Makes a man of you, that's what I say. Yes, sir, the Army's a man's job. Strictly for men – don't you think so, Mrs Constant? Brains and brawn, that's the Army today.

MRS CONSTANT: Why, yes – how right you are. You could almost be talking of my Don. That's him in the picture there.

INVESTIGATOR: That so?

(*MR CONSTANT enters from the stairs.*)

MRS CONSTANT: Why, here's my husband at last. This is the gentleman, dear, who's been waiting to see you.

INVESTIGATOR: Good day to you, sir.

MR CONSTANT: Good day.

INVESTIGATOR: I don't think we need any formal introduction, Mr Constant. I believe this will be enough for the purpose in hand. (*He takes out a leather wallet and flaps it open, showing it to them both.*) If we could all sit down for a moment – I won't take up much of your valuable time, I assure you. (*Sits.*)

MR CONSTANT: I have a limited amount of time, I'm afraid, not having eaten yet, and have to return to my work in half an hour's time. I take it you've had your lunch?

INVESTIGATOR: Yes, sir. Never start on a job without food in the belly.

MR CONSTANT: Then perhaps you would like to relax by removing your hat?

(*To MRS CONSTANT.*)

Dear – do you mind?

INVESTIGATOR: Oh, sure – sure.

(*MRS CONSTANT takes his hat from him and places it on the table.*

The INVESTIGATOR mops his brow.)

Very pretty town you have here – not too closed in. (*Going to the window.*) Who's your neighbour?

MRS CONSTANT: Mrs Slifer. She lives with her two young boys.

INVESTIGATOR: Just called on her.

MRS CONSTANT: Why, she's just –

MR CONSTANT: Did you, indeed?

INVESTIGATOR: Polish, isn't she?

MRS CONSTANT: She did come from Poland – yes. Of course, it must be a long time –

INVESTIGATOR: 1921.

MRS CONSTANT: Is that so?

INVESTIGATOR: Yes. Born in Lublin, Poland, 1902. Entered the USA 1921, became United States citizen 1922.

MRS CONSTANT: As long ago as that –

INVESTIGATOR: Did you know that some seventy per cent of CP members are Curtain born?

MRS CONSTANT: CP members?

INVESTIGATOR: Now, you're a second, or third-generation American, I'd say, Mrs Constant. Good name that – Constant. What is it?

MR CONSTANT: I would say that you have already checked on that. Haven't you?

INVESTIGATOR: (*Laughing.*) You're right there, Mr Constant. You're on to me right away – I can see that. I like a man who stands up for himself, who isn't afraid to look the world straight in the eyes. I meet all kinds. You see, I'm just a plain, ordinary guy, trying to do a job – a job that isn't easy. Trying to keep this great country of ours the way it is, that's all. I'd like you to understand that about me.

MR CONSTANT: Of course.

INVESTIGATOR: There's a good deal too much hollering going on these days. Too many smarty heads and big mouths squealing about being pushed around. Believe me, it's only one kind of people that gets pushed around. Mine's no easy job, and, before we get down to the business in hand, I'd really like you to know about me. Now, maybe you think I'm a bogeyman, you read about, nosing his way into your home. Let's get this straight: I am not that. I am not. Some people would like to have you believe that. Too

many people, I'm sorry to say. Cigarette? Mind if I do? (*Lights one.*) My biggest hate in this world of ours is being pushed around. And, what's more, seeing the other guy pushed around. I was in the Marines in the war – the last war I mean – and I seen enough then, take it from me, to have my belly-full of seeing ordinary men and women pushed around.

MR CONSTANT: Just what exactly is your business with me? I'm afraid this doesn't –

INVESTIGATOR: I'm just coming to that, Mr Constant, sir. Just coming to that. But I like to make myself clear right from the start. (*Coming down.*) Guess this shouldn't take long. Not if I get your co-operation, that is. Fine lot of books you got there. (*Picks one out.*) Dickens. We got this very same set at home. Never did get on with him. (*Replacing it.*) Mark Twain… Emerson… Never the Twain shall meet. (*Laughs.*)

MR CONSTANT: I guess you didn't come here to discuss literature, Mr – er –

INVESTIGATOR: On the contrary, Mr Constant. Part of my job is to be interested in books. Particularly other people's books.

MRS CONSTANT: (*Trying desperately to be pleasant.*) Well, that's interesting. There's a whole lot more books upstairs. In my son's room. Four walls covered with them.

INVESTIGATOR: That'd be the boy who went out just now?

MRS CONSTANT: No, my son Don. I was telling you about.

INVESTIGATOR: Oh, yes. When did you last hear from your son, Mrs Constant?

MRS CONSTANT: More than two years ago. Then, last Saturday, we received a telegram from the War Department, saying he wasn't dead at all but he was a prisoner of war, and would be repatriated as soon as ever it was possible.

INVESTIGATOR: That was certainly a wonderful piece of news for you, Mrs Constant.

MRS CONSTANT: I still can't get over it. You see, it was like some miracle happening. It's just –

MR CONSTANT: I'm pretty sure the gentleman already knows all the details about Don coming back, my dear. Looks like he knows a whole lot more than we do.

INVESTIGATOR: We'll see about that. Mr Constant – Mrs Constant: I'm afraid I have very grave news to break to you. It isn't any easier for me, seeing what nice, decent folks you are. I have been sent here to tell you that your son, Don –

MRS CONSTANT: What's happened to him? Something's happened to him!

INVESTIGATOR: I guess something's happened to him all right. He isn't dead, if that's what you mean. But, as far as we're concerned, he might as well be.

MR CONSTANT: What are you trying to tell us? Why can't you come out into the open?

INVESTIGATOR: That's just what I'm going to do, Mr Constant, sir. I'm coming right out into the open. I tell you, it's going to be a pretty hard knock, but sometimes hard knocks can be a boost, and this should boost you, if you –

MR CONSTANT: For God's sake, man, what is it?

INVESTIGATOR: Mr Constant, it grieves me deeply to have to tell you that your son, Lieutenant Constant, has refused to be repatriated. He has stated categorically that he does not wish to return home.

MRS CONSTANT: I don't believe it: He wouldn't do such a thing. He couldn't.

INVESTIGATOR: Seems like he has. Official confirmation will be on the way.

(*Goes upstage.*)

It beats me. Yes, sir. A courageous American boy from a decent, God-fearing home. How could he come to do this? What goes on behind a thing like that? A terrible thing like that? What were the influences that brought him to this? Was it only the prison camp? A guy like that doesn't crack too easy. Where did it all start? Right out there. (*Pointing out of window. Then, coming back.*) Or maybe, here.

MR CONSTANT: That's nonsense.

INVESTIGATOR: Is it? (*Slapping the backs of some books on the shelves.*) What about that? And that? And that? It doesn't make it look too good for you, does it, Mr Constant? Or you, Mrs Constant?

MRS CONSTANT: I don't know what you mean. (*To MR CONSTANT.*) Do you know?

INVESTIGATOR: Did you know that your son belonged in 1948–9 to a student organisation, known as the Young Men's Progressive League? Which is a successor to American Youth Advance, which, in turn, is a continuation of the Young Communist League? Did you know that?

MR CONSTANT: He was only a kid –

INVESTIGATOR: But you knew it!

MR CONSTANT: Not about all those organisations, or whatever they are –

INVESTIGATOR: I have here with me – (*Taking a newspaper from his briefcase.*) a copy of the *Daily Worker* of August 7th 1949, which carries, here on page four, a news item regarding an open letter to the President of the United States, released by the American Society for the Defence of the Rights of the Foreign Born, signed by a number of persons who declare their concern over the announcement by the Department of Justice that it would seek denaturalisation of a number of American Citizens. Among the names appearing in the article as having signed this open letter are: Oscar Vinson, Frederick Liebermann, Ted Allen, Paul Slifer and Donald Constant. Did you know that?

MR CONSTANT: I seem to remember Don showed me something of the kind – the open letter, I mean. I don't know about the newspaper report. But then I don't read that particular paper.

INVESTIGATOR: Right. But you know it now. I don't have to tell a man like you the implications of all this. Now, are you willing to co-operate with me in giving me any information which you may possess regarding the subject of this enquiry?

MR CONSTANT: What kind of a question is that?

INVESTIGATOR: A very plain and simple one.

MR CONSTANT: I see nothing plain and simple about it. It seems to me that a great deal is at stake.

INVESTIGATOR: Sure there's a great deal at stake. I'll have you know my own boy was killed in Korea.

MR CONSTANT: You have my deepest sympathy.

INVESTIGATOR: That boy died in an endeavour to save something from the wreckage of peace, peace in *his* language – not in the language of the Commies. Winston Churchill said: 'I would rather die on my feet than live on my knees.' And that is what the American people are saying today, Mr. Constant.

MR CONSTANT: I don't believe I could add anything to that. I can only say that I try to be a good American in my daily life, and in my work, and I have always hoped that my family were the same. I believe that they are – I know my wife is. And if I knew of anyone committing treason against this country, I would get down to the FBI as quickly as I could. As for my son – I maintain that there has been some mistake somewhere – somewhere along the line, the points have been switched…

INVESTIGATOR: Do you know a Mr Ben Kenney?

MR CONSTANT: No.

INVESTIGATOR: Robert Becker?

MR CONSTANT: No.

INVESTIGATOR: Gordon Lester?

MR CONSTANT: No.

INVESTIGATOR: Ward Perry?

MR CONSTANT: I – I believe my son knew him.

INVESTIGATOR: They were friends. Good friends?

MRS CONSTANT: They were very good friends. Mr Perry used always be asking Don to –

INVESTIGATOR: To dances? To go on dates with girls?

MRS CONSTANT: Why – no. Not really. They seemed much too busy –

INVESTIGATOR: Doing other things?

MRS CONSTANT: I don't understand.

INVESTIGATOR: Don't you?

MR CONSTANT: Just what are you implying?

INVESTIGATOR: (*With deliberation.*) You know *just* what I
 mean, Mr Constant – they go together: Communists and –
MRS CONSTANT: Stop it! Stop it, I tell you! (*In tears.*)
MR CONSTANT: Who are you to come into my house like this,
 and pry into our lives? We have quite enough unhappiness
 already – you can't go on smearing my son. Enough
 damage has been done, without people like you making
 things worse.
INVESTIGATOR: I'm very sorry, ma'am, to have caused you all
 this distress. Please believe me when I say sincerely that all
 this business grieves me very deeply, very deeply indeed.
 But it seems to me to be your duty to be unselfish in this
 matter and co-operate with me in every way you can. We
 have to protect ourselves, and we have to protect the next
 generation. (*He looks at his watch.*) I have a pretty heavy
 schedule to make up.
MR CONSTANT: I can imagine.
INVESTIGATOR: May I impose myself just a little while
 longer – one last request before I leave?
MR CONSTANT: Well?
INVESTIGATOR: I should very much like to take a look at
 Lieutenant Constant's room.
MR CONSTANT: And if I refuse?
INVESTIGATOR: Then you are refusing to look at the facts in
 the face, Mr Constant. It could mean you being subpoenaed
 to appear before the Committee on Un-American
 Activities. And you don't want that. Am I right?
MR CONSTANT: Very well – go ahead, if you wish.
MRS CONSTANT: No! Why should he – why should he!
MR CONSTANT: Please, dear, don't make things difficult. (*To
 INVESTIGATOR.*) Third door at the top of the stairs, to your
 left.
INVESTIGATOR: Thank you. (*Crossing to the stairs.*) I'll be as
 quick as I can. (*Pausing.*) Don't think I enjoy this.
 (*Enter MRS SLIFER at the stairs.*)
MRS SLIFER: Well, it is finished. It don't matter now if Don
 was to walk in right at this minute, you wouldn't have to
 worry one bit – it's all fixed up good, just like it was before

he went. (*Seeing the INVESTIGATOR.*) Oh, excuse me, I am sorry! I was just fixing up Don's room for him coming back.

INVESTIGATOR: That's all right, ma'am. My business with Mr Constant is just about finished for the present. Excuse me. (*MRS SLIFER stares at him as he passes her on the stairs and – Exit INVESTIGATOR.*)

MRS SLIFER: My! He's a fine man, ain't he? Now, I'll bet he's somebody. He's somebody big, you can see that. He a friend of yours, Mr Constant? (*Into sitting room.*)

MR CONSTANT: No, Mrs Slifer.

MRS SLIFER: Ah, he's a big man. You can see that. He's a stranger, ain't he?

MR CONSTANT: He is.

MRS SLIFER: I knew that. Ain't no one round here keeps an automobile like that. (*Crossing to kitchen.*) I must put away this mop of yours, and get back to my kids. They'll be burning the kitchen down if they don't get lunch soon. Where did you say he comes from?

MR CONSTANT: Washington.

(*Exit MRS SLIFER.*)

MRS CONSTANT: What are you going to do?

MR CONSTANT: I'm afraid I don't know. Do you?

MRS SLIFER: (*Re-entering.*) Washington! Well! Now that is how Paul will be one day. You see. (*Crossing to the front door.*) A fine man, driving into town in a big automobile. Just like that one out there. All the way in from Washington.

MRS CONSTANT: Thank you for helping out, Mrs Slifer.

MRS SLIFER: (*At front door.*) It's nothing. Your boy comes home so we got to give him a big welcome. Maybe we'll have lots of beer and everything. Oh, we'll have a time all right. 'Bye, now! And don't you get worrying, either of you – you'll hear some news about Don real soon. You see. My! That's some car!

(*Exit MRS SLIFER.*)

MRS CONSTANT: What's he doing up there? Why should he want to root around Don's things? Why did you let him go up there? He's got no right.

MR CONSTANT: You heard what he said, my dear. I've no wish to appear before any Committee.

MRS CONSTANT: What does it matter? You've done nothing wrong. You've nothing to hide.

MR CONSTANT: That's not the point. Why, if I were to be summoned to testify, I'd lose my job before I'd ever got there and opened my mouth.

MRS CONSTANT: Lose your job!

MR CONSTANT: That's the way it goes. It happens all the time. They fire you first – just to make sure.

MRS CONSTANT: But – that's crazy!

MR CONSTANT: It doesn't seem to make much sense, certainly. But, you see, it's this way: they don't have to prove your guilt – you have to prove your innocence.

MRS CONSTANT: I just can't believe it – any of it.

MR CONSTANT: It's like the old question: 'Have you stopped beating your wife?' It doesn't matter if you answer yes or no. You're licked either way. And I've a feeling we're licked.

MRS CONSTANT: But what did he mean about a subpoena? Surely, they couldn't force you to go?

MR CONSTANT: If I were to refuse I could be fined for contempt. Or jailed.

MRS CONSTANT: Jailed! But – but your job! I just don't know where I am. I'm all confused and mixed up. Everything is happening at once. What is happening to us, for heaven's sake?

MR CONSTANT: You ask me, my dear? I've been asking myself that question for too long to have any idea of the answer. (*The INVESTIGATOR appears at the top of the stairs. He descends, carrying a yellow covered book, identical to the one of ARNIE's, used in Act I, together with a few others.*)

INVESTIGATOR: Well, I guess that winds up my little visit just now. The more people co-operate, the better it is. (*In to sitting room for his brief-case.*) No use pretending you've liked having me here. But it's been pretty painful for me, too. I'd like you to know that. Pretty painful.

MRS CONSTANT: Is that my son's property you have there?

INVESTIGATOR: I'd just like to take these with me, if you don't mind, ma'am.

MRS CONSTANT: But what do you –

MR CONSTANT: I'll see you to the door. I guess you must be a pretty busy man these days.

INVESTIGATOR: Goodbye, Mrs Constant. And may I say you have my heartfelt sympathy? (*Crossing with MR CONSTANT.*) I haven't even got a hotel room booked yet. Can you recommend me a good place?

MR CONSTANT: I wonder if it would be a good thing for me to recommend one to you – for them, I mean? But I reckon you'll find yourself made welcome in any one of them. (*The INVESTIGATOR stands in the open doorway and stares at him hard for a moment.*)

INVESTIGATOR: You feel they'll put out the red carpet for me, huh? (*He explodes with laughter.*) Forgive me – I'm forgetting how you must be feeling. Yes, this seems a nice enough little town. You seem like a nice couple. I feel that somehow. Can't see either of you trying to do harm to anyone, I know, vicious people when I see them. Hope I'm right. Goodbye, Mr Constant.
(*Exit INVESTIGATOR*
MR CONSTANT watches him go and sees his car drive off, then returns to the sitting room.)

MR CONSTANT: Are you all right, my dear?

MRS CONSTANT: Could it really be that Don's refused to come back? Do you think that's really true? That he doesn't want any part of us? Why should he do that? What's happened to everybody? People weren't like this when we were young. (*She is crying.*) Oh, Don. What have we done wrong?

MR CONSTANT: We can't undo it now.

MRS CONSTANT: What's got into all these young people? How can they be so cruel?

MR CONSTANT: Maybe you'd better go lie down? You look done up. Why don't you go up to your room, hm?

MRS CONSTANT: No – I – why, goodness, you'll be wanting your lunch.

MR CONSTANT: It's all right,. I've no time now, anyway. I must be going. I'll get a sandwich later.

(*He goes to the hall and collects his hat. She follows him.*)

MRS CONSTANT: I don't know where I am. What I'm going to do? Why did this have to happen? I'm not even sure what has happened. Why didn't he – (*She buries her head on his shoulder.*)

MR CONSTANT: Now… (*Putting his hands on her shoulders.*) I wish I could help you, my dear. But, you see, I have always left everything to you. You have always been so strong, so very strong indeed. You have never needed what strength I may have had. I don't know that I can help you now. Try and get some rest.

(*Exit MR CONSTANT.*

MRS CONSTANT goes back to the sitting room, moving slowly towards 'Don's Corner'.

ARNIE enters through the front door.)

ARNIE: Hi, Mom! Water sure was good! Gosh, I'm going to be late! (*Bounding upstairs.*) Who was that man, Mom? He had a car a mile long. Did you see it?

(*Exit ARNIE upstairs.*

MRS CONSTANT takes down DON's photograph.

In doing so, she knocks down one of the silver cups. She stares down at it, then goes to the settee and sits, clutching the photograph.

ARNIE re-appears and dashes down the stairs.)

Hell! I'm going to miss that meeting! (*He stops and looks at her.*) Mom? Are you all right?

MRS CONSTANT: I'm all right, dear.

ARNIE: You don't look so good, Mom? There's nothing wrong, is there?

MRS CONSTANT: Come here, will you, dear?

(*He goes over to her.*)

ARNIE: What is it, Mom?

MRS CONSTANT: (*taking his hand, she puts it up against her cheek for a moment.*) Oh, Arnie –

ARNIE: Mom – are you sure there's nothing wrong?

MRS CONSTANT: I hope not. Oh, I hope not.

ARNIE: If it's Don you're worried about, you can forget it. If he's alive like they say, there's nothing going to stop him getting back to you. You can bet your life on that. Look, Mom, I really do have to go now, otherwise I'd stick around with you a bit. Why don't you get some rest. You look so tired – you've worn yourself out on that room. Now if you don't put up your feet a while, I'll tell Don – and will he be mad! Gosh! I must hurry! 'Bye, now! (*Kisses her.*) Remember what I said now! (*Crossing to front door.*)

MRS CONSTANT: Goodbye, dear. Don't be too late back.

ARNIE: Sure. (*Stopping.*) Oh, Mom – have you seen my book. I left it round somewhere. Now I can't find it.

MRS CONSTANT: What book dear?

ARNIE: A thick book – with a yellow cover.

MRS CONSTANT: A yellow cover – why that was Don's book. That man took it away.

ARNIE: Took it away? What for?

MRS CONSTANT: Oh, I don't know, dear – some reason or other. Arnie – you're not letting this Ward Perry take up too much of your time, are you?

ARNIE: I don't know what you mean Mom. I think he's a nice guy and I like him a lot. You're getting as bad as Caryl – putting me in dock.

MRS CONSTANT: I'm sorry, son, it's just that I do so want to be proud of you. I – I don't want you to betray your mother. You know I want you to grow up into a clean-living, clean-thinking man with no thought of –

ARNIE: No thought of what? If you mean all this business about Ward being a Communist – well – that's just nonsense. Sure he is – but he doesn't go around with a hammer and sickle does he? I suppose you think he sends secret messages to the Kremlin in the dead of night and plans to blow up the White House and all that sort of thing.

MRS CONSTANT: I just want you to be careful what you say and do, that's all.

ARNIE: What I say, and do? Heavens, it's a free country isn't it? Ward says most people go through a state of Communism at some time or other; Ward says it's like

most other things you go through, you either pick 'em up on the way and keep 'em or leave 'em be – it's up to you.

MRS CONSTANT: Ward says – Ward says. Oh, Arnie, you mustn't believe everything everyone says to you.

ARNIE: I don't Mom… But if I don't hear all sides to the question, how can I decide which to accept and which to reject?

MRS CONSTANT: I think you're much too young to bother your head with politics, Arnie. You'll only get all mixed up inside and you won't know where you are at all.

ARNIE: Gee – I don't agree with everything Ward says, a lot of it is sheer punk, sure it is. He says it's right and I say it's punk. No one's going to ram the red flag down my throat – or any other coloured flag, come to that.

MRS CONSTANT: It wasn't that so much, Arnie, but – these people, they don't believe in God.

ARNIE: Gee Mom – you think that I should tag along with some of these revivalists blowing a golden horn? That's alright for people who like that sort of thing. OK that's their business. You think I need God on my side, is that it?

MRS CONSTANT: Arnie – please. I've never heard you talk like this before – that's blasphemy.

ARNIE: No it isn't Mom. Of course I believe in God but I'm pretty sure He didn't intend that He should do all the thinking for us – He surely gave us brains to think for ourselves and – well – I guess that's what I'm doing.

MRS CONSTANT: Yes, I know Arnie, that's all very well, but you're so young. Why at your age anyone could just wind you round their little finger with their ideas and beliefs.

ARNIE: No-one is winding me round anything, Mom, let alone Ward Perry, because I guess that's what you're implying.

MRS CONSTANT: How can you possibly say that when you don't even know the difference between right and wrong?

ARNIE: My conscience will show me the difference between right and wrong, Mom. Listen, you don't seem to even want to understand – I'm old enough to handle a gun, aren't I? – I'm old enough to be drafted, to drop atom bombs if necessary – and I would too, if it meant folks

could go on thinking and believing what they like, so long as they don't do any trespassing.

MRS CONSTANT: Well, that's quite a speech – for you… I had no idea. Nevertheless, I think you're making a great mistake in going round with – certain people.

ARNIE: If I am making a mistake – then I willingly pay for it. You people are always so ready to jump to conclusions. I don't know *why* you've got this idea about me and Communism. If you really want to know what I think about Communism, I'll tell you – I think Communism is like sex – its virtues and its dangers are vastly over-rated.

MRS CONSTANT: I'm sure I don't know what you mean by that –

ARNIE: Gee – you women. You always worry over nothing.

MRS CONSTANT: Nothing can very often be something, Arnie.

ARNIE: Well, I'm too old for these lectures, Mom. I have to go now. If anyone calls for me while I'm away tell them I'm down at the Students' Union, will you? (*Crossing hallway and turning.*) Sorry, Mom.

(*Exit ARNIE.*

MRS CONSTANT stares after him. Then she rises and searches the bookcase. The 'phone rings and she goes to answer it.)

MRS CONSTANT: (*On phone.*) Yes? Yes, this is the Constant's residence. (*She sees the yellow book on the chair by the table and picks it up. She opens it.*) Who is that. Oh. No, I'm afraid Arnie isn't here right now. No, I don't, not till tonight I don't suppose. Could I give him a message? I see – very well Mr Perry. Yes – oh – by the way Mr Perry – I wonder if you would be good enough to call on me some time very soon. It's very important – no, I'm afraid I can't discuss it on the telephone. Yes. Yes, that would be fine… I'll be expecting you. Goodbye Mr Perry. Goodbye.

(*She replaces the receiver slowly, still staring at the fly-leaf of the yellow book.*

Quick Curtain.

End of Scene 1.)

SCENE 2

(*Evening of the same day. At rise of curtain CARYL is seated on the settee, smoking a cigarette. MRS CONSTANT comes down the stairs. She is outwardly calm.*)

MRS CONSTANT: Ah, there you are, Caryl – I thought I heard you talking to your father.

CARYL: Hullo, dear. Are you all right, Mom? Yes, I was. Mom – I think you're doing the right thing.

MRS CONSTANT: I'm so glad you think so, dear. I need you now, Caryl. You see, your father doesn't agree with me. He suggested that he took this Perry man into his study and talked to him there. Imagine that – I know your father too well to have him deal with this on his own. I guess his study is aptly named 'the foxhole'. I know quite well what would happen. They'd have a Scotch, and a cigarette, and probably arrange to go fishing together. Oh, no. Isn't Sam with you?

CARYL: He's probably on his way over now. I left a note for him to drop over after he'd eaten.

MRS CONSTANT: Did you tell him what it was all about?

CARYL: I did. We've already been talking about it, before now – so it's no news to Sam.

MRS CONSTANT: Good. Well, I hope he shows up soon, anyway. I'm depending on him for a great deal of support.

CARYL: Is Arnie in on this?

MRS CONSTANT: Not at the moment – no. He went down to the Students' Union this afternoon, and hasn't come back yet.

CARYL: We're behind you, Mom. Believe that. Mom – I haven't said anything about Don – I just don't know what I can say to you. It seems too cruel. It'll take a bit of getting used to, I guess for all of us.
(*Sound of car drawing up.*)
That's Sam now, I expect.

MRS CONSTANT: Oh, good. Dear, reliable Sam.
(*CARYL goes out on to the porch and, after a moment, comes back with SAM.*)

SAM: Hullo, Mom.

MRS CONSTANT: Hullo, Sam dear. It was nice of you to come.

SAM: Not at all. (*Kisses her.*)

MRS CONSTANT: Caryl says you know what it's all about.

SAM: Well, not all. I guess you intend to warn off this Ward Perry. I don't know how you're going to go about it exactly. Why don't you let Pop handle it? Be much better than all of us just littering up the place.

CARYL: Mother wants to take charge. She's asked Pop, and he won't do it in the open. He wants a palsy-walsy chat in 'the foxhole'.

SAM: Well, I don't really see what I can do.

CARYL: Stick around, son. We need a man around to scare the pants off this guy.

SAM: Look here, Mom. Caryl's only just told me about Don. Why don't you call this whole thing off? I have a pretty good idea how you must be feeling. I'm dazed myself. It's a terrible thing that's happened, and I guess you're feeling pretty sick and bitter at this moment. You're in no state of mind for this kind of thing right now. Arnie's all right and, as for Don – well, maybe there's been some mistake –

MRS CONSTANT: There's no mistake. I know that now.

SAM: Well, even if it's true, maybe he'll change his mind or something. He's been a prisoner – remember –

CARYL: So were thousands of other boys, Sam. But they haven't all done this.

(*SAM looks at them both for a moment.*)

SAM: OK.

(*A pause.*

CARYL and MRS CONSTANT are seated. SAM goes up to the window.)

CARYL: What time is he coming?

MRS CONSTANT: He should have been here five minutes ago.

CARYL: He'll be late, I shouldn't wonder – quite deliberately.

(*Pause.*

SAM leans by the window. There is the sound of a freight train whistle.)

SAM: 'A heaventree of stars, hung with humid, nightblue fruit.'

CARYL: What's that?

SAM: Nothing. The wind is stifling.

(*MR CONSTANT comes out of his study and starts mounting the stairs.*)

MRS CONSTANT: (*To him.*) Are you really going to turn your back on all this?

MR CONSTANT: (*Turning on stairs.*) I'm not turning my back on anything. I'm fully aware of what is going on, but I still say it's not for you to handle it. It's my job. And unless I am allowed to do it my way. I will have absolutely no part in it.

(*As he starts going upstairs, the front door bell rings sharply. He stops for a moment and looks down at the group below. Then goes on his way.*
Exit MR CONSTANT.
The bell rings again.)

CARYL: Well? Don't let's just stand here. Who's going to answer the door?

MRS CONSTANT: I will, dear.

(*She crosses to the hallway, to admit WARD PERRY. He is about 34, slim, fair, neatly dressed in a dark suit, well-laundered white shirt and bow tie. He has an air of quiet dignity at all times.*)

MRS CONSTANT: Mr Perry? Come in, please.

PERRY: Thank you.

(*There is a pause while she leads him into the sitting room.*)

MRS CONSTANT: You probably know my daughter – and this is Mr Kessler, my son-in-law.

PERRY: How do you do?

SAM: Hullo, Mr Perry.

MRS CONSTANT: You were a little late. I began to think you weren't coming.

PERRY: Yes. I'm sorry.

SAM: Well – shall we sit down?

(*They do so in silence. Pause.*)

MRS CONSTANT: Well, Mr Perry. I expect you're wondering why I asked you over.

PERRY I hardly think it was for a glass of sherry.

MRS CONSTANT: No, hardly. Please don't make things more difficult for me than they are already, Mr Perry. You will appreciate the fact that this is not at all easy for me.

PERRY: It was your own suggestion that I should come over, Mrs Constant.

MRS CONSTANT: Yes, I know. And I know too that you are an intelligent and cultured man, Mr Perry – but, whatever your attributes, I wish to make it clear that I do not wish you to have anything more to do with my son, ever.

PERRY: I see. I should have said that Arnie was old enough to look after his own interests.

CARYL: Not when there are people like you around, *Mister* Perry.

PERRY: I don't think I quite understand all this. Certainly, I will 'leave your son alone' – as you put it. But please, may I have the reason?

CARYL: We don't want him tainted the way you tainted Don!

PERRY: (*Rising.*) Now, look here, Mrs Kessler – I think you'd better withdraw that.

SAM: Just a minute, Caryl. Please sit down, Mr Perry. A day or two ago, we came across a book which you had given Arnie.

MRS CONSTANT: This one. (*Producing yellow book from behind settee cushion.*)

PERRY: That is so – yes.

SAM: Don't you think the inscription a little – strange?

PERRY: If I had considered for one moment that the inscription was strange, I most certainly would not have written it.

CARYL: Is it true that six months ago you went to a psychiatrist?

PERRY: If it were – can you give me a reason why?

MRS CONSTANT: Yes – because you have an unhealthy mind. (*PERRY looks at her directly for a few moments before he speaks.*)

PERRY: Mrs Constant! I came here tonight, resolved, at all costs, to keep my temper –

MRS CONSTANT: Your temper! That makes me laugh! What right have *you* to lose your temper! You are not the injured party!

PERRY: I am waiting to hear what you mean by 'an unhealthy mind', Mrs Constant.

MRS CONSTANT: Don't you know?

PERRY: No. I do not know. It's not the kind of expression I feel I would use of anything. It doesn't really mean very much, does it?

CARYL: Oh, listen to him, will you!

PERRY: But I'm waiting to hear what you mean by it. What do you mean by it, Mrs Constant?

MRS CONSTANT: You're very clever, Mr Perry. I can see that. And I dare say you don't think very much of our intelligence. No doubt we haven't read a great many highbrow books and so on!

PERRY: (*Politely.*) To be quite frank with you, Mrs Constant, I cannot say that I think very much of your manners.

CARYL: How dare you!

MRS CONSTANT: Let him go on, Caryl. Let him speak his mind. I intend to speak mine. No doubt my son has been impressed with your airs, and your superior ways, but they don't impress me, Mr Perry. I see through it all. I know all about you and, believe me, I'm not the only one. People are on to you and, if you don't watch yourself pretty closely, you're headed for real trouble. And I just want to make sure you don't get my son mixed up in it.

PERRY: You have quite a talent for insult, haven't you, Mrs Constant?

CARYL: God – listen to the smug little – ! Sam – why don't you speak up! Don't leave it all to Mother. Why don't you let him have it!

PERRY: (*Rising.*) You are all obviously intent on a brawl. I'm sorry – but I've no intention of taking part in it. Maybe you'd better write me a letter.

MRS CONSTANT: No! You're not running out, Mr Perry! You'd like to do that because you know you're cornered, but you're going to listen to what I have to say before you

leave this house. I have a great deal at stake. Something you wouldn't understand. I have just discovered that I have lost one of my sons today.

PERRY: I'm deeply sorry to hear that.

MRS CONSTANT: (*Shrill now.*) You are, are you! I thought he was everything that was fine and good, and manly. But now it seems I was living in a dream world. But I'm not living in a dream world any longer. My eyes are open, Mr Perry. And I'm going to move heaven and earth to make sure I don't lose my other son!

SAM: Mom – take a hold on yourself! You're all upset –

MRS CONSTANT: Do you think I am going to let this man take both my boys away from me! How does *he* know what I'm feeling! What do you know about real life, and real people! Why you were never even in the Army!

PERRY: I don't feel this is getting us anywhere. Maybe I'll come back when you're feeling better.

MRS CONSTANT: Don't you stand there, making fun of me! There's a name for men like you!

PERRY: And I'm sure you wouldn't hesitate to use it, Mrs Constant. Very well – if that's the way you want it: I'm still waiting to hear you tell me what you mean by an 'unhealthy mind'. But I guess you've made yourself pretty clear. Mrs Constant – even in these times, there is still some law protecting people from slander. Do you wish me to take this matter to court?

MRS CONSTANT: You wouldn't dare – you wouldn't dare!

CARYL: He's bluffing all right!

PERRY: Am I? It seems – one way and another – that I haven't very much to lose at the moment. But I could drag the family name of Constant through the mud. And I don't think your husband would relish the idea very greatly – he's doing very well in his business just now I believe, isn't he. So I feel I must warn you that if any of your slanderous attacks reaches my ears again, I shall consult my lawyer immediately.

MRS CONSTANT: Well – to think that I should live to see this – to think that I should be spoken to like this, at my age.

CARYL: The net's closing round you from all sides, and you know it! You don't impress me! Listen – glamour boy – I have a little news to lay at your doorstep, too. I have witnesses who would be willing to be called who have seen you at the drug stores with your arm round Arnie's shoulder.

PERRY: (*White.*) Really, Mrs Kessler, is there anything so very extraordinary in that?

CARYL: I happen to know too that you were refused a passport when you wanted to go abroad during the summer vacation last year. Would you care to explain why that was?

PERRY: I decline to answer that.

CARYL: 'I decline to answer that'. That's what I thought, that's what I thought. And do you know what? We all seem to be forgetting that Don figures in this dainty pastel picture too – doesn't he? Which one is he, Mr Perry? Is he the one with the pale pink bow in his hair?

SAM: Caryl?

CARYL: But I forgot – it's red ribbon these days, isn't it, Mr Perry?

SAM: Can't you see this isn't getting us anywhere, Caryl?

PERRY: You're right there, Mr Kessler. (*Rises.*) If you'll excuse me – I'll be going. I've had a long day, and I haven't eaten yet.

SAM: Isn't it possible to talk this over quietly, Mr Perry?

PERRY: It just doesn't happen that way, I'm afraid. Do what you like, Mrs Constant, and you, Mrs Kessler – but I'm warning you again. I knew what I was walking into before I came. You see, this is a small town –
(*ARNIE enters at front door.*)

ARNIE: Ward! Hello, Ward! What are you doing here?… Oh, I see… I get it.

MRS CONSTANT: Please go upstairs, Arnie.

PERRY: Don't bother – I'm going. (*Crossing to the front door.*) If we meet again – I guess it'll be in court.
(*Exit PERRY.*)

ARNIE: Wait a minute, Ward – I'll walk a little way with you!
　(*Exit ARNIE.*)

MRS CONSTANT: ARNIE!

CARYL: There's your precious Arnie for you! The sins of the
　brother's…

SAM: How does that one go on?

CARYL: I'm tired. Take me home.

MRS CONSTANT: Won't you have some coffee, dear? It won't
　take a minute. You too, Sam. (*Crossing to kitchen.*) It was
　good of you to come along. (*At door.*) I think we've got him
　worried, don't you?
　(*Exit MRS CONSTANT.*)

SAM: He seems a decent guy to me.

CARYL: That's naïve if you like. God, Sam, are you soft or
　something? You've only to look at him. It's usually these
　so-called cultured men who are a bit cracked somewhere.

SAM: What about the so-called women? You ploughed your
　way through Mr Plato to William James, right on up
　through the moderns, didn't you? What does that make
　you, I wonder?

CARYL: You should know. Hell of a lot of good you've been. I
　don't think I'll stay for coffee now – I feel slightly sick.

SAM: Mom, here a minute. Never mind the coffee. I want to
　ask you something.

CARYL: Come on Mom. J Edgar Hoover wants you.
　(*MRS CONSTANT comes in from kitchen.*)

SAM: You know Mom – I think we're making a mistake in
　dealing with it like this. Maybe we're tackling it from the
　wrong end – the wrong angle altogether.

MRS CONSTANT: I don't think so, Sam. Oh, I don't know what
　to think. Heaven knows what harm that man may have
　done to Arnie.

SAM: That's just it, Mom, you don't know, and the only way to
　find out is not from Perry, but from Arnie himself.

CARYL: Hell of a lot you'd get out of that little clam. That one
　is so secretive and sly these days, talk about the Japs being
　inscrutable. I think he needs some medicine they handed
　out to our boys during the war.

MRS CONSTANT: I think Sam's right Caryl.

SAM: Look, you're his mother, his friend, aren't you? Have a talk with him – but don't chew him up like a cement-mixer.

MRS CONSTANT: I *have* tried to talk to him Sam – but I just can't get near him.

SAM: And you won't Mom, so long as he thinks you've got a gun in your hand. What you have to do now is to help him to find himself. I think if you talk to him directly and honestly, he'll have greater trust and confidence in you.

MRS CONSTANT: You think Arnie doesn't trust me? Oh Sam, surely.

SAM: No – no I didn't mean that exactly – but be generous with him, whatever his thoughts and feelings may be. I'm pretty certain that if you or Pop or both of you, if you let him know that you're with him right there behind the eight ball, things won't be half as bad as they seem.

CARYL: 'Dear Auntie Flo – I've been kind of worried about my little boy lately, you see, he's not like other little boys, –'

SAM: Ha, ha, ha, very funny.

MRS CONSTANT: Yes, I think Sam's right, Caryl. I'll have a talk with him. Don't you think so Caryl?

CARYL: It doesn't seem to matter very much what I think these days. Some people make me puke.

SAM: That goes for me too.

CARYL: We're not staying for coffee Mom, thanks.

MRS CONSTANT: Oh – just as you like, dear.

SAM: Don't worry, Mom. This may have been a bit of a flop – but I'm sure it'll sort itself out in time.

Caryl: 'In time' will probably be too late. Oh, well, I'm going (*Crosses to hall.*) Goodnight, Mom.

(*Exit CARYL.*)

SAM: Goodnight, Mom. Talk to Pop about it again, I'm sure he'll agree with what I've said.

CARYL: (*Off.*) Come on Sam. Are you coming home or not?

(*Exit SAM.*

MRS CONSTANT is left to herself, she looks around her a little helplessly. Then she crosses to the telephone and picks it up.)

MRS CONSTANT: Seven – three – 0, please… Oh, Mrs Slifer?
Yes, it is. I just wanted to thank you properly for helping
me out so much – it's been a great help – (*Her voice breaks.*)
No, nothing really – I'm alright – it's – it's just that – Don
is not coming home after all. No, I really don't know
why – Thank you – that's most kind of you…yes, yes, I'd
like that, yes do come round – I made coffee for Sam and
Caryl, but they couldn't stop – so we can have it, can't we.
Yes, see you in a little while.
(*MRS CONSTANT replaces the receiver. She stands there as
ARNIE comes in the front door.*
Enter ARNIE.
*MRS CONSTANT and ARNIE look at each other steadily and
for a moment. She crosses to settee and sits. ARNIE starts
upstairs.*)
Arnie dear, come here a moment will you? I want to have
a little chat with you.
(*ARNIE remains on the stairs and does not turn.*)
Didn't you hear me dear? Don't stand there dreaming
Arnie – Mom wants to talk to you.
(*ARNIE comes slowly in to the sitting room.*)
There, that's better, isn't it? (*Pats settee.*) Sit down, dear.
Now I have something to tell you which I think you should
know. It's not going to be easy for me – in fact I've been
putting it off, but I think you should know before you read
it in the newspapers. Arnie – do pay attention dear, please.
It's about your brother. I know how much you admired
him, a little too much perhaps, for your own good. I can
see now that these things can be magnified out of all
proportion and force one to take the wrong path – the
devil's path, Arnie, and not the right path – God's path.

ARNIE: Don't give me that malarkey – I don't believe in
God – sure I thought I did – not any more though.

MRS CONSTANT: Arnie! Do you know what you're saying?
That's blasphemy!

ARNIE: Well I have said it, haven't I?

MRS CONSTANT: We'll talk about that later. In the meantime,
you may like to know that your brother prefers to stay out

in China or India or Korea or wherever it is, instead of coming home to us – his own family.

ARNIE: Good! I'm glad!

MRS CONSTANT: What on earth has come over you Arnie? Why are you behaving so strangely. Oh yes – yes of course, I understand perfectly. That Perry man has been talking to you, hasn't he – he's tried to turn you against me! I believe he's almost succeeded!

ARNIE: That Perry man, as you call him, sure has been talking to me. He and I have just been having a cosy little chat too. He told me a few fascinating facts that concern me primarily – I am not above passing them on to you. He told me that you had ordered him not to associate with me any more. That's not all – oh, I can't believe it, I can't believe all this… You started all this, why? And he told me a lot more in a short space of time without mincing any words – but I guess I'd better mince 'em for you, hadn't I? He said he was sick of the sight of me, that he never wanted to set eyes on me again anyway. And, this is the stop-press, he said that certain people had suggested that because we were being seen about together so much that we were perverted. That just about completes the cross-word doesn't it? A word in seven letters meaning unwanted, untouchable, despised, disgraced, sneered at and jeered at, made the subject of those nasty mean little jokes on the side. And to think I'd heard about this sort of thing, I didn't know it would touch me – I didn't know – Jeez, I didn't know. I thought everything about Ward and me was good and fine and right. I didn't know. Aren't you proud of me, your son, a pervert?

MRS CONSTANT: Then it is true! Answer me! (*Gripping his arm.*) It is true, isn't it? It is true!

ARNIE: (*Shouting.*) Yes! Yes! Yes! It's true! Is that what you want! It's true – anything you want to believe. Seems like you've already made up your mind what you want to believe anyway! Maybe Don's got the right idea after all, staying out there – people like you are enough to turn us all into Commies and perverts.

MRS CONSTANT: You little beast! (*Slaps his face again and again.*) You horrid little beast! (*She drives him back across the room and he falls backwards against the steps.*) I should have known – I should have known – you filthy little beast!

ARNIE: (*Raising his arm against the blows.*) Mom, don't – please don't.

MRS CONSTANT: Get out – get out of this house, before I kill you!

ARNIE: (*Crawling away.*) Pop! Pop! Pop!

MRS CONSTANT: Get out, I tell you! Get out!

> (*ARNIE, sobbing, rushes out of the front door.*
> *MRS CONSTANT, exhausted, goes to the doorway, and switches on hall light.*
> *She leans her forehead against the wall.*
> *Then, slowly, she turns her head toward the stairs to see*
> *MR CONSTANT standing there.*
> *Slow curtain.*
> *End of Act Two.*)

Act Three

(*Late afternoon, a few weeks later.*

'Don's Corner' is now quite bare. No flowers decorate the room. The curtain rises very slowly on an empty stage. The television is playing Samuel Barber's Adagio for Strings.

MRS CONSTANT enters from the kitchen. She is wearing black and carries a vase containing autumn leaves which she places on low table L. She then crosses to the television set and watches for a moment.

A shadow appears on the mesh door and –

MERRICK enters. He looks across at MRS CONSTANT.)

MERRICK: Mrs Constant.
 (*She does not move.*)
 … Mrs Constant!
MRS CONSTANT: (*Who, throughout the rest of the Act shows a dazed grief, unreleased as yet by tears.*) Oh, oh, I'm so sorry. I didn't realise anyone was there. I guess I must have been dreaming. Do come right in Mr Merrick.
MERRICK: Thank you, ma'am, thank you. (*He crosses into the sitting room.*) Sorry to be a worry to you again, but I just came over to ask another favour. (*He switches off television.*) I wonder if you'd be so kind as to allow Mrs James to take the chair on Wednesday? She has been asking me some time now when she would be allowed to preside and I thought right now was a good opportunity, a very good opportunity.
MRS CONSTANT: Of course Mr Merrick, anything you say.
MERRICK: Naturally, I'm mighty sorry about all this, mighty sorry.
MRS CONSTANT: It seems to me Mr Merrick, that very soon I shan't be able to go outside my own front door.
MERRICK: Now you mustn't take it to heart, Mrs Constant. The people will forget, eventually, people do forget you know, and I know that grief does not last forever. After all,

it was not entirely your fault that you have been touched by so much sorrow.

MRS CONSTANT: Not entirely my fault, Mr Merrick?

MERRICK: Well it's like this, Mrs Constant; it was only to be expected that trouble would brew up over your son Don remaining with them Reds and then there –

MRS CONSTANT: And my son, Arnie, Mr Merrick, what about him? Why was it that there was only the family at his funeral? He had friends before he died – can you tell why they should all forsake him now that he's dead?

MERRICK: You seem to forget Mrs Constant that when your son drowned himself in the river that night, it set the whole town talking – it was bound to, and rumours weren't getting very pretty. No, they weren't pretty at all.

MRS CONSTANT: And why haven't you said all this before?

MERRICK: Well, I thought it would be only fair to give you time to get over this tragedy. To lose two sons in so short a time is indeed a terrible tragedy, and I would like to say something else, Mrs Constant. I think it's only fair to tell you about it before the town gets a hold of it. Lily Wilson, the young coloured girl, is with child.

MRS CONSTANT: Oh? That's one thing you can't blame me for, Mr Merrick. Enough trouble has been put on my doorstep without adding more.

MERRICK: These are the facts as they stand: her brother, Chippy Wilson, came to me today and told me what I have just told you. And between us we have very strong reason to believe that Arnie was responsible, yes sir, young Arnie.

MRS CONSTANT: Arnie and her. But it's impossible, it's unbelievable. What will they think of next?

MERRICK: Mind you, she won't *say* who it is. But this and your son's suicide ties up pretty neatly, doesn't it, pretty neatly. Plus this piece of evidence. (*He takes out a crumpled sheet of paper.*) Something Lilly wrote to herself which her brother sensibly brought to me.

MRS CONSTANT: (*Taking the paper.*) But, I don't understand – it just says Arnie Constant, Arnie Constant, Arnie Constant, over and over again. (*Turning paper over.*) Arnie Constant,

Arnie Constant (*She laughs a little hysterically.*) Arnie
Constant.

MERRICK: Looks like he's the one, doesn't it, Mrs C. He done
it alright – and ran away to escape the consequences by
committing suicide. Clear as daylight.

MRS CONSTANT: Yes, and do you know, Mr Merrick, I'm glad,
glad – not because he committed suicide – but because of,
oh so many things you couldn't begin to understand. I'm
glad. Well, you just tell Lily Wilson that I'll be over to see
her tomorrow. Yes, I'll call on her tomorrow. Please don't
say anything about this to anyone else – yet. And tell her
not to be afraid – you look shocked, Mr Merrick.

MERRICK: I am shocked, ma'am, shocked and surprised
that you appear to have no remorse and shame in your
heart. I do not think that you are doing the right thing
by not attending our meetings any longer, that is where
you have erred, just when you need God most. (*He shakes
his head.*) Time will tell Mrs Constant, time will tell. 'And
the destruction of the transgressors and of the sinners
shall be together and they that forsake the Lord shall be
consumed.' Mark the words of Isaiah, Mrs Constant, 'They
that forsake the Lord shall be consumed.' I will inform Lily
Wilson that you will see her, though I very much doubt
whether she will see you. This is the devil's work Mrs
Constant, believe me –

(*The front door opens suddenly and SAM enters supporting MR
CONSTANT.*)

SAM: Can somebody give me a hand – Pop's a bit sick. I think
he ought to lie down for a while.

MERRICK: (*Crosses to front door.*) I consider it my duty to pray
for you at the next meeting, Mrs Constant, I shall pray for
you most fervently. (*He goes out.*)

MRS CONSTANT: But Mr Merrick – (*She crosses the hall as SAM
comes out of 'the foxhole'.*) Oh Sam, it isn't true, is it? Has Pop
really been drinking, has he?

SAM: It's that and a lot of other things Mom. He's pretty
shaken up in many ways. Anyway, leave him there for a
little while – he needs the rest.

MRS CONSTANT: But I can't leave him there, can I? What am I to do with him? I've never known him to do such a thing before.

SAM: I'll just pop over and get Caryl to keep you company for a time, would you like that?

MRS CONSTANT: Yes I would. But where was Pop – how was it you brought him home? It's not like him to go out drinking. Right there in front of the Rev Merrick – it's disgraceful.

SAM: Yes, yes I know – I know all that. Let me go and get Caryl will you? There are one or two things I think you both ought to hear. Won't be long. (*He goes out*.)

(*MRS CONSTANT goes to 'the foxhole' door and knocks gently*.)

MRS CONSTANT: Pop, are you alright? Are you awake? Shall I make you some coffee? – No, I'll make you some tea, shall I?

(*The door bell rings and MRS SLIFER enters*.)

MRS SLIFER: You there, Mrs Constant? Is everything alright – I saw Sam going tearing away in his car.

MRS CONSTANT: (*Coming from kitchen*.) Why, yes, Mrs Slifer, everything's alright.

MRS SLIFER: Wish everything was right with me Mrs Constant. All day I have had bad news but I think I must not trouble Mrs Constant with it – and now I can't bear it no longer. It's Paul, Mrs Constant. He's been sacked from the State Department. Why would they want to do that to my Paul? I know who done it – laughing boy who was here with the big hat. Remember that man who walked up those stairs – and that laugh? He came to my place and I'm frightened by what he ask me – but I don't let him see I'm frightened. You'd think I was in the witness box.

MRS CONSTANT: I'm sorry about Paul, Mrs Slifer. He's such a good boy, I'm very sorry that this should have happened to him. I know how much Washington meant to him – and you.

MRS SLIFER: He's done nothing wrong, he *is* a good boy. But when that man came round spilling beans and shooting questions through the side door, I am wondering what I

have said. Oh, Mrs Constant, suppose I got my Paul into trouble over something I said wrong. Do you think I was wrong to stand up to that man?

MRS CONSTANT: I'm not sure. It's difficult to know what to do. We're outcasts now, it seems, because of our children. This is our reward for all the sacrifices we've made, you and I.

MRS SLIFER: I don't know what you mean. Reward? You don't ask no reward when your kids grow up do you? You don't present them with a bill do you and say 'You owe me one thousand dollars fifty cents which I spent on feeding you, clothing you, having you educated.' You don't do that do you? My Paul come home to me and get job here maybe – not for me – oh no, for himself. People push him off his feet. OK. So I help him up again if I can.

MRS CONSTANT: He won't get a job here, and you know it Mrs Slifer.

MRS SLIFER: And why not, why won't my Paul get a job here? He's clever he's intellectual too. Too damn intellectual for that Washington lot, that's what it is. They don't like it. Laughing boy with the hat don't like it. When he come to me such smart talk he had. You know what he said to me? Such nerve. He said 'I doubt your veracity, Mrs Slifer,' and I got right up close to his face and I say, 'and I doubt your veracity too with a capital doubt and a capital veracity'. My Paul is too smart for him. OK so he don't get a job here. He go somewhere else. Your husband is an influential man Mrs Constant, perhaps he could help my Paul – perhaps he could give him a job in his own business?

MRS CONSTANT: Yes, perhaps. It's an idea anyway.

MRS SLIFER: Would you ask him? Tell him my Paul is a good boy Mrs Constant, tell him that.

MRS CONSTANT: I'll do my best, though I can't promise anything. My husband isn't at all well right now and I'm afraid I couldn't worry him at the moment.

MRS SLIFER: All you have to say is will you give Paul Slifer a job – or not. That's all, and he just says yes or no – that's all. It's quite simple.

MRS CONSTANT: Well, anyway, I'll do my best for you., I'll await a favourable opportunity, then I'll mention it to him.

MRS SLIFER: Don't just mention it to him – *tell* him. Paul Slifer's a good boy –

(*There is the sound of a car drawing up.*)

MRS CONSTANT: Yes, of course. That sounds like my son-in-law. If you don't mind, Mrs Slifer –

MRS SLIFER: You want that I should go. OK I can take a hint! (*Crossing to door.*) As for these towns-people – me an outcast! Huh! (*She snaps her fingers.*) I never was *in*-cast, so why worry! (*Exit.*)

(*CARYL and SAM are heard arguing as they approach.*)

CARYL: (*Enters through front-door followed by SAM.*) Well all I have to say is for Pete's sake have we or have we not been through enough trouble already.

SAM: Yes, yes, OK. But that isn't the point.

CARYL: Hullo, Mom. Then what is the point, may I ask?

SAM: Just a minute Caryl, don't go blowing your top. I brought you here didn't I? – before anything was decided. Does that make you happy?

CARYL: What would make me happy would be not to hear you yapping so much and I were a thousand miles away.

SAM: That can be arranged –

MRS CONSTANT: Now you two – I think we're letting things get on top of us –

(*The door opens of 'the foxhole' and MR CONSTANT comes out and goes upstairs in silence, watched by the others.*)

CARYL: Well, look what the cat brought in, if you please. There's a pretty picture for you – the whole family crazy and Pop ends up with DTs.

SAM: Caryl – please – you're upsetting your mother.

CARYL: And what about me? Don't I count? Don't you realise that this whole town is just waiting to be blown sky-high? The police are on to every tiny move that we make? And why? All because of that goddamned Ward Perry – every second of the day and night they are piling up the evidence. Brother, you don't know half of what Officer Mathews knows.

SAM: Look, Caryl – will you listen for a moment to what I've got to say?

CARYL: Of all the damn fool things – Pop losing his job like that. Not content with that, he has to –

MRS CONSTANT: Pop? Lost – his job. I don't understand.

CARYL: Paul Slifer's got himself kicked out I hear. Now it's Pop. These things always run in threes. Guess Sam will be the next, won't you, Sam?

SAM: Oh, for God's sake Caryl! This isn't the time to be flippant, believe me. Listen, Mom: Pop's lost his job because he's being called in front of the Committee. In other words he'll be pretty well blacklisted from now on – or, if not, greylisted. If you know what I mean. I ran into him in Tracey's bar this lunch-time. I could see he needed a drink.

MRS CONSTANT: Why didn't you bring him home, Sam? Why didn't you bring him home, instead of letting him get drunk like that?

SAM: He wasn't drunk – he was in a kind of daze.

MRS CONSTANT: Why doesn't he refuse to face this Committee? They can't make him answer any questions.

SAM: If he doesn't – it's either gaol or a heavy fine.

CARYL: If there was a way out of it, you can bet Pop would find it quick enough.

SAM: How can you stand there and be so cold-blooded about it? This man is finished. Don't you understand? What's he going to do now? How does he go on from here?

MRS CONSTANT: I can't believe it. How could they sack him – after twenty one years? They surely couldn't turn on him like that.

SAM: They can, and they have. The thing we have to decide now is: what are we going to do about it?

CARYL: The real fairy godfather, aren't you, Sam?

MRS CONSTANT: Don't talk to Sam that way, Caryl. I'm sure he –

CARYL: And I'm sure he doesn't want you butting in on his precious blueprints on how to run a family. Seems to me he should look after his own family first.

SAM: I guess I should at that. Believe me, I can't forget you and your mother, like a couple of crazy things, grilling that inoffensive guy Perry.

CARYL: Inoffensive! That's what you call it! It's a good thing the rest of this town doesn't feel that way about it.

SAM: Frankly, I don't care what he is. He's done no harm to me. Neither his morality nor his politics interest me one little bit. I suppose that isn't the right attitude these days, and I'm out of line. But if it is, I'm staying that way. Maybe he isn't what you like in either respect, but it seems to me that this house of normal, ordinary people is none too healthy.

(*Quietly MRS CONSTANT goes out into kitchen.*)

CARYL: Just what do you mean by that?

SAM: Just this: I'm not one of these kid glove characters you seem to hate so much. I'm no so-called intellectual either. In fact, I know you don't think I'm so bright. And perhaps you're right too, But when I look around me, I don't like the things I see. What do I see? I see my wife and her mother tearing into some guy whose only real crime is that his ideas don't exactly size up to theirs. You had nothing on that guy Perry, and you know it. You're just plain vicious!

CARYL: Sam!

SAM: And you nearly got me doing it – you did that! That's the thing that gets me. You nearly carried me along with you. I can see it all so clearly.

CARYL: You're crazy.

SAM: When I see women ganging up and vicious, that really frightens me. That really turns me up! It's no good, Caryl – I just can't forget it. You see, you are the real leaders in these things. There's nothing we don't do or say that you women don't have to approve before it becomes the law of the land. And when you get started properly, tearing everything apart you suspect or don't or can't understand – I don't see much hope for me or my children.

CARYL: How can you talk that way to me! I happen to be your wife – or have you forgotten that little detail, in the midst

of all this high-minded horror. Haven't you any respect for –

SAM: Don't give me any of that respect and womanhood line, Caryl. That will really give me a laugh! I just don't see my way clear. I see Arnie – a fine sensitive kid with a heart to match his mind, driven to his death.

CARYL: Will you shut up, Sam! You're getting me mad.

SAM: You don't like that do you! No. You don't feel so good about it, do you? Well, neither do I. I see a man like Perry, who looks like he's got plenty to give to the community – at least, as much as you – hounded out of town. There's Paul Slifer – his career ruined. There's Oscar Vinson – some freedom loving American beat him up so bad, he's in hospital. Ted Allen, back from Korea, and no one dare speak to him, in case he contaminates them.

CARYL: If there weren't so many witches leaving their tall hats and brooms around, there'd be less trouble I'd say.
(*MR CONSTANT comes downstairs carrying suitcase, hat and coat which he places by 'phone table. No one notices him as he returns upstairs.*)

SAM: I see your father, a thoroughly decent guy who has never opened his mouth in his life, who's always done what he's told, lose his job – after twenty one years. For what? What's he got to look forward to? A blacklist? Your blacklist?

CARYL: Well? Why can't he stand up for himself. These weak men make me sick!

SAM: Well that's good! That really is fine! Because listen, honey: With all the other weak male creatures in this land of the free, I have played ball with conformity and its inseparable side-kick of womanhood. But from now on, there's going to be a change. I demand the right to be just as wrong as I like – provided I kick no one in the face. And no one – not you or any investigating Committee is going to unzip my brain and index my motives or convictions. Because I happen to believe in the rights of minorities, and the biggest minority of all is me! And whether you like it or not – that is what you are married to – (*Crossing the*

hall.) and it may interest you to know that I am considering taking up beliefs in any or all of the following: black magic, socialism, astrology, militant atheism, vegetarianism, yogi and pelmanism. Also, I have just started, as of now, The League for the Protection of Coptic Sleepwalkers. If ever a woman had grounds for divorce, I guess you've got it! (*Exit.*

After a moment, CARYL rushes to the window and flings it open.)

CARYL: Where are you going?

SAM: I'm going to get good and stinking!

CARYL: (*Yelling at the top of her voice.*) You come right back here! (*Sound of car drawing away.*)

Why, you bastard! You lousy bastard!

MRS CONSTANT: (*Appearing at kitchen doorway.*) Caryl! How dare you!

CARYL: (*Shouting.*) How dare I what? You heard what he said! You must have done! That's why you're a flop Mother, because you never dared. A fine mess you've made of things. I won't bore you with a list of them, but believe me, it's pretty long. Anyway it'll give you something to think about during the long winter evenings. (*To front door turning.*) My God! What a family! Arnie and Don – Pop and you – what a set of tramps.

MRS CONSTANT: After all I've done for you.

CARYL: Thanks for nothing. (*Exit.*)

(*MRS CONSTANT goes out after her, calling out. After a few moments re-appears in the front door.*)

MRS CONSTANT: (*Very quietly at first.*) Pop! Pop! where's Pop! (*Moves to study door.*)

Our girl's gone Pop. Pop. Pop!

(*She knocks.*)

Pop… Pop…are you there? (*She moves toward the stairs.*) Are you there, Pop?

(*The door of 'the foxhole' opens and WARD PERRY is seen.*)

PERRY: (*Softly.*) Mrs Constant.

(*MRS CONSTANT gives a startled gasp.*)

(*Entering.*) Please don't be frightened.

MRS CONSTANT: Go away – go away – I'll get the police –
(*She moves toward the 'phone.*)

PERRY: (*Stopping.*) Please. Please Mrs Constant – you've got to
listen to me –

MRS CONSTANT: Leave me alone, get out of here – you've
caused enough trouble already – you – murderer – the
police are on to you –

PERRY: Listen Mrs Constant – why do you think I came in
through the window? For fun? Why do you think I've
come here at all? Certainly not to pay you a social visit.

MRS CONSTANT: If my husband were well enough, he'd throw
you out of the house. If it's money you want, I'd rather
die –

PERRY: There's nothing I want from you. I have heard from
Don.

MRS CONSTANT: You've – I don't believe it. How? Has he
written?

PERRY: Yes, and he's asked me to give you a message.

MRS CONSTANT: This is some trick – I know it – I don't trust
you at all – where is the letter? Let me see it?

PERRY: I'm afraid I can't. Some friends of ours called today
and picked it up, among other things. Seems like they
couldn't wait to follow it to its destination. Shouldn't be
surprised if the whole of the FBI hadn't read it long before
I ever had it –

MRS CONSTANT: Don – how is he? Is he well?

PERRY: It was written before he was released and in it he
says mostly what we already know – except this. He sent
his deepest love to you both with the knowledge that his
decision not to return would hurt – but he asks you not to
worry. He feels sure that one day he'll return and see you
again but until then he must fight for what he believes in.

MRS CONSTANT: Why couldn't he have been repatriated
and still fight for what he believed in. We'll never see
him again. And I'm not so sure that I want to see him
again. What have I done to deserve all this? What has
happened? There's nothing left now – nothing – not even

my husband – (*She becomes aware of PERRY again.*) Have you
anything else to tell me?

PERRY: I took a long time making up my mind to come here.
No doubt you look upon me as the source and fountain of
all your grief. Yours is the grief of shame – it brings shame
into the room with it. God knows we have made mistakes,
but please Mrs Constant, don't make the mistake of being
ashamed of your sons.

MRS CONSTANT: Please, please go Mr Perry – nothing you say
now can possibly undo this terrible damage. You think I
drove Arnie to – you think it was me, don't you?

PERRY: They say that innocence does not drive itself to
suicide, only the guilty destroy themselves. I don't believe
it. Arnie wasn't guilty. Arnie was as guiltless as the birds
flying in the air. I'm no Dr Conwell, but Arnie was
essentially a lonely boy, and I thought I could help him
in some small way. You thought I was wrong for him and
I thought the only thing to do was to sever our friendship
immediately, cleanly. You will never know what tortures
have been mine ever since.

MRS CONSTANT: That's God's judgement on you for your
wickedness, I have nothing to say to you. You'll get your
just deserts in time, you mark my words. I've heard plenty
about you, it's useless for you –

PERRY: You've heard, you've heard! Don't you see what
you are doing by this zealous inquisition – and by you,
I mean you and your neighbours and friends. Don't you
understand why I came here. Heaven knows why I'm
doing it, but I'm trying to give you back your pride. Listen:
Arnie is dead. Thousands of kids get killed by drunk
drivers. Well this town's got itself pretty high and Arnie's
the first victim. And the party has only just started. They're
only getting warmed up. The big party's on the way. But
just because a crazy set-up has run him down – don't for
heaven's sake spend your time being ashamed of him!
He was a fine young man – he was easier for a drunk to
pick out that's all. As for Don, get it out of your head that
he's a dead man now. While people like me are just plain

jay-walking, he's got out of the way. Oh, I don't say he's done the right thing. It could be that he's made a terrible mistake – but he's run no one down doing it.

MRS CONSTANT: Hasn't he? What about me? What about his family?

PERRY: It wasn't his intention to hurt you, I'm sure of that. He wrote to me so that I could break the news to you quietly, which I could have done if that letter had reached me in time.

MRS CONSTANT: He went to Korea didn't he to fight against the very thing he now believes in.

PERRY: Sure, he went to Korea, like the rest. I guess it was like everything else – he had to see for himself. And that Medal of Honour. The idea of Don enthusing death upon some pointless hill-side – it didn't make sense. But I think I can understand – if you're trying to establish some unlikely higher calculus, Don would have to make sure that simple arithmetic didn't add up either. However tragically wrong he may have been, he hasn't chosen this way because it's an easy one. Maybe he wasn't the person you thought and had enshrined in that corner. But then he was unpredictable at all times. He changed, he grew out of people before they even accustomed themselves to his variety. He was too exacting for belief, too curious for fanaticism, too universally enthusiastic even for friendship – perhaps for love even.

(*Pause – there is the sound of a police car siren as it approaches and fades into the distance.*)

MRS CONSTANT: That sound should bring you back to earth, Mr Perry.

PERRY: Alright. I understand Mrs Constant. I've wasted my time – and yours. I'm very sorry, I was only trying to bring a little honesty into this place.

MRS CONSTANT: Honesty! Well, that's fine coming from you. You want honesty, Mr Perry? Very well, I'll be honest with you. I hate you and loathe you and will do so until the day I die. Nothing you say or do will wipe away all the distress you have caused my family. Nothing. You have smeared

us all with your – your decadence. Why you aren't in jail heaven only knows.

PERRY: Which way do you wish me to leave – the way I came?

MRS CONSTANT: I don't mind in the least, so long as you go. (*As PERRY turns to go, MR CONSTANT comes down the stairs with suit-case etc.*)

MR CONSTANT: Mr Perry. This is a surprise, I must say.

PERRY: Don't worry, sir, I'm just leaving, I'm leaving town altogether.

MRS CONSTANT: I can think of no-one who wants you here.

MR CONSTANT: I believe we have an appointment at the same place tomorrow?

PERRY: Oh?

MR CONSTANT: Yes, it seems I have two little sessions tomorrow; one, to defend myself, and the other to testify against you. I expect you would think it uncharitable of me not to wish you luck?

PERRY: It seems a common failing, sir, to believe the worst in our fellow-men.

MRS CONSTANT: Pop – what have you got that suit-case for? You're not going tonight are you? You're not leaving right now – surely.

MR CONSTANT: (*Looks at his watch.*) Yes my dear. I'm afraid so – I have a long journey ahead –

MRS CONSTANT: But you can't go. Please Frank you can't leave me here alone. You won't come back! Of course! You're not coming back, are you?

MR CONSTANT: I'll be back, don't worry. Oh, Perry, I guess we'll be travelling together – if you like to get the station-wagon out. Here's the key.
(*PERRY takes the key.*)

PERRY: Goodbye, Mrs Constant. (*Pause.*) Goodbye. (*Exit PERRY.*)

MRS CONSTANT: How could you! How could you go along with that man! Frank – you don't have to go – please – you're sick – that's it, I'll tell them you're sick. (*She clutches*

his arm.) You aren't well enough to go on that journey tonight... Please –

MR CONSTANT: (*Breaking away.*) Don't honey! Don't! Please don't make things worse than they are already. (*Going to her.*) I'm sorry. I'm sorry my dear. I didn't mean to shout like that. Believe me I don't want to go – tonight or any other time, but I *have* to go. Try and understand that.

MRS CONSTANT: Then you needn't come back. That's what you want to hear me say, isn't it?

MR CONSTANT: Relax for a minute, honey, please, please. I am coming back to you. Get that? I am coming back. In the last couple of hours I've been doing a lot of thinking and I think it's time somebody made a stand against all this being kicked around and I don't just mean by using the Fifth Amendment either.

MRS CONSTANT: What's the good of making a stand? What's the good? We have nothing left to fight for, nothing at all.

MR CONSTANT: That's nonsense, we have everything, we have each other. Just because I don't go around slinging ropes around the branches of trees and getting lynch-drunk, it does not mean that I don't care. I do care. But if we're not very careful we'll be swept away by this flood-tide of investigation in to the very thing they think they're cleaning up. When I come back honey, we'll do some cleaning up of our own – quietly, without hysterics, but quite as effectively, believe me.

MRS CONSTANT: But you have no job –

MR CONSTANT: No – but we won't let that worry us. Now I must go. (*He kisses her.*) I'll open up a bicycle shop or something. (*He crosses and picks up his case etc.*) Or an opposition drug-store. (*He moves to front-door and smiles.*) You know – I'm quite looking forward to it. And – you know another thing? We haven't been so close together in years, as we are now.

(*Exit.*

MRS CONSTANT moves slowly down to the settee, in the gathering dusk, and sits as she hears the station-wagon start up and move away. Then –)

MRS CONSTANT: Tomorrow I'll go and see Lily Wilson.
　(*Slow Curtain.*
　The End.)

APPENDIX

The Devil Inside Him

With the exception of typographical and other similar errors, the text is that submitted to the Lord Chamberlain's office for licensing. Some minor changes were made to the subsequent version put on by Desmond under the title *Cry for Love* in 1962, but these have not been incorporated within this text, as it is probable that Osborne had no involvement in the production. In one case only have we preferred the 1962 version, where it seems that Osborne's original version contains an erroneous reference to there being no lodgers in the house (in fact, the lodger, Burn, is introduced shortly afterwards.).

- p 40 *Well, don't stand there gaping, girl…And get a tray set for Mr Burn.*

 Lines originally read:

 MRS PROSSER: Well, don't stand there gaping, girl. What's the matter with you? Here it is, nearly five to six and no tea on. Mr Prosser will be home soon. And Huw. Just because we've no lodgers to look after doesn't mean to say that we've nothing to do.

Personal Enemy

With the exception of typographical and other similar errors, the text preferred is the original version submitted to the Lord Chamberlain's office for licensing. Lines marked by | in the margin were marked 'DELETED BY THE LORD CHAMBERLAIN', and were not permitted to be used during live performance. In the examples below, Osborne and Creighton submitted alternate text to replace the disallowed lines (in one case below, the new lines were in their turn disallowed).

- p 133 *All right. You heard me talk about Don…not his precious Red pals!*

The lines were not deleted, but the Examiner noted: 'This could be political not sexual. CDH [Charles Heriot, the Lord Chamberlain's reader].'

- pp 154–6 *What book dear?… Sorry, Mom.*

Replaced by the following lines:

ARNIE: A thick book – with a yellow cover.

MRS CONSTANT: Yellow cover – why that was Don's book. That man took it away.

ARNIE: Took it away? What for?

MRS CONSTANT: Arnie – I want you to tell me something. You're not letting this Ward Perry – well – influence you in any way, are you?

ARNIE: Influence me? I don't know what you're talking about, Mom. He's a good guy, and I like him. You're getting as bad as Caryl – putting me in dock.

MRS CONSTANT: I'm sorry, son. But I do want to be proud of you, I – I don't want you to – betray your mother. I want you to grow into a decent clean-living man, with no thought of –

ARNIE: Please, Mom, I'm too old now for these kind of lectures. If anyone calls for me – I'm down at the

Students' Union. (*Crosses to the hallway and turns.*) Sorry, Mom.

- p 160 *I do not wish you to have anything more to do with my son, ever.*

Replaced by the following line:

I wish you to leave my son alone.

- p 160 *We don't want him tainted the way you tainted Don!*

Replaced by the following line:

Yes, you have an unhealthy mind.

- pp 164–5 *Mom, here a minute. Never mind the coffee…Come on Sam. Are you coming home or not?*

Replaced by the following lines:

SAM: That goes for me, too.

CARYL: We're not staying, Mom.

MRS CONSTANT: (*In from kitchen.*) Oh – just as you like, dear.

SAM: Sorry, Mom – seems like it was a bit of a flop.

MRS CONSTANT: Oh – I don't think so. I don't think so – was it?

CARYL: Goodnight, Mom. (*Crosses to hall and –*) (*Exit CARYL.*)

SAM: Goodnight. Try not to worry – forget all this.

CARYL: (*Off.*) Come on Sam. Are you coming home or not?

- p 166–8 *Arnie dear, come here a moment will you?…*ARNIE, sobbing, rushes out of the front door.

Replaced by the following lines:

MRS CONSTANT: Arnie.

ARNIE: Yes, Mom.

MRS CONSTANT: Come here a moment, dear, will you? (*He goes to her.*)

ARNIE: What is it, Mom?

MRS CONSTANT: Arnie – I have something to tell you. I just hadn't the courage earlier in the day – or the strength maybe. But you've got to know sometime – anyway, before you read it in the papers.

ARNIE: It's not about Pop, is it – nothing's happened –?

MRS CONSTANT: No. It's your brother. I know you've always admired him and hero-worshipped him – a little too much perhaps for your own good. I realise now that things can be overdone, can force one to take another path – the Devil's path, Arnie. And not the right path – God's path.

ARNIE: Gee, Mom – are you sick or something?

MRS CONSTANT: Please don't joke about this, Arnie. This is very serious.

ARNIE: I'm not joking. Anyway, what is this all about Don?

MRS CONSTANT: Your brother has decided that he prefers to stay in Korea or China, or wherever it is. He prefers that place to his own home.

ARNIE: Mom!

MRS CONSTANT: I'm glad it shocks you. If that shocks you – why don't all these other things shock you?

ARNIE: What other things?

MRS CONSTANT: You're so deep in this, aren't you Arnie? So deep that you can't even see God's clear blue sky above you for the mud and slime in your eyes.
(*Pause.*)

ARNIE: Of course – I can see it all now! That's why Ward was here! No wonder he wouldn't talk about it. I asked him what it was about, and he wouldn't say. He wouldn't say a word!

MRS CONSTANT: Because he was too ashamed – that's why.

ARNIE: Ashamed? Mom, what's got into you? I've never seen you like this before. What has Ward to be ashamed of?

MRS CONSTANT: Don't you know Arnie? You should know – you above all people! I have asked Mr Perry to leave *you* alone from now on.

ARNIE: You did that? Are you going crazy or something? What made you do a thing like that! But what has it got to do with you who my friends are? You're not going to decide for me, I'm old enough to decide for myself –

MRS CONSTANT: That's not true.

ARNIE: You're not breaking me and Ward up! We're fine, good friends, he's been like Don to me. He's the best friend a guy ever had – he'd do anything for me, anything.

MRS CONSTANT: Then it is true! Answer me! (*Gripping his arm.*) It is true, isn't it? It is true!

ARNIE: (*Shouting.*) Yes! Yes! Yes! It's true! Is that what you want! It's true – anything you want to believe. Seems like you've made up your mind what you want to believe, anyway! Maybe Don's got the right idea, after all, staying out there – people like you are enough to turn us all into Commies!

MRS CONSTANT: You little beast! (*Slaps his face again and again.*) You horrid little beast! (*She drives him back across the room and he falls backwards against the steps.*) I should have known – I should have known – you filthy little beast!

ARNIE: (*Raising his arm against the blows.*) Mom – Mom, don't! – please don't.

MRS CONSTANT: Get out – get out of this house, before I kill you!

ARNIE: (*Crawling away.*) Pop! Pop! Pop!

MRS CONSTANT: Get out, I tell you! Get out!

(*ARNIE, sobbing, rushes out of the front door. Exit ARNIE.*)

(Note that the lines marked by | in the margin opposite were also deleted by the Lord Chamberlain when the script was resubmitted.)